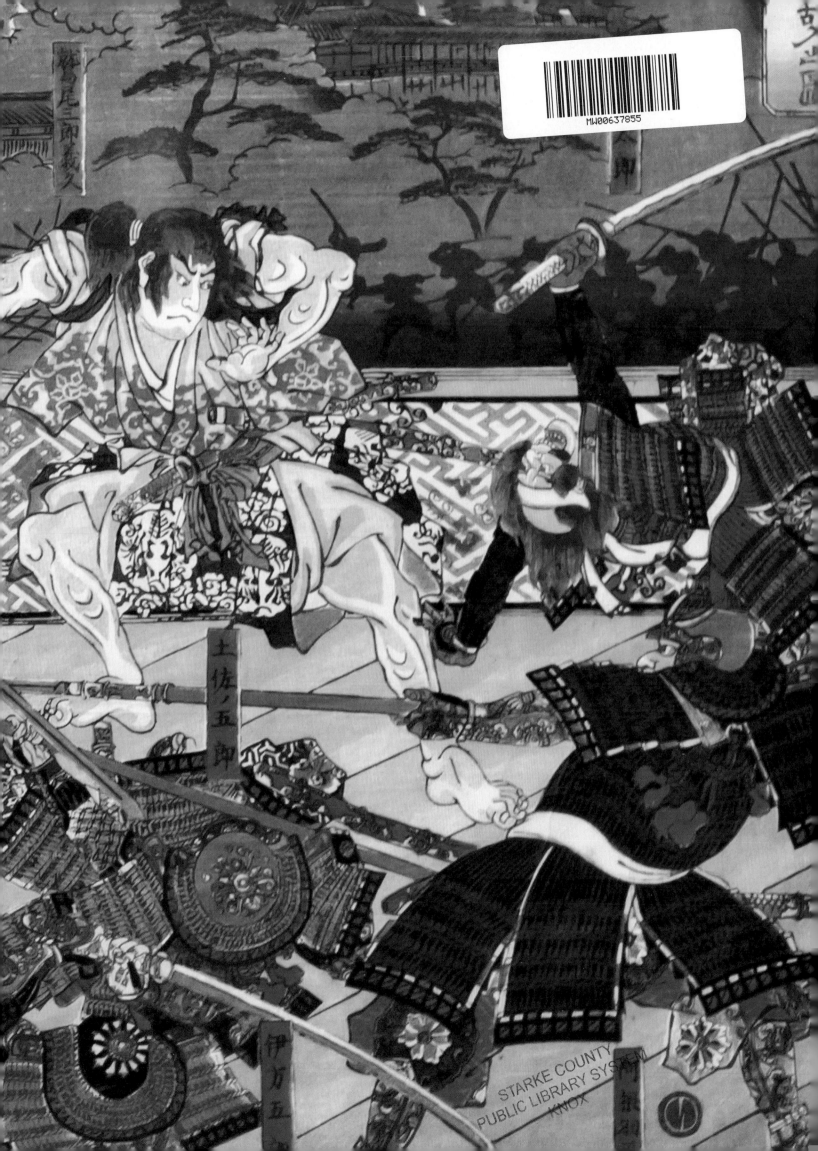

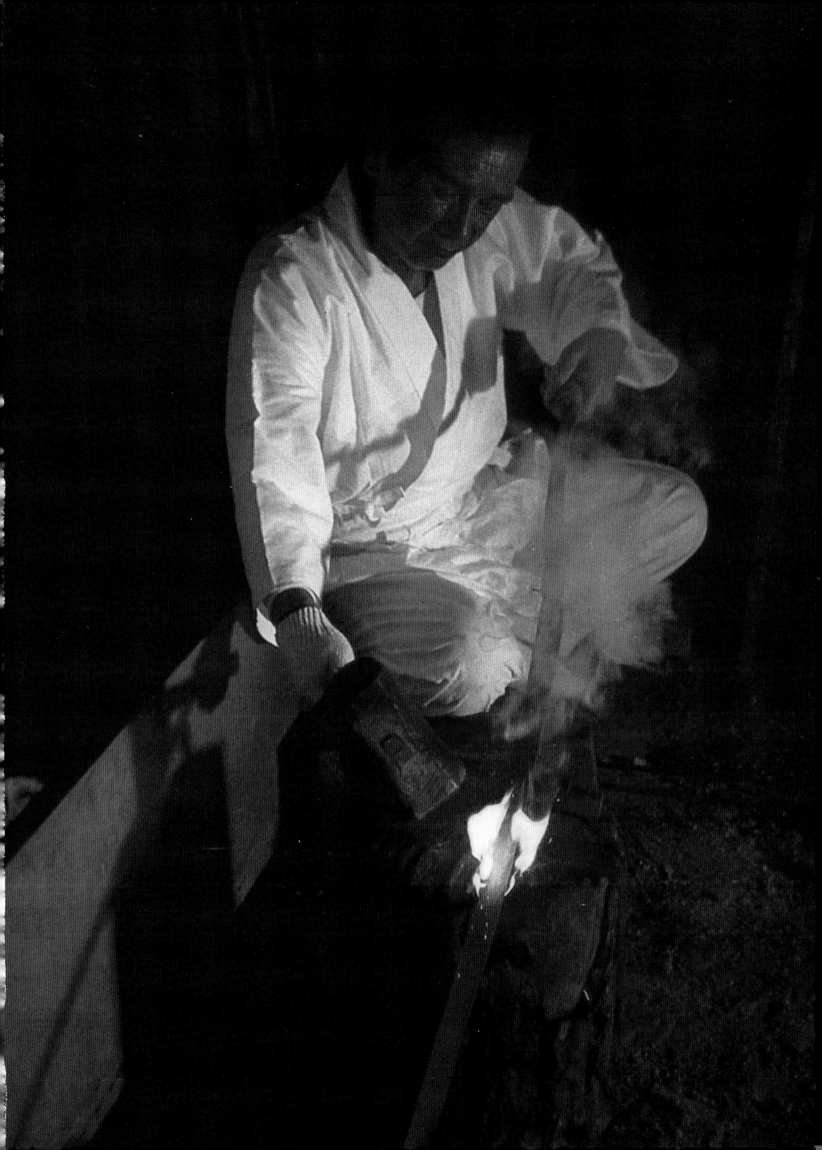

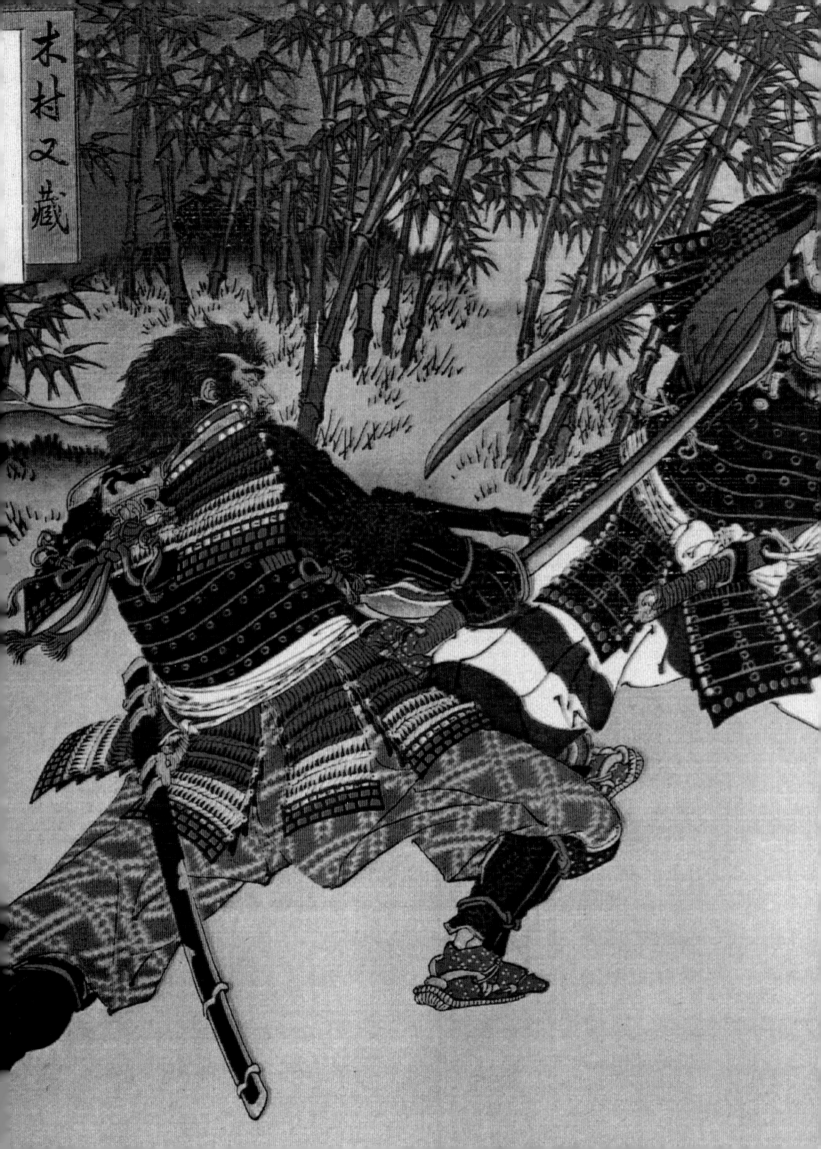
木村又蔵

SAMURAI SWORDS

A COLLECTOR'S GUIDE

A Comprehensive Introduction to History, Collecting and Preservation

CLIVE SINCLAIRE

TUTTLE Publishing

Tokyo | Rutland, Vermont | Singapore

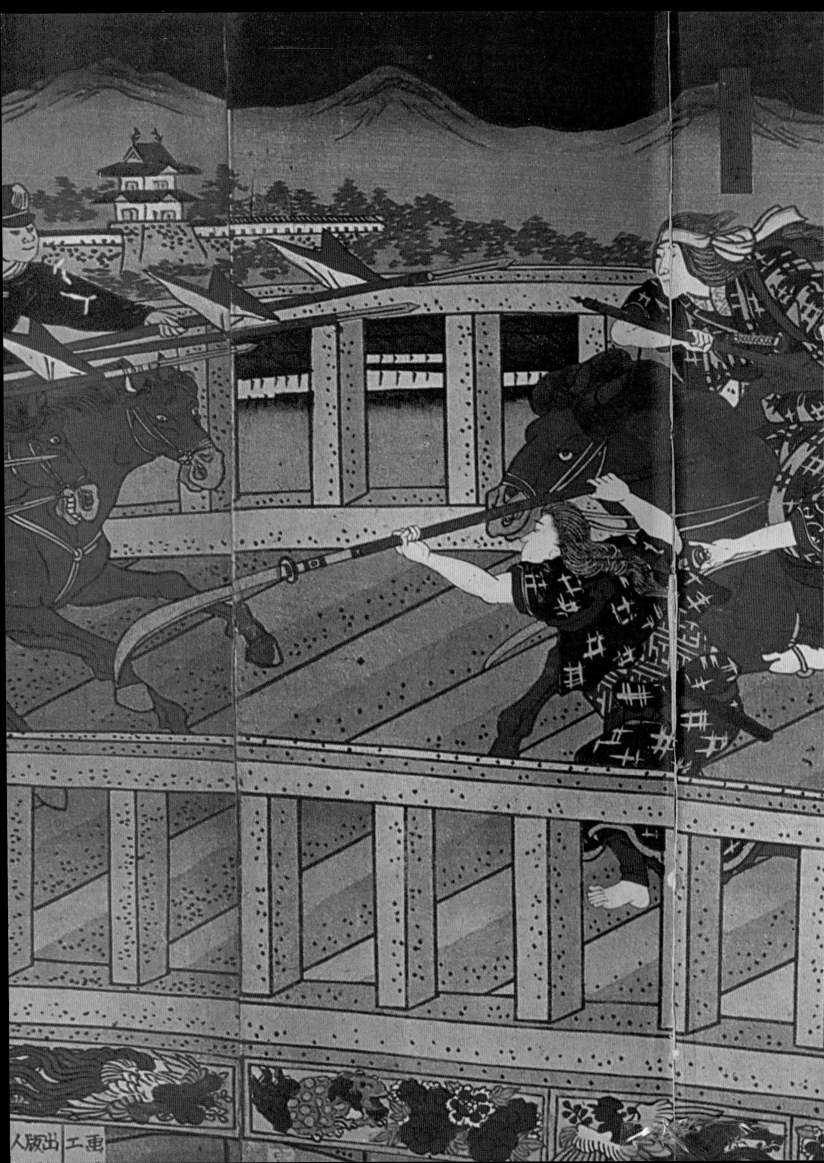

CONTENTS

Introduction and Acknowledgments

Ever since Early Man was able to hammer out bronze and iron blades, the sword has held a special and romantic place in the affections of the warrior classes of all nations. It has been the badge of honor, the symbol of war and courage in early civilizations, and indeed it may be credited in many cases with spreading both religion and civilization across the globe. Even today, when it has lost its practical usefulness as a decisive weapon, it retains part of the dress uniform of many armies and navies throughout the world. As a symbol reflecting the ancient customs from the days of chivalry, monarchs still ennoble deserving subjects by laying the flat of a sword onto their shoulders. Oaths of allegiance have long been taken on the sword, and when a commander surrendered his sword to a victor, this has been the symbol of abject and total admission of defeat.

In its practical usefulness, in its artistic merit, and in its exalted status, nowhere did the sword have greater importance, in the minds of the people, than in the "Land of the Rising Sun," Japan. Indeed, it is true that the Japanese sword was the last sword to be made for actual use in combat, as recently as only sixty-five years ago.

Some fifty years after the first atomic bomb was dropped on Hiroshima City in western Japan on August 6, 1945, I was at the Hiroshima Peace Park taking part in the commemoration ceremony of remembrance. Throughout most of the intervening years I had one overriding and enduring passion; I collected and studied the arts of the Japanese sword. The bug of the Oriental warrior, with his great swords and halberds, first bit me at school. Here, a close friend named Lee Chuen Pee, a Hong Kong Chinese, was a very skilled illustrator. His subjects, mostly in pen and ink drawings, were the heroes of feudal China drawn in microscopic

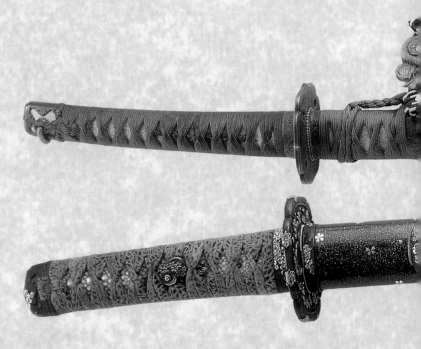

Top This is an *ito-maki-tachi* or thread-wrapped slung sword. The metal mounts are solid silver, which dates it from the late Edo or early Meiji periods (circa 1860) when such mounts were worn only on formal or processional occasions rather than with armor in battle.

Above This richly mounted *wakizashi*, or short sword, is in the *han-dachi* (half-*tachi*) style of the Mino-Goto school. All the metal mounts, including the *tsuba* are in the alloy *shakudo* with a punched surface (*nanako*) and gold floral decorations. The *tsuka* is wrapped in skin.

detail. He drew panoramic battle scenes with skies full of dragons, and I was fascinated by this alien martial culture. On leaving school, I took up *judo* and it became easy and natural to further develop this interest towards the warriors of Japan, the *samurai* and their weapons. When I began collecting in the late 1960s, there were many legendary characters active in the field of Japanese sword appreciation. Raymond Jonnes, for instance, who had served as a British infantry captain in World War I, was said to have been regularly seen

in the trenches of northern France wearing a *tachi*! Too old for combat in World War II, he was to be found in the streets of London as an air-raid warden during the Blitz wearing a *kabuto* (*samurai* helmet). Years later I saw him at a London auction house when he stopped the proceedings and urged all present to stand and bow to a sword which was inscribed "*Masamune*" (of highly dubious authenticity).

in a trade with Robbie, that realized in excess of ¼ million pounds (half a million dollars) at Sotheby's, London, in 1993, when his collection came up for sale after his death. This was a world record for a 19th century sword, which went back to Japan.

Another larger-than-life character of the time was Sir Frank Bowden, who had a country estate at Thame, deep in England's Oxfordshire countryside.

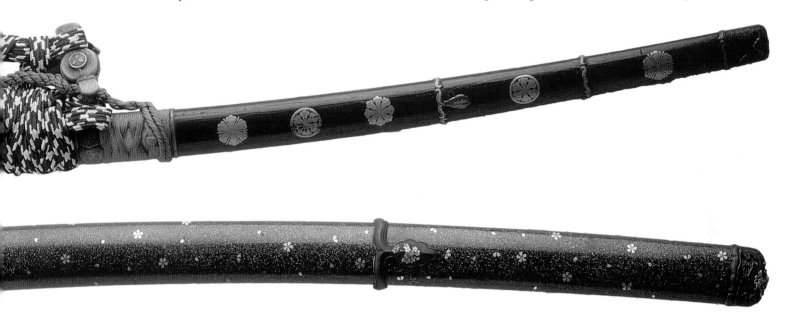

Another character was Basil W. Robinson, universally known as Robbie, the author of *Arts of the Japanese Sword* (my copy is autographed and dated August 1974). He was fortunate to have been advised in his early acquisitions by a Japanese officer who had been a POW under Robbie's charge in Singapore. President of the To-ken Society of Great Britain at the time, Robbie was also Deputy Keeper of the Department of Metalwork at the Victoria and Albert Museum in London and was known to trade swords with Field Marshal Sir Francis Festing. A veteran of the Burma Campaign during the war, Festing had a love of swords, as was well known to his subordinates, who ensured he was given the pick of the crop of swords coming to them. This included a Nagasone Kotetsu *katana*, or long sword, given to him by a Major General Hedley, who in turn had been given it by the Japanese commander of the army in Sumatra, Lieutenant-General Moritake Tanabe. It was Festing's Masayuki (Kiyomaro), obtained

The refectory was known as The Armoury and, as he was a patron of *kendo*, after a competition held in the vicinity the participants would often be invited back to look at some of his swords. These numbered in excess of four hundred! As well as swords, Sir Frank had many suits of Japanese armor, but most of his collection was dispersed in several London sales in the 1980s. Sir Frank, also a member of To-ken Society of Great Britain, boasted a pet cheetah named Chui, which sat in the front seat of his car as he drove around Oxford.

These and many other colorful characters throughout the world greatly enriched our lives in my early collecting days. There can be no doubt that the Japanese sword holds an immense romantic fascination for many. This fascination, while understandable in native Japanese people, whose own culture and history are involved, is far less understandable in a non-Japanese. Many collectors like me are introduced to the sword via the practice of Japanese martial arts such as *judo, karate,*

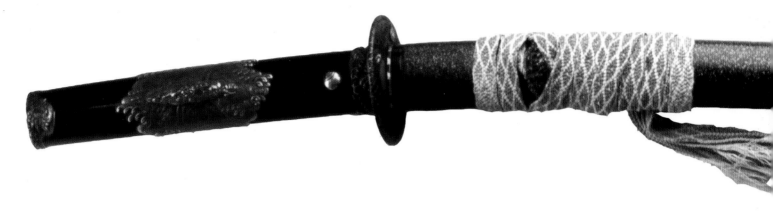

Above and Right A very skillfully made and ornate *daisho*, created in the alloy shibuichi and silver, depicts waves and dragons throughout. This *koshirae* (set of mounts) was made by Omori Tokinobu and dates from about 1860. The Omori family specialized in making deeply undercut wave designs as seen here.

iai-do or *kendo*. Once bitten, we find the fascination can easily take a firm hold of both the collector and his wallet.

The Japanese sword is a subject that can accommodate the serious student, the merchant, the martial arts practitioner, and many other interested parties, all of whom will have different levels of knowledge, skills, and enthusiasm. Hundreds of books have been written on the subject in Japan, and increasingly these are being translated into English to supplement the "home grown" publications that are available. Interest in the subject is still growing all the time outside of Japan, although the undoubted difficulties of learning the subject cause many collectors and enthusiasts to fall by the wayside, while only those beyond any hope of redemption persist. As with many other antiques, the life of a sword that is lovingly cared for and preserved far exceeds our own expectations of mortality... Our primary objective, therefore, is to preserve the sword, as have many generations before us, so that those who follow will still have it to appreciate. In the meantime, while it is in our keeping, it is a responsibility and a privilege but also ours to enjoy and appreciate.

The difficulty of trying to fully understand a technical subject, the vocabulary of which is largely in a foreign tongue, will be easily appreciated. It is even more difficult for the beginner to understand when the language is Japanese and the written word is in Chinese type *kanji*. It is especially daunting when it is considered that the inscriptions on Japanese sword blades and various fittings are all written in this manner and that the *kanji* used on swords is often unreadable by modern Japanese who are not familiar with the subject. Those *kanji* of pre-Meiji period (1868) are more generally complicated than today's.

When I first became interested in the subject I was quite amazed that some very "ordinary" Western collectors could read a Japanese signature with little or no reference to dictionaries or charts. It is surprising how quickly one may become familiar with inscriptions, which are mainly provinces, titles, names, and dates, when seeing them on a regular basis. Initially, it is necessary to recognize what you are looking at, even if you are not completely *au fait* with the meaning. For instance, if you recognize the character "*nen*" (meaning "year") you will know that you are looking at a date

and that this is probably preceded by a number and year *nengo*, or period, which may be checked in a reference. Similarly, the squarish character "*kuni*" will be preceded by two characters naming a province, and so on. So when you are starting, it may be necessary only to recognize a relatively few characters, which act as pointers or flags to the full inscription. I am very pleased that in this book we are able to provide an appendix that lays out many of the *kanji* to be found in sword inscriptions. This shows most of the *kanji* used in swordsmiths' names, the names of the provinces, and the various *nengo* used when dating swords. I am especially pleased in that these, unlike some that may be found, are beautifully brushed by a steady and skilled hand. I have used these charts over many years and found them to be an excellent reference when trying to translate a difficult inscription.

If you are not conversant with the Japanese language, another seemingly insurmountable hurdle is the terminology used when describing Japanese swords. One should not be over-awed by this problem; it is difficult to avoid using the Japanese language terminology when talking to a fellow collector or a

dealer, but I am sure that every effort should be made so to do. In many fields, technical terminology must be used to accurately describe objects or procedures, and Japanese swords are no exception.

Obviously, since the subject is Japanese, that is where the terminology originates and some of it is rather poetical and complicated; again, outside of a sword context, it would be unlikely to be understood by the average modern Japanese. It is not, as has been suggested, some kind of a code used by the initiated to exclude the rest, but a living, working, and useful way of precisely describing features observed. Throughout this book, I have simplified and explained terms wherever possible, and we have included an extensive glossary to assist the reader's understanding.

I have been very fortunate in that I have been able to see, handle, and appreciate many of Japan's best swords over the years. This has been in the obvious places such as the NBTHK's Sword Museum and Tokyo National Museum at Ueno, where swords of National Treasure status have been available for hands-on study. However, just as enjoyable, I have been entertained by private collectors in Japan, the USA, and Europe. It is

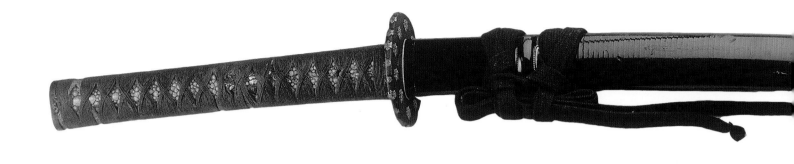

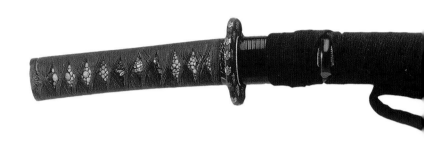

Above and Right The fine, black, lacquered *saya* on this *daisho*, contrasting with the gold decoration on the metal fittings, represented the subdued and understated taste of the *samurai* during the Edo period.

important on occasions such as these that your sword handling etiquette is faultless: your reputation, whether good or bad, will follow you wherever you go. It should be second nature to you so that it is not constantly on your mind and interfering with the appreciation of the swords. I was also given some good advice: only look at good swords. To look at poor quality swords will not train your eyes to recognize good things, even when they are present.

In recent years I have noticed that many more sword collectors from around the world are making the trip to Japan, where they might see and appreciate the finest swords. A number have taken up residence in Japan, some as full-time apprentices of polishers or English language teachers, others to improve their skills at martial arts and to generally follow the "way." They quickly become familiar with (some fluent in) the language and some are happy to act as unofficial sword "tour guides," taking visitors around and introducing them to various dealers, shrines, and museums.

Other events, such as the Dai Token Ichi antique sword fair, attended by some sixty dealers from all over Japan, are now the Mecca for annual sword pilgrimages to Japan by collectors from all over the world. This particular event offers an opportunity to see and appreciate an enormous variety of swords, all of which are in good condition and are fully authenticated. There is also the opportunity, but not an obligation, to buy anything from the smallest fitting to the largest suit of armor. It goes without saying that there is always an important social aspect to such gatherings!

Similarly, sword shows are an important feature outside of Japan, especially in the USA (San Francisco, Tampa, and Chicago) and, less frequently, in Australia and Europe. Once again, the opportunity of seeing many swords and discussing them with the owners should not be missed. Increasingly, the Nihon Token Hozon Kai (NTHK) brings a *shinsa* team (judging and appraisal panel) from Japan to coincide with one of these shows. This gives the collector the opportunity of having an expert and written opinion on his swords at a fraction of the cost of sending it to Japan for *shinsa*.

I am hopeful that this book may serve as something of a practical and introductory guide to the subject, especially for the novice collector. I have included much background detail, such as the history of the

samurai themselves, and my personal assessment and understanding of the international Japanese sword market and how to operate and survive in it. Other parts describe what is construed as correct behavior when attending meetings where swords are on display for hands-on study. This may help to avoid embarrassment or, worse still, damaging swords.

I take this opportunity to thank all those who have "aided and abetted me" in the creation of this volume. They include my friend and fellow collector David Maynard who had the tedious job of proofreading my manuscript and correcting my technical input; Roger Robertshaw, a fellow lover of the swords of Hizen Province, who allowed me to use some of his excellent illustrations from his work *Hizen Tadayoshi*; Lonnie and Hiroko Kapp; Yoshihara Yoshindo; Iida Yoshihisa of IidaKoendo Co, whose family have been sword dealers in Japan since Meiji times; Danny Massey, whose excellent website provided the translation of the NBTHK's *shinsa* criteria; London's favorite merchant in Japanese swords, Don Bayney, for permitting me to use some of his stock for illustrations, and who is also owed a debt of gratitude for allowing his emporium to be

used as a meeting and discussion place for many years; Bob Benson for permission to reproduce material from his magazine *Bushido*; Richard Fuller for permitting me to use illustrations from his excellent books on Japanese military swords; my friend and teacher Mishina Kenji, who for many years has endeavored to educate me and opened many doors for me in Japan; Victor Harris, Curator Emeritus of the British Museum, whose knowledge and understanding of Japanese sword culture is known worldwide; the brave members of the To-ken Society of Great Britain, for their generosity in keeping me as their chairman for so many years; Roald Knutson and Tony Norman for their support; and all those who, over several years, have helped me understand and appreciate Japanese swords, both in Japan and the world at large.

Finally, I dedicate this book to my grandson Mr. Christopher Sinclaire who is, at the time of writing, the youngest person in Europe to own a Japanese sword.

Clive Sinclaire

The Rise and Fall of the *Samurai*

From the end of the 12th century until the latter half of the 19th century, a military elite, the *shogun*s, governed Japan. The emperor was a figurehead, but real power, both administrative and military, rested with the *shogun*s, the first being Minamoto Yoritomo in 1185 and the last being Tokugawa Yoshinobu in 1868. Their rule was a reflection of the spirit and codes that had been their own for centuries and which had been forged on various battlefields throughout the length and breadth of the country. This code became known as *bushido*, the Way of the Warrior, and it is in a written treatise on *bushido* (the *Hagakure*) that the phrase "the way of the *samurai* is death" is to be found. Often misunderstood, this phrase means that a *samurai* should be prepared to die in the service of his lord at a moment's notice. He should wake up every morning and believe he was already dead, thereby freeing his mind of any complications and inhibitions that might cause him to hesitate from bringing about his death in an appropriate and honorable manner. The manner of his going would enhance his reputation incalculably, bring honor to his family, and would be recounted for generations to come. *Bushido* exists today, albeit in a somewhat less intense and modified form, in the corporate warriors of Japan's big business and in the thousands who practice the Japanese martial arts such as *kendo*, *iai-do*, *judo*, and *karate*. Its roots go back over 1,000 years and are an integral part of the history of the country.

At the end of the 8th century, the capital of Japan was moved from Nara City to Kyoto. By this time, Buddhism and the Chinese way of writing had been largely absorbed from the continent. Great Buddhist monasteries with large estates and tax free privileges

Below Tryptych of the Minamoto heroes, Yoshitsune and Benkei, at their first encounter at the Gojo Bridge in Kyoto. Their exploits provide some of the richest stories in Japanese folklore.

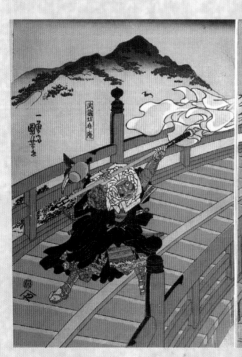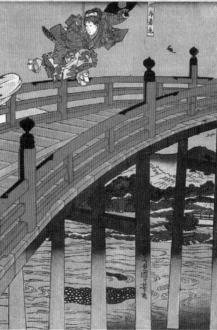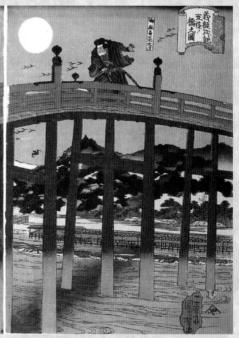

existed far and wide. These various religious sects were supported by armed and militant clerics known as *sohei*, who guarded their privileges jealously, even to the extent of employing their own swordsmiths to keep a ready supply of weapons at hand. It is not surprising, therefore, that the imperial court moved to Kyoto to avoid this hotbed of Buddhist activity centered in Nara.

Around this time, a significant number of imperial offspring were rusticated to the countryside, away from the influence of the somewhat effete imperial court in Kyoto. Here, often in a frontier environment, they attracted followers from more humble backgrounds. Mostly agricultural workers, these followers received a certain amount of protection from their "lords" and repaid this by bearing arms on their behalf, when called upon to do so. As these aristocrats were constantly feuding with their neighbors and fighting the aboriginal inhabitants of the islands, one can assume that their services were in constant demand. They became grouped into clans and known as "those who serve," the embryonic *samurai* or *bushi* who would come to influence every aspect of life and art in old Japan.

By the middle of the 12th century, two main families had risen to prominence and they disputed power and influence over the court in Kyoto. Known as the Heike (or Taira) and the Genji (or Minamoto) it seemed that they would inevitably meet in armed conflict, and throughout the period a number of skirmishes took place between them. The Heike clan was fortunate enough to have greater influence over the emperor than their country cousins and succeeded in having the Genji declared rebels against the retired emperor, Go-Shirikawa.

Full-scale war broke out in 1180, and heroes and villains populate the stories of what are generally known as the Gempei Wars (Gempei is a contraction of Genji and Heikei). The opposing *samurai* armies were dressed in magnificent and brightly laced armors called *o-yoroi*. They brandished swords of incredible quality and grace and were experts with the Japanese long bow, the preferred weapon of a gentleman of the time. Each side sought out worthy opponents of equal rank and social

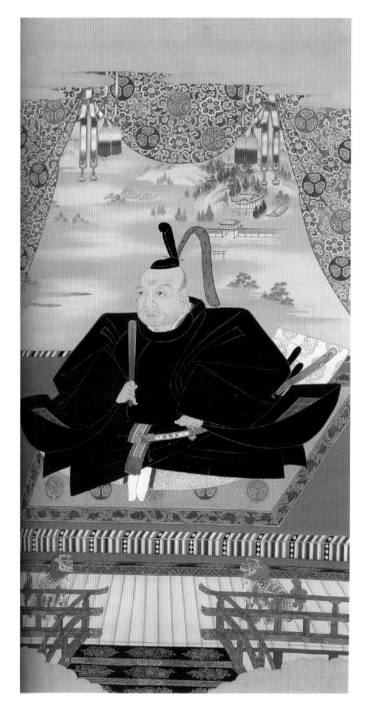

Above The first Tokugawa *shogun*, Ieyasu, whose family ruled for fifteen generations before being finally deposed in 1868.

standing, calling out their pedigree to each other before the killing took place. Interestingly, both sides employed some of the militant monks, the *sohei*, impressed by their martial prowess, particularly with the *naginata*, a glaive-like weapon.

Driven by great acts of bravery and a complete lack of regard for their own safety, the combatants of the Gempei Wars are known to all Japanese schoolchildren to this day. The great Genji general Minamoto

Above A Gempei Wars legend tells of the famous race between *samurai* generals Kajiwara Kagesue and Sasaki Takatsuna (the winner) across the River Uji, to gain the honor of being the first into battle, 1184.

Yoshitsune and his faithful retainer, the giant monk Benkei, combined tales of brilliant military strategy and heroic deeds, which were concluded only by a tragic death—all the ingredients of a classic Japanese drama. After a series of bitterly contested battles, the Genji virtually annihilated the entire Heike clan at the Battle of Dan-no-ura in 1185.

Minamoto Yoritomo, leader of the Genji, established the first government of the *samurai*, for the *samurai*. The cowed emperor in Kyoto was persuaded to confer the title of *Seii-taii-Shogun* (Barbarian Suppressing General), supposedly a temporary title, on Yoritomo, thereby acknowledging the reality of the situation. Yoritomo's *shogunate* was thereafter known as the Minamoto *shogunate* or *bakufu* (a word loosely meaning military camp). Yoritomo himself was considered a good administrator and politician but was consumed with jealousy and suspicion to the extent that he had his younger brother Yoshitsune, the hero who had brought him many victories, hunted down and killed. Consequently, it is Yoshitsune and his retainer, the warrior monk Benkei, who reside in the *samurai* hall of

fame, while Yoritomo is universally disliked.

The Minamoto *shogunate* established by Yoritomo was based in Kamakura, Sagami Province (near present day Tokyo), many miles from the imperial court in Kyoto. Thus it was able to promote and maintain a martial atmosphere, far from the corrupting influence of Kyoto's aristocratic environment. Kamakura attracted many of the best sword-makers and armorers of the day, and many swords from this time are still preserved and revered by sword connoisseurs.

Strangely, considering the rapid rise to power, the Minamoto *shogunate* was to exert direct power only for a mere three generations and allowed the Hojo family to fulfill all the necessary functions in the role of regents, which they did with some efficiency. However, in late 1274 the country was faced with the threat of foreign invasion that had never before been experienced. The great Kublai Khan, grandson of Genghis Khan (who one legend claims to have been Yoshitsune, having escaped from Yoritomo!), planned to make the islands of Japan part of the great Mongol Empire. To this end he sent a large fleet to invade Kyushu Island.

Right Yamamoto Kansuke, severely wounded at one of the frequent battles at Kawanakajima between Takeda Shingen and Useugi Kenshin. The engagements were seldom decisive, but excellent training!

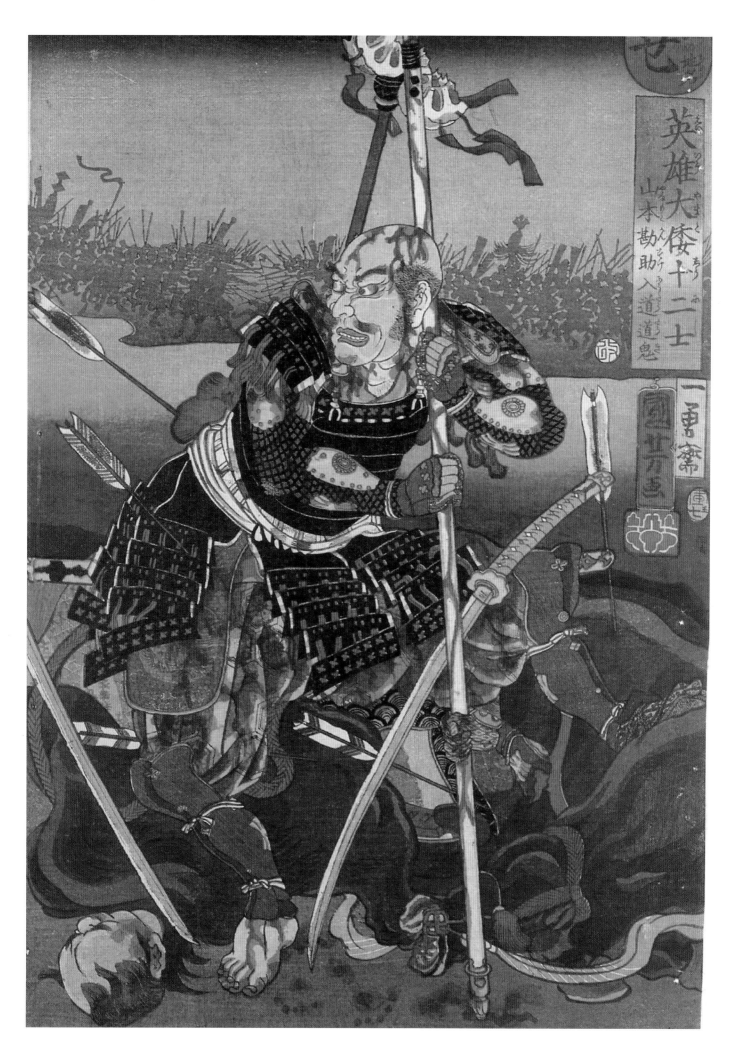

The Mongolians made a number of fiercely contested landings in northern Kyushu, and the *samurai* were taught hard lessons. The weapons, tactics, and strategies of the invaders were completely different from those employed by the Japanese and, were it not for their intense bravery, the *samurai* may well have lost the day. What actually saved the Japanese was "divine intervention" in the form of a ferocious typhoon that wrecked the Mongolian fleet and wreaked havoc in their ranks. A second attempt a few years later met with a similar fate, Japan again being saved by the divine wind, or *Kamikaze*. This was to become the inspiration for those 20th century *samurai* who, in such places as Okinawa and Iwo Jima, were to sacrifice their lives in a vain attempt to again save the country. On the positive side, the near defeat at the hands of the Mongolians encouraged a reassessment in sword-making which gave birth to a new style known as *Soshu-den* (Sagami Province tradition), led by arguably the greatest swordsmith of all time, Masamune.

The cost of the defense and the constant state of preparedness that followed the two abortive invasions caused the Hojo government great financial stress, and many *samurai* were upset at their treatment after the wars. Once again, discontent would ferment into rebellion, and the Emperor Go-Daigo was ready to recruit disaffected *samurai* in order to restore the country to direct imperial rule and to defeat the

Right Taira Kiyomori (1118–1181) was the renowned, merciless, and tyrannical leader of the Taira clan; he died from sickness rather than in battle.

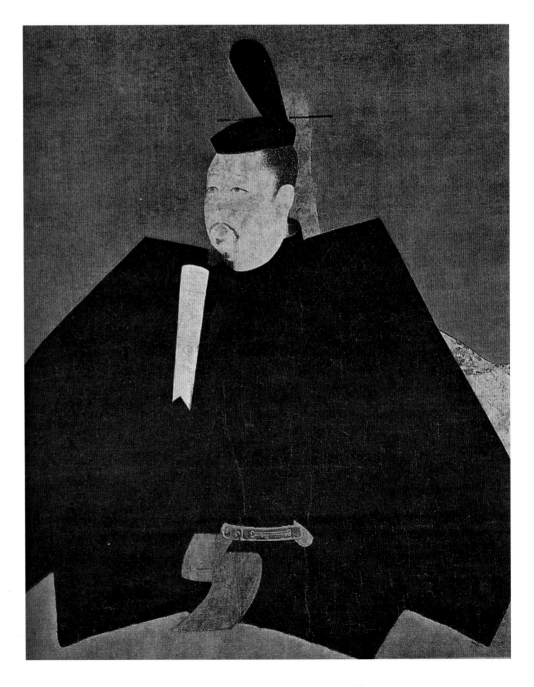

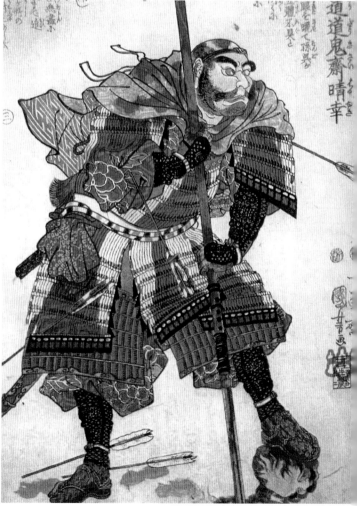

Left This print by Sadanobu Hasagawa depicts the heavily armored warrior Kajiwara Kagesue. Note the circular object by his sword and near his waist, which is a spare bow string.
Below A *yamabushi*, or warrior monk, wounded but victorious, rests on his *yari*. In the Gempei Wars (1180–1185), both sides recognized the martial expertise of these clerics and employed as many as possible.

"usurpers" of his imperial prerogative. Therefore, it was in the 14th century that the greatest acts of *samurai* loyalty were to be found.

It was an unusual situation to find a powerful *samurai* such as Kusunoki Masashige declaring for the emperor, and many rallied to the imperial cause. Kusunoki was to gain eternal fame when the headstrong emperor, ignoring advice to the contrary, ordered him into a battle at Minatogawa, from which there was no chance of survival. Kusunoki, knowing his fate, obeyed the orders and, when defeat was inevitable, committed *seppuku*

(ritual suicide) in the time-honored *samurai* way.

However, the imperial forces did have some success, even overthrowing the Hojo at Kamakura. This was greatly helped by a turncoat, one Ashikaga Takauji, who saw great advantages for his clan (who were of Minamoto stock) so deserted the Hojo and changed sides. Go-Daigo was briefly back on the throne, but Ashikaga set up a rival court in the north. This strange situation, which lasted until 1392, lent its name to the period—the Namboku-cho, or period of the north and south courts—and it continued with much confused fighting throughout the land.

After taking advantage of every twist and turn of fate, in 1338 Ashikaga Takauji was proclaimed the first Ashikaga *shogun* and established his *bakufu* (*shogunate*, or office of administration) in the Muromachi district of Kyoto. By the time the imperial squabbles were resolved in 1392, Ashikaga Yoshimitsu was the third Ashikaga *shogun* in what was to herald in the Muromachi period.

Warfare had changed considerably by this time. Armor had become lighter, swords shorter, and foot soldiers were far more commonplace. Most of these foot soldiers were from peasant stock and were known as *ashiguru*. By 1467, the first year of the Onin period, they found employment with several warring factions and managed to devastate the city of Kyoto. This was to mark the beginning of a hundred years of civil wars that became known as the *Sengoku-jidai*, or the period of the country at war.

Local feudal lords, or *daimyo*, fought each other over land or wealth, mobilizing hundreds of thousands of men in the process. Fathers murdered sons; sons murdered both fathers and brothers. The lofty ideals of *bushido* were observed more in their breach than in their enactment in the quests for land, power, and influence. It was a time when the lowly could overthrow those of higher social status and then be overthrown themselves. This was known as *Gekoku-jo*—wherein the lower classes oppressed their social superiors, when lowly peasants might rob and kill wounded and noble *samurai*, stealing their weapons and armor! There were few well-organized clans capable of ruling, and even these had risen from a

bloody and ruthless past. Clans such as the Takeda and Uesugi are examples of this.

Battle tactics had changed again, with heavy reliance on the *ashiguru*, and there was a huge demand for weapons, especially swords and spears. Whenever there is such a great demand, quality is the first casualty. Most of the swords of the time are shadows of the earlier ones and were made with purely practical considerations, mainly in the provinces of Bizen and Mino. Massed spearmen and cavalry were the order of the day and war was carried out on the run. In tune with the mood of the day, armies saw no moral problems with changing sides in the middle of an action. Indeed, if this would preserve the name of the family or clan by bringing it out on the winning side, it was especially justified.

Amid all this confusion, in the mid-16th century

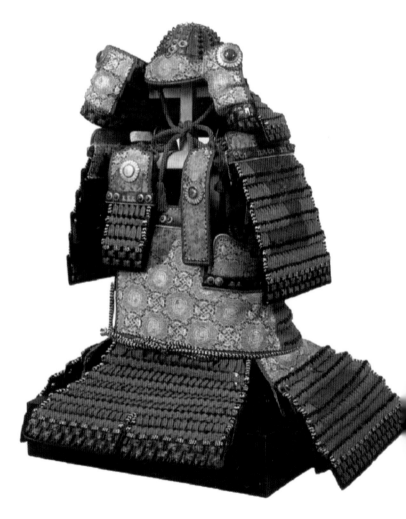

Above This amazingly well preserved *o-yoroi* is typical of the ancient style of armor worn during the Kamakura period (1185–1333), with large *sode* (shoulder defenses) and hefty, riveted helmet bowl.

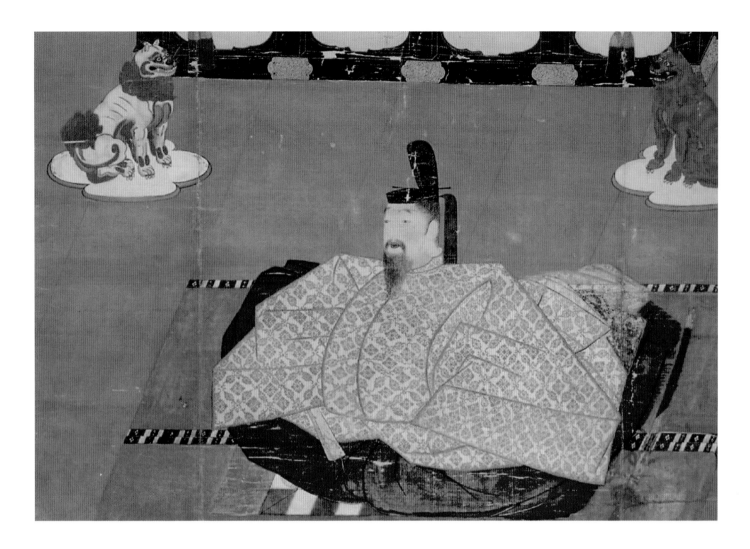

Above It was the Emperor Go-Daigo who ordered Kusunoki Masashige to certain death in a futile and ill-conceived battle at Minatogawa in 1336, and it was he who would see the start of the Namboku-cho period when two emperors were on the throne, one in the south and one in the north.

Right Part of an Utagawa Kuniyoshi print entitled "Fight to the Death of the Heroic Kusonoki Clan *Samurai* at Shigo Nawate." Kusunoki Masatsura was killed during the battle on February 4, 1348, at the age of twenty-two.

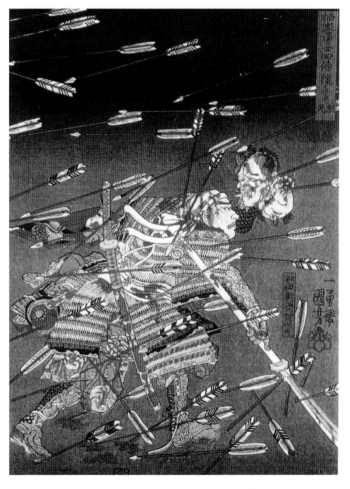

there arose in Owari Province a particularly ambitious and capable young man by the name of Oda Nobunaga. Born in 1536, his ambition was to unify Japan under his rule rather than that of the weakened and by now dissolute Ashikaga *shogunate*. He ruthlessly set about subduing his neighbors and all other opposition. An innovative strategist, he was the first to employ massed firearms that had been introduced by Portuguese traders in 1546. This he did with great effect at the Battle of Nagashino, where he destroyed the feared cavalry of the Takeda clan.

However, he was assassinated in 1582 by one of his own generals, Akechi Mitsuhide, who was hunted down by one of Nobunaga's most talented and able generals, Toyotomi Hideyoshi. Akechi was put to the sword within eleven days, earning him the derisory nickname, the "eleven-day *shogun*." It was the low-born Hideyoshi who would then take on the cause of unification.

Hideyoshi was a most capable military leader and politician, as well as a great patron of the arts. He was based at Fushimi Castle at Momoyama, a few miles from Kyoto. Many of Japan's incredible screens and paintings come from the so-called Aiuchi-Momoyama period (1573–1600) of Hideyoshi. He was particularly fond of the tea ceremony and he encouraged sophistication in the otherwise boorish *samurai*, while maintaining a vicious and cruel streak in himself. His military exploits were profound and he even managed to bring the *samurai* of far away southern Kyushu Island

Above By the latter part of the Muromachi period (16th century) the *uichigatana* was becoming the accepted way of mounting and wearing a sword, rather than the slung sword or *tachi*.

Right A model of a busy street scene in the commercial district of Edo, depicting the first Mitsui store.

Below Kusunoki Masashige, sent to certain death by imperial command, bids his son farewell. He became the legendary paragon of loyalty to the throne.

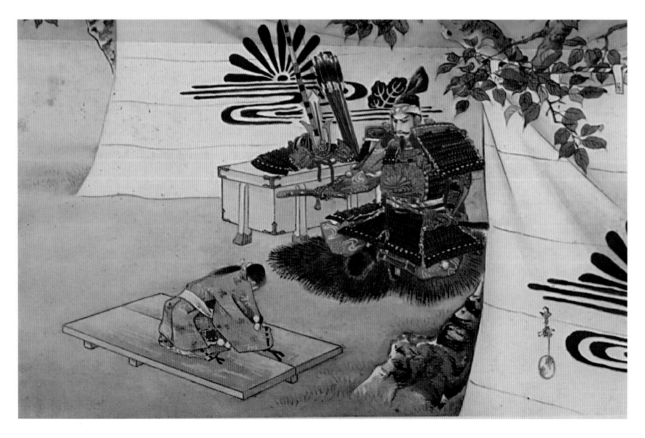

under his control. His greatest, if somewhat reluctant, ally was Tokugawa Ieyasu, a powerful *daimyo* from the eastern Kanto area.

The end of the Momoyama period was a time of relative peace that brought its own problems. Many *samurai* were still under arms from the recent civil wars but were no longer retained by warlords, and therefore their skills were redundant. In this condition they were known as *ronin* or wave-men, being tossed around by the waves of chance and circumstances beyond their control.

Hideyoshi's answer to this was to send an army to invade the Korean mainland, thus giving many *samurai* employment in the only trade they knew. The invasion was suddenly aborted when Hideyoshi died unexpectedly of natural causes, and all the *samurai* were recalled home. This was the opportunity that Tokugawa

Ieyasu had waited for, and he became the third of the great unifiers of Japan, as well as the most enduring.

Tokugawa's tough Kanto *samurai* proceeded to eliminate those forces that remained loyal to Hideyoshi's heir, predominantly from western Japan. A decisive battle took place at Sekigahara in 1600 and Tokugawa Ieyasu was the outright winner, helped by defections on the other side. The remnants of the western army were finally eliminated some thirteen years later at the siege of Osaka Castle. The house of Tokugawa had succeeded in unifying the entire country and Tokugawa Ieyasu, of ancient Minamoto stock, became the first in a line of fifteen *shogun*s that were to oversee a period of peace that would last for the next two hundred and fifty years. However, it was a peace at the price of a strict military dictatorship in which the *samurai* were at the top of the social ladder. Ieyasu made his capital at Edo in the east,

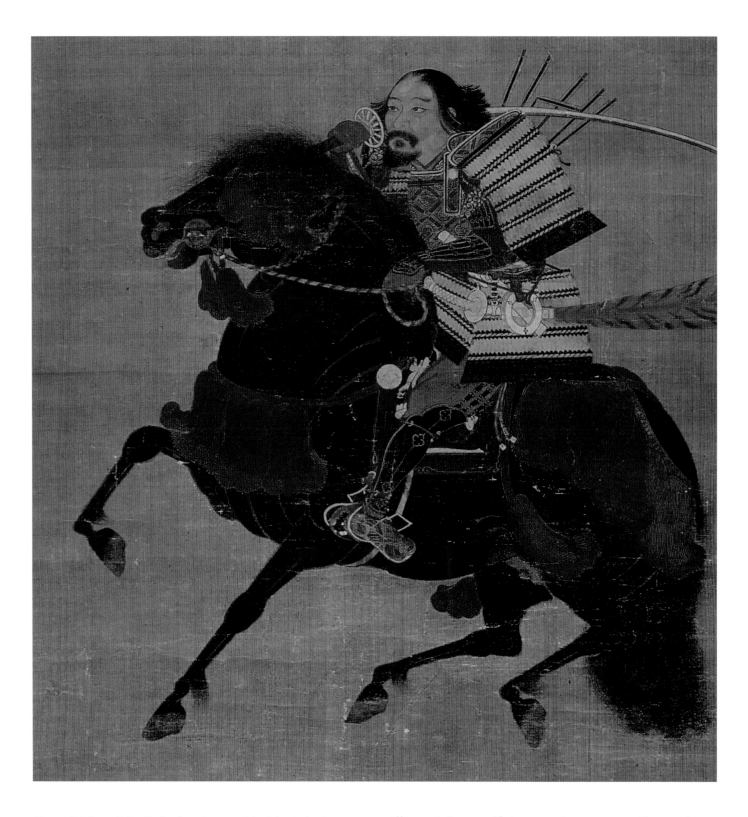

Above Ashikaga Takauji, the first *shogun* of the Nambokucho period, was offended by his rewards from Go-Daigo and assumed the title of *shogun*. Note the "tiger-tail" *tachi* he is wearing.

a small, swampy village that is today called Tokyo.

As the period of peace began, many things relating to swords were to change. Without the need to provide purely functional weapons, the swordsmiths were able to make swords that were of greater artistic merit, while still remaining as efficient cutting weapons. It was also ordered that the *samurai* should now wear the *daisho*, or pair of swords. This was a visible badge of rank that distinguished the *samurai* from all others and was a constant reminder of his martial background. He would never be unarmed, always at least having his short sword with him.

Towns grew up around the various *daimyo* castles, which became the centers of commerce and life in

Above A *daisho* (*daito* and *shoto*) mounted in the *han-dachi* style. It was the *daisho* that became the badge of rank of the *samurai* class during the Edo period.

Right This distinctive armor with antler crest was worn by Honda Heihachiro Tadakatsu, who was reputed to be Tokugawa Ieyasu's favorite general.

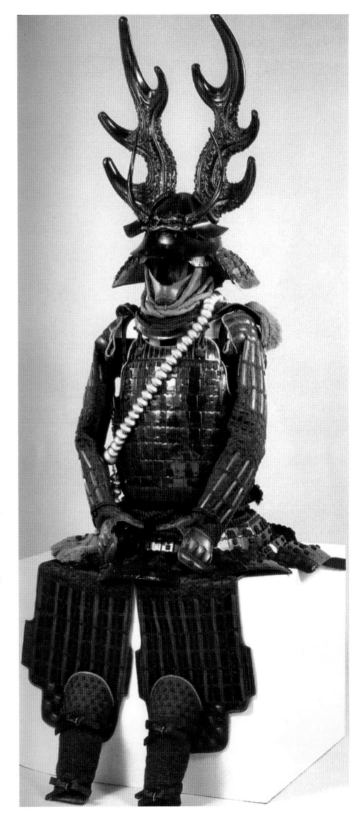

general. The Tokugawa made certain of their security and survival as *shogun*s by introducing a series of laws. Marriage alliances and the allocation of fiefs to *daimyos*—so that a Tokugawa-supporting clan was adjacent to a less reliable one—helped cement their hold on power. Those who had been on the losing side at Sekigahara, mainly the clans of Satsuma, Choshu, Tosa, and Hizen provinces, known as *Tozama*, or outer *daimyo*, still harbored grudges against the Tokugawa. All *daimyo* were obliged to make annual visits to Edo, where many of their families were kept practically as hostages. Such constant movement between the home province and Edo kept many of them in financial straits; thus few funds were available for insurrection.

All aspects of life were controlled by the *shogunate* and it became illegal, on pain of death, to leave the country. Exclusion laws prevented foreigners from entering the country, except for a few Dutch traders in Nagasaki. The more fortunate *samurai* remained gainfully employed by some of the clans, where they often became bureaucrats and administrators within the rigid hierarchy of the clan system. But they were encouraged to practice the martial arts and be prepared for action at all times. The less fortunate were forced to become *ronin* and make their way in life as best they could.

It was at this time that *bushido*, along with many other things, became highly structured and recorded in

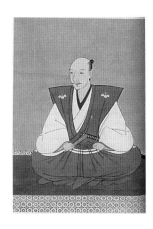

Above Oda Nobunaga, the first of the great unifiers of Japan, who pioneered the use of mass musket fire at the Battle of Nagashino in 1575.

Right Two lightly armored *ashiguru* (foot soldiers) of the late Muromachi period (second half of the 16th century). These soldiers were employed as artillery but were still armed with swords for close-quarter work.

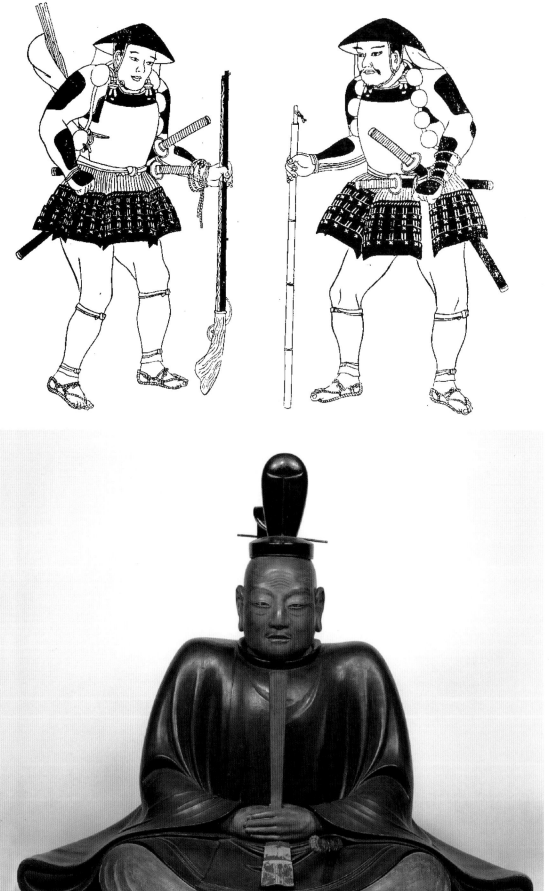

Right A wooden statue of the deified Tokugawa Ieyasu, dated 1603.

Far Right Part of a screen depicting the decisive battle of Sekigahara in 1600, which established the Tokugawa family as the rulers, or *shoguns*, for fifteen generations until the assumption of direct imperial rule in 1868. The red armored warriors in the foreground are the "red devils" of the Iie clan from Hikone.

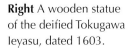

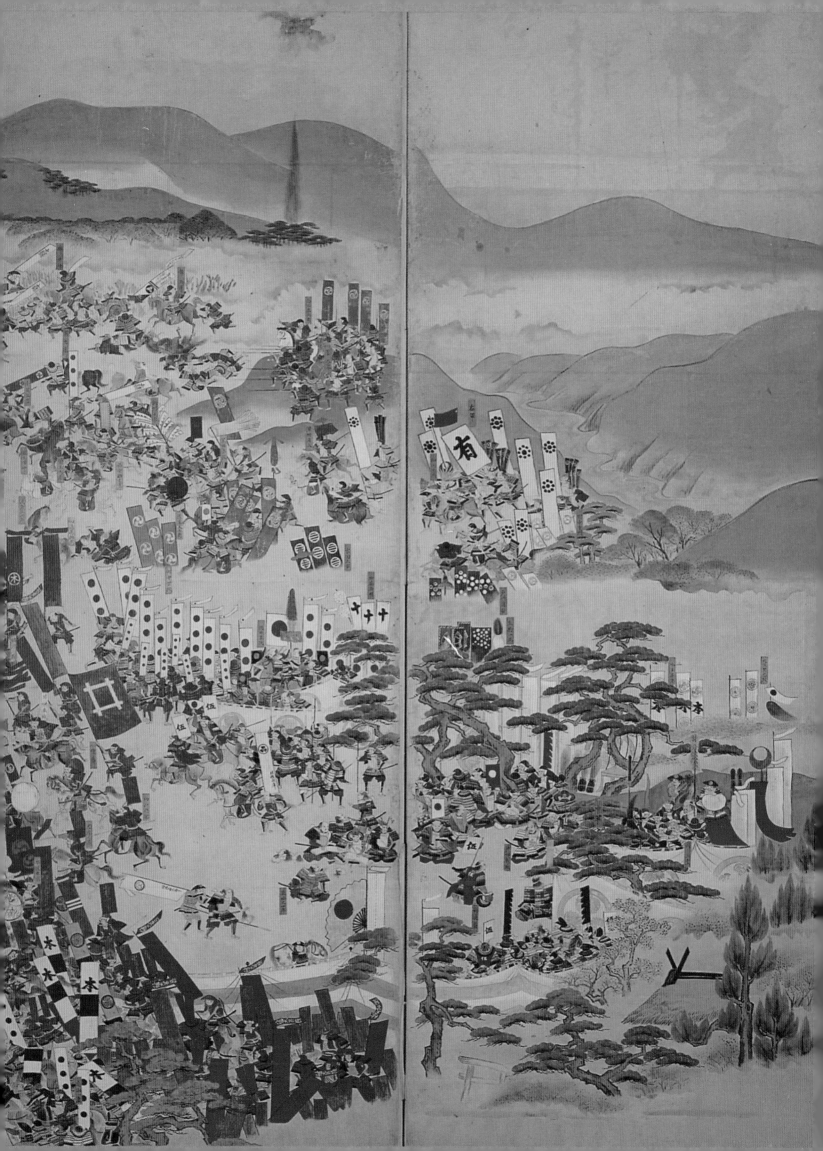

Right One of the battles at Kawanakajima in a print by Sadahide. Although this is a rather stylistic interpretation, battles did take place here between Takeda Shingen and Uesugi Kenshin in 1553, 1554, 1555, 1556, 1557, and 1563.

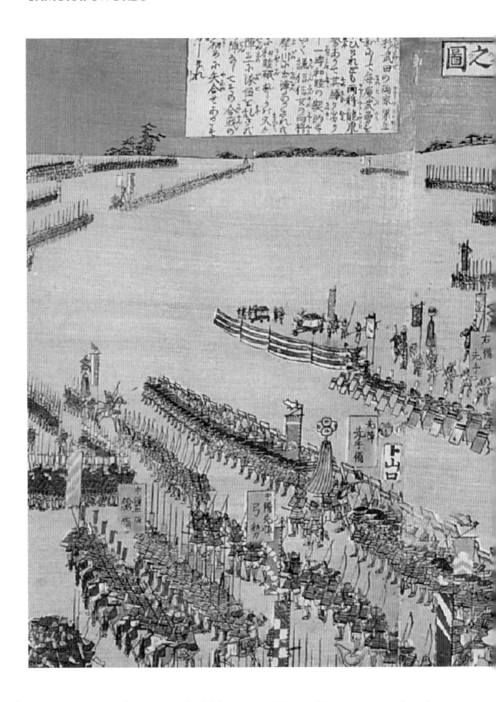

books such as *Hagakure*. The ideals of the code, now no longer needed in battle, had to be learned by these peacetime *samurai*. Yamamoto, for instance, the author of *Hagakure*, was a retainer of the proud Nabeshima clan of Hizen Province, and never actually experienced battle. It was not until the mid-19th century that the *samurai* found reason to unsheathe their swords in anger once again.

By this time the Tokugawa *shogunate* was under intense domestic pressure as a result of crop failures, which drove peasants to riot, as well as external pressure from incursions by foreigners attempting to force trade treaties on the reluctant *shogunate*. It was an opportunity not to be missed by the *Tozama* to ferment revolt against the Tokugawa. (These *Tozama*, considered outsiders by Japan's rulers, were the eighty-six *daimyo* who did not submit to Tokugawa Ieyasu until after the Battle of Sekigahara in 1600, while those who sided with him before were known as *Fudai-daimyo*.) They chose to support the fight to reinstate direct imperial rule and to expel the barbarians who had come uninvited to their shores.

By 1868 they had succeeded in the former but the latter proved impossible. The emperor Mutsuhito (better known by his posthumous name of Meiji) was reinstated to direct rule and took up residence with his court, in the last *shogun*'s castle at Edo. The commission of *shogun*, granted to Minamoto Yoritomo in 1185, had

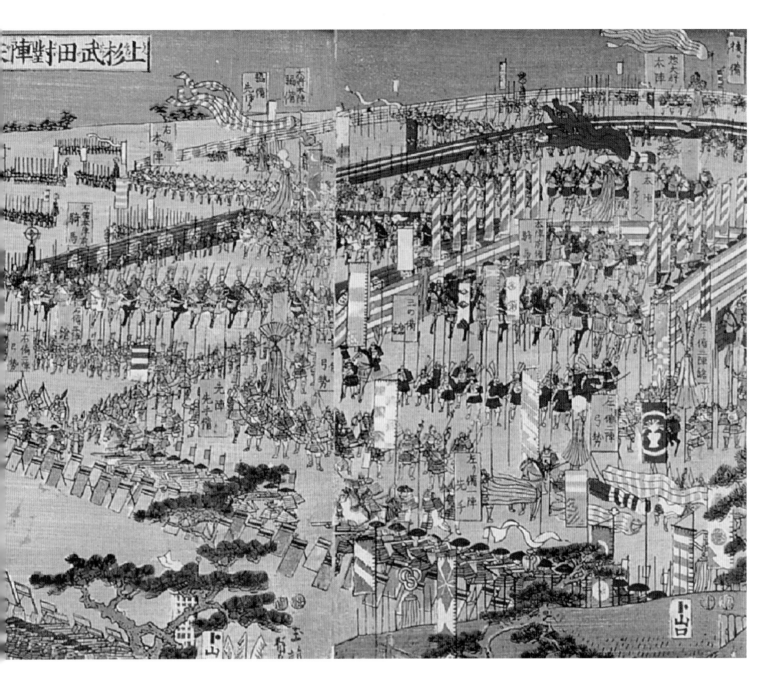

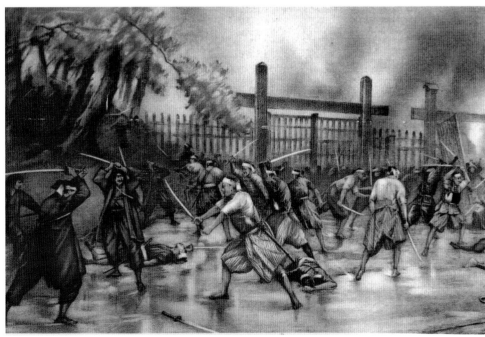

Right At the so-called Battle of Ueno (in modern-day Tokyo) in July 1868, following a rowdy night, the *shogunate* troops fought the imperial forces but were vastly outnumbered and died to a man.

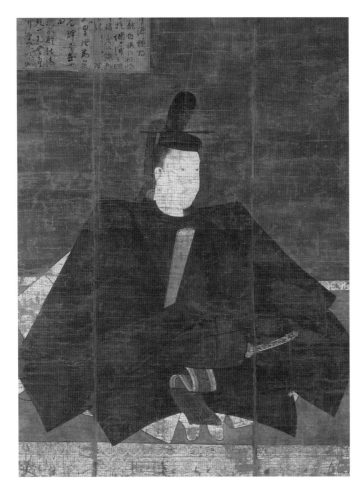

Above Minamoto Yoritomo who became the first *shogun* after his clan's defeat of their rivals, the Taira. Yoritomo was to set up his capital at Kamakura in the east of Japan, far away from the corrupting atmosphere of Kyoto.

Below Depicted on these fittings is a poignant scene of an old battlefield in Musashi Province. It refers to a well-known poem which says, "*The summer grasses, all that is left of the warrior's dream.*" The scene reminds the more sensitive *samurai* of the impermanence of life and the futility of war. As well as a *tsuba*, there are a pair of *menuki* (hilt ornaments) and a *kodzuka* (utility knife handle), unsigned, probably mid-18th century.

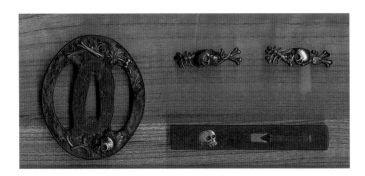

finally been handed back to the emperor almost seven hundred years later.

Conservative elements resisted the changes, and *shogunate* support manifested itself in isolated skirmishes, such as the so-called Battle of Ueno. Here on July 4, 1868, after a rowdy night spent trying to provoke the imperial officials, some 3,000 *samurai* fought with their swords to the last man. By 1877, the *samurai* of Satsuma Province, led in the field by the redoubtable Saigo Takamori (previously a leading, but now completely disillusioned, *samurai* of the imperial cause) were in open rebellion against the new government. A conscript army using modern rifles against the old fashioned sword-wielding, armor-wearing *samurai*, quashed the rebellion. Saigo Takamori felt forced to commit suicide. Not for the last time was the *Yamato Daimishi*, or Japanese spirit on which they relied, beaten by superior technology and overwhelming numbers.

The *samurai* class was disbanded, and the wearing of swords was prohibited to all but the modern army and police force as Japan rushed headlong into a program of modernization and westernization. This was largely encouraged and organized by ex-*samurai*, many of whom were of lower rank within the clan's hierarchy, inspired by the spirit of *bushido*, which was now directed toward nationalism rather than loyalty to a feudal lord.

By 1905 the Japanese had fought a war with China and beaten the Russian navy in an historic battle, but they were treading a path towards military fascism, a corruption of true *bushido*. This was the road that would inevitably lead to the infamous attack on American forces at Pearl Harbor in December 1941, and finally to the mushroom clouds over Hiroshima and Nagasaki in August 1945.

Below A classic *ito-maki-tachi* (thread-wrapped slung sword). Originally designed with the scabbard wrapped to avoid chafing on the armor, in the Edo period this mount became used for ceremonial wear.

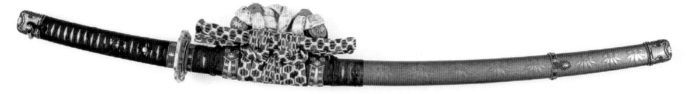

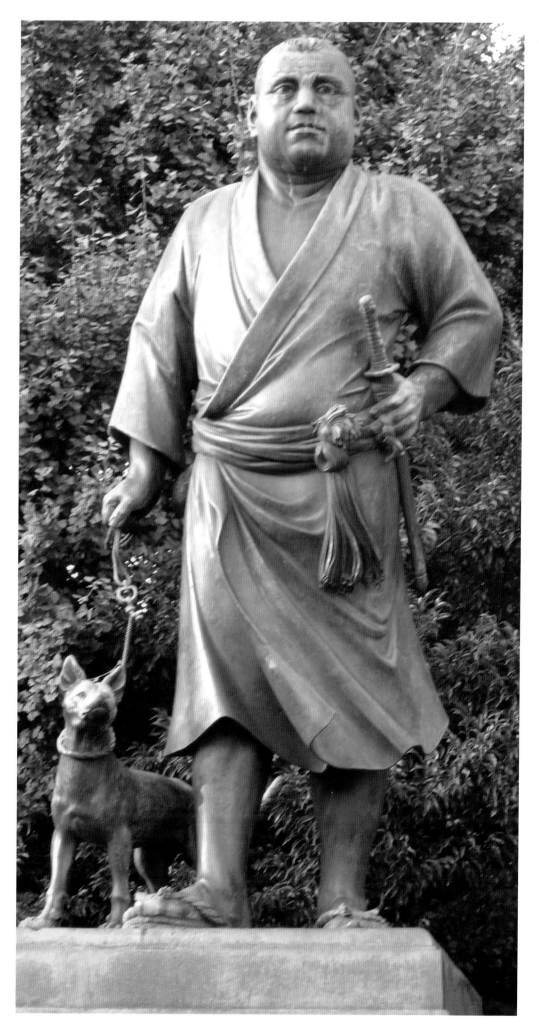

Left The famous statue of Saigo Takamori in Ueno Park, Tokyo. It is said that the short sword represented here is his *Izumo (no) Kami Kanesada wakizashi*.

Development of the Japanese Sword

The history and development of the Japanese sword are intrinsically entwined with the history of the country itself, as practical and political considerations influenced and developed both the shape of the sword and forging techniques. The earliest swords, known as *chokuto*, were straight, ridgeless blades and both the makers and blades were imported from mainland Korea and China. The later, straight, ridged versions, known as *kiriha-zukuri* in shape, may have been among the first to be domestically produced in Japan, and indicate a thrusting or stabbing form of fencing. Along with sword-making and metal technology, both Buddhism and the Chinese method of writing were imported into Japan in the 7th and 8th centuries AD, known historically as the Nara period. At this time Nara was the imperial capital.

For the next two hundred years or so the main improvement was to gradually introduce curvature into the blade. This began in the *nakago* or tang area, leaving the blade still relatively straight, but then curvature was gradually introduced into the blade itself. This may well have been to facilitate the Japanese form of fencing, which employed a cutting rather than a stabbing action. For this a curve is essential to provide maximum contact between the blade and the target for as long as necessary.

By the 10th century, having gone through these transitions, the Japanese sword was more or less the same as those made today. That is to say, it was a single-edged, curved blade with a ridge line running its entire length, or to describe it properly—a *shinogi-tsukuri tachi*, with *zori* (curvature). The Japanese sword is unique in that, even at such an early time in the development of metalworking, it combined different steels that had variations in hardness and carbon

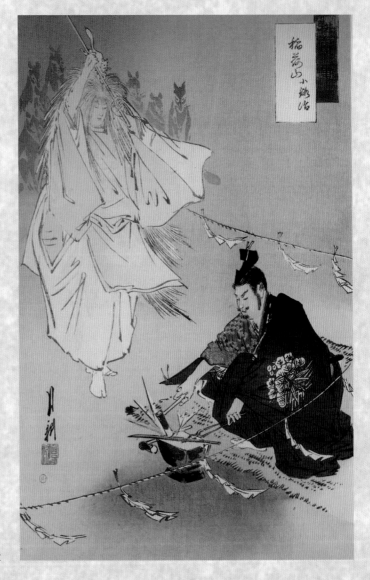

Above A print entitled *Inariyama Ko-kaji* (the swordsmith of Inari Mountain). It depicts the 9th century swordsmith Sanjo Munechika forging a sword and being aided by the fox spirit of the mountain. Spectral foxes watch in the background.

content. This allowed for a hard cutting edge (which could be made very sharp) to be combined with a relatively soft core or body that provided weight and would cushion the shock of impact. The swords were expected not to bend, break or chip in combat.

Such blades were made mainly in the vicinity of Nara in Yamato Province and Kyoto in Yamashiro Province. It is these two provinces that lend their names to the two earliest "schools" or traditions of sword-making, i.e. *Yamashiro-den* and *Yamato-den*, followed closely by *Bizen-den*, around present-day Okayama Prefecture, which was said to have a warrior-based clientele as well as plentiful supplies of natural ore and water. The five sub-schools of *Yamato-den* (*Hosho*, *Tegai*, *Senjuin*, *Shikake*, and *Taima*) were mainly supported by the Buddhist monasteries of the area, while those swords of *Yamashiro-den* (*Awataguchi* and later *Rai*) reflect the refined taste of the noble and aristocratic people of the imperial court, which by then had moved to the Heian district of Kyoto in Yamashiro Province. Although both Yamashiro and Yamato blades exhibited an even curve throughout their length (*naka* or *tori-zori*), those from Bizen had a low center of curvature towards the handle, referred to as *koshi-zori* or *zori* on the hip.

At the end of the 12th century, the *samurai* were in control of the government, after the famous battles of the Gempei Wars, in which the Minamoto clan (the

Right This graceful sword is a representative of Yamashiro-den from the late Kamakura period. Its graceful, even curve and *suguha hamon* are typical of the Rai school of this time. The sword is signed with the two-character signature Kuniyuki, and it is *Juyo Token*.

Below and Right A *tachi* blade signed *"Bizen Kuni Osafune Ju Nagamitsu saku"* (made by Nagamitsu from Osafune in Bizen Province). The swordsmith was of the prolific Osafune school and the *tachi* is dated 1297.

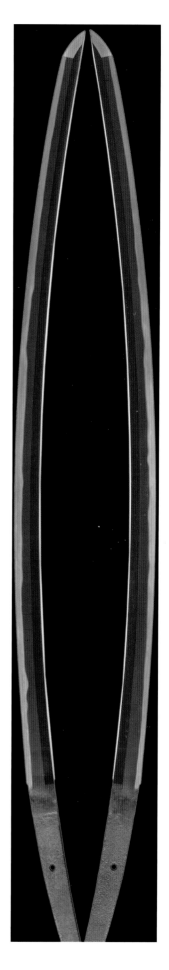

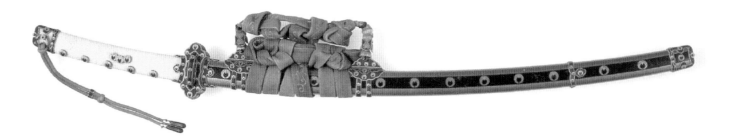

Above A style of *tachi* known as an *Efu-no-tachi*. Originally worn by imperial guards (*Efu*) in the Heian period, it was revived and copied throughout the Edo period and even into the 20th century.

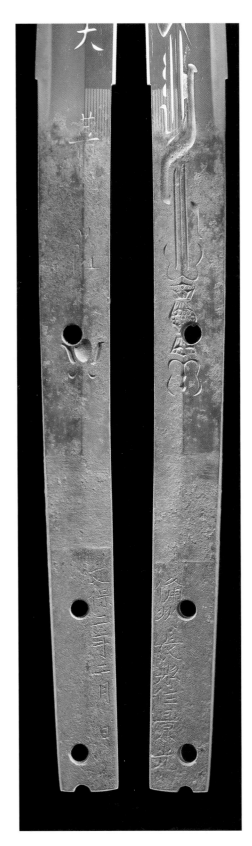

Genji) completely annihilated their rivals for power, the Taira (the Heike). The victorious Minamoto Yoritomo then established his *shogunate*. A shrewd man, he moved far away from Kyoto, the effete imperial capital with its corrupting influences, and set up his capital far to the east, at Kamakura in the province of Sagami, more commonly known by its alternative name of Soshu.

Although Yoritomo had established his *shogunate*, it was not uncontested, and a few years later the retired Emperor Gotoba prepared an uprising to regain his usurped power. In preparation, Gotoba gathered around him the best swordsmiths of the day. They attended him on a continuous basis and taught him to make fine swords. The large number of Bizen swordsmiths who attended the emperor's court attests to the fact that this school was highly regarded at this time. Swords made by Gotoba still exist in Japan, and are simply signed with an imperial chrysanthemum crest called a *Kiku*; these swords are therefore known as *Kiku Gyusaku* (Imperial Chrysanthemum Made). It is said that the later Emperor Gotoba's dark and brooding mood, as he plotted to overthrow the upstart Yoritomo, may be seen

Left A Kamakura period blade by the master Bizen swordsmith, Kagemitsu. The three holes in the *nakago* (plus one right at the end) indicate that it has been shortened on several occasions while still retaining a superb shape and an inscription reading "*Bishu Osafune Ju Kagemitsu*" and a date equivalent to 1318.

Right The retired Emperor Gotoba forges a sword aided by a *sakité* or hammerman. Gotoba's swords were simply signed with a sixteen-petal *Kiku* (imperial chrysanthemum) and those extant examples are called *Kiku Gyusaku*.

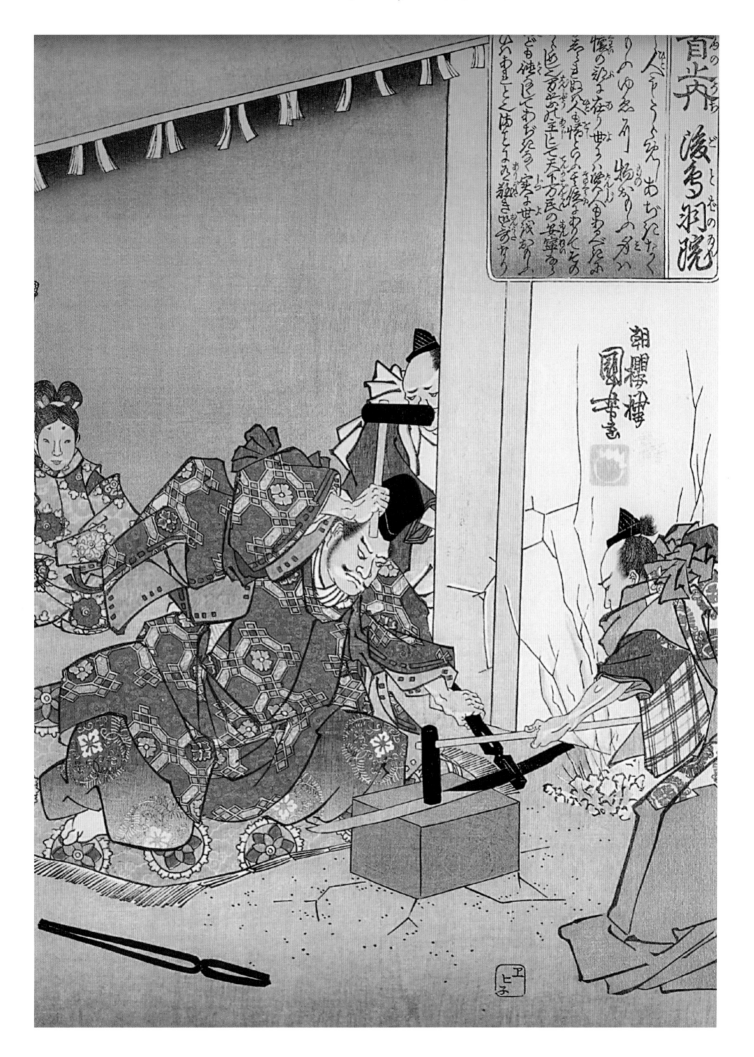

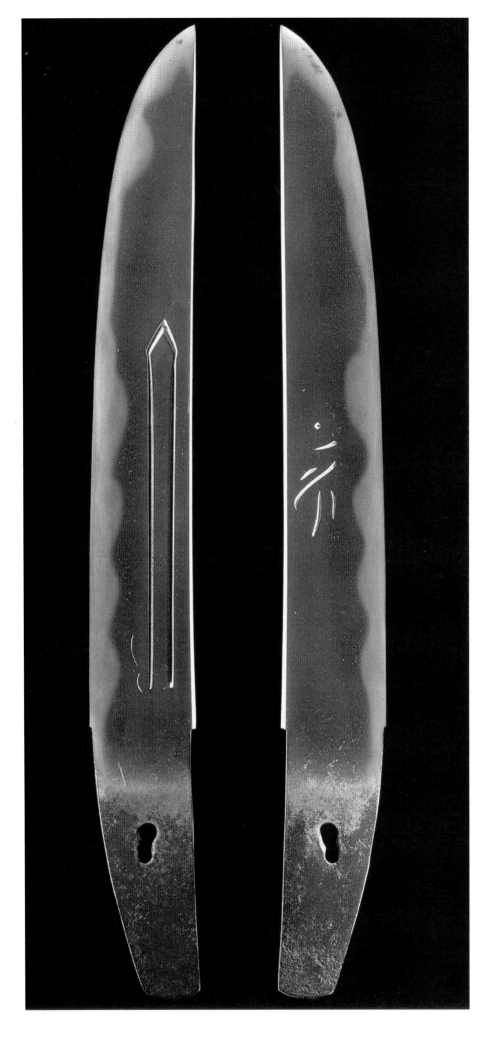
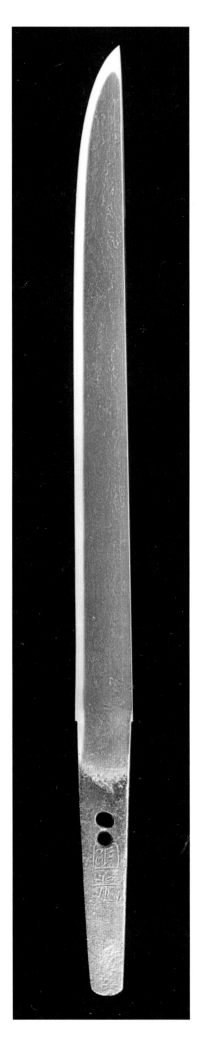

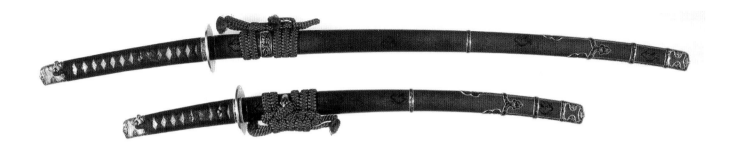

Above A *daisho*, or paired long sword and short sword. The black lacquered swords are decorated with metal fittings in the style of a *tachi*; this style is therefore called *"han-dachi,"* or half-*tachi*.

Right Kaneuji, who was one of the famous Masamune students, is attrbuted as the maker of this sword. He was the founder of Mino-den and worked in the early 14th century. Clearly seen are the wide body and large *kissaki* (point) that are characteristic of this period. This sword, although unsigned, is *Juyo Token*.

Far Left This sword was made by Masamune and its short, stubby shape is responsible for its nickname, Hocho Masamune, or "Kitchen knife" Masamune. Three different versions of Hocho Masamune exist, all of which are classified as "National Treasures."

Left This *tanto* dates from the mid-13th century and is signed "Kunimitsu, father and teacher of Masamune." Shintogo Kunimitsu was one of the founders of the Soshu tradition of sword-making based in Kamakura.

in his swords. In fact, he was probably responsible only for the *yaki-ire* (quenching) of the blades rather than the demanding labor involved with the hammer work of the forging. Gotoba's uprising was not to succeed and the so-called Kamakura *shogunate* remained under the regency of the Hojo family.

The military atmosphere that was prevalent in the Kamakura period allowed the production of swords to flourish, and many swordsmiths gathered at Kamakura to be patronized by the great *samurai* families who lived there. The style of swords from the middle Kamakura period was to set the pattern for swords for many years to come.

In 1274 and 1281 Japan suffered invasion from Kublai Khan's Mongol hordes, and it was found necessary for the *samurai* to drastically change their battle tactics from individual or single combat to group warfare. The slim and elegant swords carried by the warriors of Japan proved vulnerable to chipping and irreparable damage in the intense combat. In answer to these problems, swords became wider and stronger in appearance, and more resilient. Masamune, a pupil of Shintogo Kunimitsu, developed that style and produced gorgeous blades that were far less likely to be badly damaged in battle, being wider in form and with more pronounced *hamon* (the tempered and hardened edge).

Masamune had ten famous pupils, known collectively as the "Masamune *juttetsu*," who spread their master's teachings throughout Japan. In the late Kamakura period (around 1320) Masamune produced blades in the more slender style, with a medium-size point. His later blades were of the larger proportions of the Namboku-cho period. Many of his swords are of historical importance in famous collections, and rated as "National Treasures." The well-known Ishida Masamune

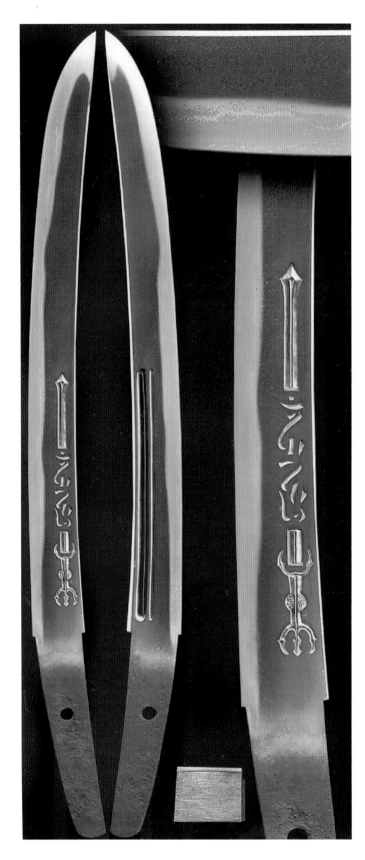

Above Although it has been dated as early the 14th century, this *hirazukuri tanto* (without a ridge line) has more of the character-istics of a later blade. It is signed "Jumyo," an auspicious name that stood for longevity, and therefore swords with such a signature were suitable as gifts.

was exhibited in London in 1990, while there is a good, although unauthenticated, Masamune in the Victoria and Albert Museum in west London. The three so-called *hocho* or "kitchen knife" Masamune are from this later period of his work. *Kabuki* plays featuring Masamune ensure that his name is remembered in Japan today, even among schoolchildren.

Soshu-den, the fourth great tradition following *Yamashiro-den*, *Yamato-den*, and *Bizen-den*, had arrived and became widely popular throughout the country.

By the early 14th century, the Kamakura *shogunate*, still controlled by the Hojo family as regents, was in dire financial straits and was finally overthrown by Emperor Go-Daigo. An imperial succession dispute then heralded a new era of warfare, known as the Namboku-cho period, characterized by there being two emperors reigning at the same time! Emperor Go-Daigo had set up his court in Yoshino in the south (Nan) of Kyoto, while Emperor Komyo, protected by a self-appointed *shogun* named Ashikaga Takauji, held court in the north (Hoku). This state of affairs lasted for sixty years until the Emperor Go-Komatsu ascended the throne in 1392 and reunited the two courts.

Sword designs in this period often became exaggerated in their proportions, with wider bodies, extreme lengths, and long points. Known as *seoi-tachi* (shoulder *tachi*) and *no-dachi* (moor swords), some had blades of forty-seven to fifty-nine inches in length, although they were later shortened to more manageable lengths. However, some swords were made at about twenty-seven inches in length and began to be worn through the belt, with the cutting edge upwards, whereas previously most swords were of the *tachi* or slung-sword type. This latter development may have been brought about by the difficulties encountered with the larger swords in street and indoor fighting, as well as the tendency towards fighting on foot rather than on horseback.

At this time, both the *Soshu-den* and *Bizen-den* styles of sword-making were most popular, while those of Yamashiro and Yamato were in decline. The influence of *Soshu-den* on Bizen swordsmiths during

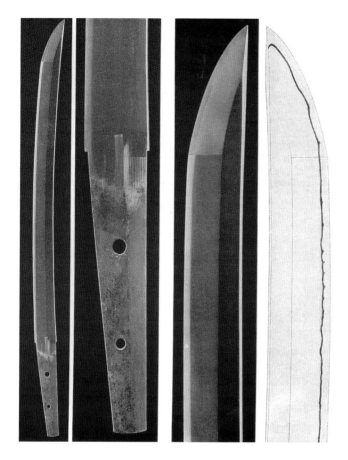

Above This sword retains many of the features of the 14th century blade, having *o-kissaki* (large point) and a wide body or *mihaba* (width). As with many that are extant today it is *o-suriage* (greatly shortened) so that now it is only a *wakizashi*. This sword is by a ko-Mihara artist.

tradition we recognize in the *koto* period of sword-making. Nowadays they are collectively known as the *Gokkaden*, or "the five traditions of sword-making."

With the settling of the imperial dispute in 1393, Ashikaga Yoshimitsu became the first "official" Ashikaga *shogun* and, while there were still skirmishes throughout the country, a state of relative peace reigned. The new age became known as the Muromachi period, named after the area in Kyoto where the *shogun* had taken up residence. The long, unwieldy swords of the Namboku-cho period were abandoned and there was a general

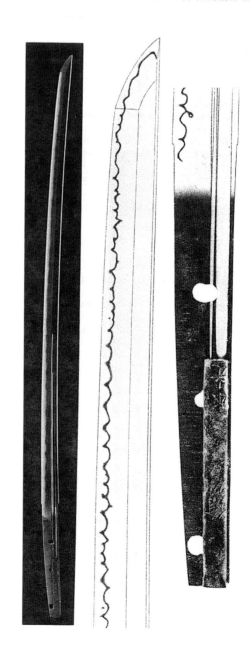

Below An Oei period (1394–1428) *katana* by Yasumitsu of Bizen. It has been shortened and the original *nakago* has been preserved and folded back on itself. This is known as *orikaeshi-mei*.

this period is evident in a hybrid style known as *So-den*. It seems that the main manifestation of this was that Bizen swordsmiths, such as Kanemitsu, Tomomitsu, Masamitsu, and Motoshige, made swords of similar proportions to those of Soshu and were more likely than before to include *nie* (visible martensite crystals) in the *hamon*. As well as *tachi*, *tanto*—or daggers—were longer than before, and *nagamaki* (a type of polearm) reached enormous proportions.

Koto ("old swords"—pre-1596)

Kaneuji and Kinju, two of the Masamune *juttetsu*, had returned to their home province of Mino. Saburo Kaneuji had been influenced by the style of *Yamato-den*, as well as his teacher Masamune's *Soshu-den*, and he is credited with the creation of *Mino-den* on his return to his native province. After the traditions of Yamashiro, Yamato, Bizen, and Soshu, *Mino-den* became the fifth

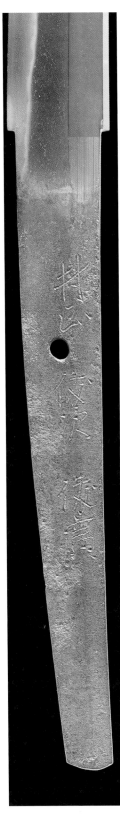

Left The *nakago* of a blade signed by Muramasa, whose blades were considered as inauspicious for the members of the Tokugawa since there were several incidents resulting in injury or death to members of the family.

return to the style of swords popular in the Kamakura period. Such swords were again made in a slender shape. The popularity of *Soshu-den* waned, while that of *Bizen-den* flourished with such swordsmiths as Yasumitsu, Morimitsu and Moromitsu, who were known as the *san-mitsu* of Oei period (1394–1427) *Bizen-den*.

At this time the production of *wakizashi* (short swords of about fifteen to twenty inches in length) began, mostly also in the *shinogi-zukuri* shape (with a ridgeline); the long sword is known as *uichigatana* or *katana*.

The historical periods of sword-making

Prehistoric	up to 538	
Asuka	538–645	
Nara	645–784	*Chokuto* (straight swords)
Heian	784–1185	transitional stage
Kamakura	1185–1333	
Namboku-cho	1333–92	*Koto* (old swords)
Muroboku-cho	1392–1573	*Koto* (older and later old swords)
Momoyama	1573–1600	*Sue Koto* (later *koto*)
Edo	1603–1780	*Shinto* (new swords)
Bakamatsu	1780–1868	*Shinshinto* (new new swords)
Meiji, Taisho, Showa eras	1868–1912	*Gendaito* (modern swords)
Heisei	1989–	*Shinsakuto* (newly made swords)

Below A *daisho*, the *shoto* of which is a *hamadashi-tanto*. Such a combination is associated with Hatamoto (direct retainers of the *shogun*). This pair has the *mon* of the Oda family and the binding over the horn *kashira* (top of the handle) indicates a formal mount of a *daisho*.

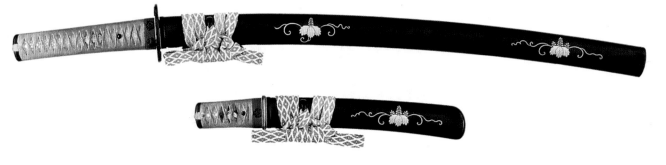

Peace proved to be a passing phase that was not to last. Rebellions against the now-weak Ashikaga *shogunate* in 1439 (the Eikyo Rebellion) and in 1467 (the Onin Rebellion), began the periods of civil strife known as *Sengoku-jidai* that were to last more than a hundred years. A constant stream of wars created a huge demand for swords, which became almost mass-produced, with a consequent loss of quality. It was only the "special order" blades from this period that retained any vestiges of artistic merit, and cutting ability was the only criterion for all others. The production of swords through this period was mainly in the *Mino-den* style as created by Kaneuji. Swordsmiths of this school who were famous in the Muromachi period included Kanesada, Kanefusa, and Kanemoto.

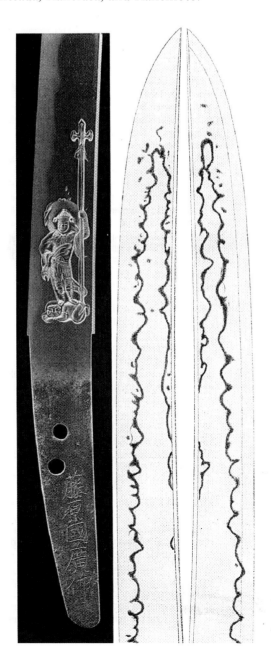

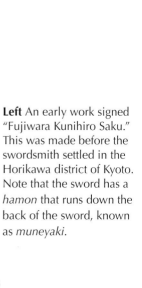

Right Arguably the finest swordsmith of the Shinto period, this sword is signed "Nagasone Okisato Nyudo Kotetsu," who lived in Edo in the mid-17th century. It has been classified as *Juyo Token*.

Left An early work signed "Fujiwara Kunihiro Saku." This was made before the swordsmith settled in the Horikawa district of Kyoto. Note that the sword has a *hamon* that runs down the back of the sword, known as *muneyaki*.

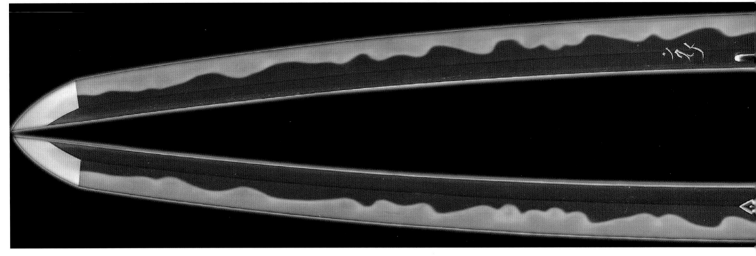

Above A 17th century flamboyant *shinto katana* from Osaka signed *"Ikkanshi Tadatsuna Hori-do saku,"* indicating that he carved the dragon *horimono* for which he was famous. It is also dated Genroku 3rd year (1690).

Ise Province is adjacent to Mino, and it was from here that the supposedly dark character Muramasa hailed. Encouraged by *kabuki* plays such as "The Cutting Down of 100 in Yoshiwara," legend has it that Muramasa cursed the Tokugawa family and that his blades were therefore shunned by them. As Tokugawa Ieyasu's grandfather and his eldest son were both killed with Muramasa blades, while he and his father were injured by them, maybe there was good reason to shun them! It got to the point where simply owning one was considered to be an anti-Tokugawa statement, and in the Bakamatsu period (end of the *shogunate*) anti-Tokugawa troops favored Muramasa blades for precisely that reason.

As well as *Mino-den*, the later *Bizen-den* was very productive. A town named Osafune in Bizen, where swordsmiths had already been working since the earliest days of domestic sword-making, appears to have been almost entirely populated by swordsmiths, many of whom were named Sukesada. The great demand for swords at this time led to shortcuts being made in the manufacturing process, and swords were made on what was tantamount to a production line. At the same time economies were made in raw materials and this may often be seen in such swords where core steel (*shingane*) is seen on the surface or coming through the surface or

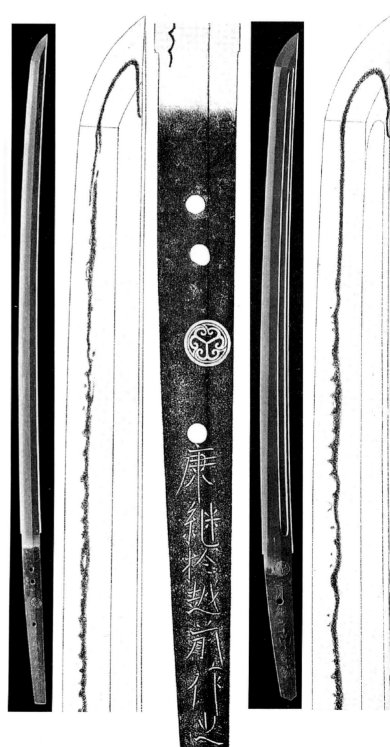

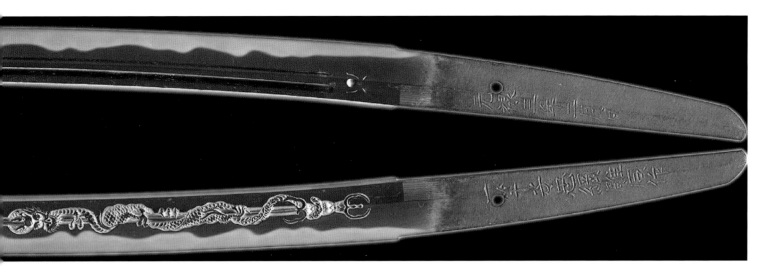

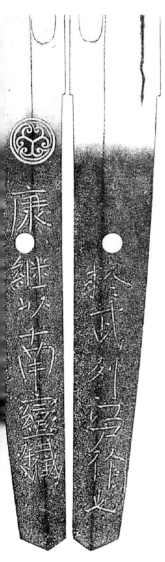

Left The Yasutsugu line of swordsmiths were retained by the Tokugawa family and permitted to inscribe the Tokugawa *Aoi-mon* on their swords. The long sword, which has extensive *machi-okuri*, is signed "*Yasutsugu Echizen Tsukuru Kore*" (Third Generation of Echizen, Kanbun era). Some of the swordsmiths were required to work in Edo and others remained in Echizen. The second sword is a *wakizashi* and the *nakago* inscription states that it was made in Edo out of *nanban testsu* (foreign steel).

skin steel (*kawagane*). This is the result of subsequent polishing and is a condition known aptly as *tsukare* or tiredness. Such swords are popularly known as *kazu-uichi-mono* (things made in number).

Towards the end of the Muromachi period, the powerful *daimyo* from Owari Province, Oda Nobunaga, began his attempt at the unification of the country. On his death in 1582 (he was assassinated by one of his own generals), the work was carried on by Toyotomi Hideyoshi and eventually completed by Tokugawa Ieyasu after the Battle of Sekigahara in 1600. This period (up to the first year of the Keicho period, 1596) is known as the Momoyama period in sword history and was a time of great creativity in the culture and arts of Japan. In Japanese sword history the start of the Keicho era ended the *koto* (old sword) period and began that of the *Shinto* (new sword) period.

Shinto ("new swords"—1596–1780)

Around 1600 Tokugawa Ieyasu established his capital at a small fishing village named Edo, far to the east of Kyoto on the Kanto plain and quite close to Kamakura. With the unification of the country under Tokugawa Ieyasu, peace finally came to the land and the new creative surge of the Momoyama period was reflected in the genius of a Kyoto metalworker named Umetada Myoju and his main student, Horikawa Kunihiro, These two sword-smiths attracted many pupils who were to spread the new styles of sword-making throughout the land. Umetada is known as the father of the *Shinto* (new sword) period and both his and Kunihiro's influence

41

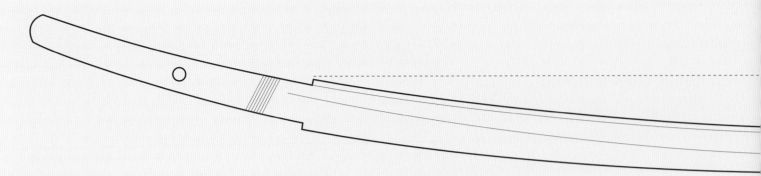

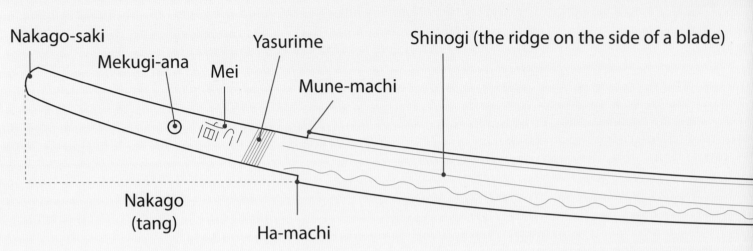

Nakago-saki

Mekugi-ana

Mei

Yasurime

Mune-machi

Shinogi (the ridge on the side of a blade)

Nakago
(tang)

Ha-machi

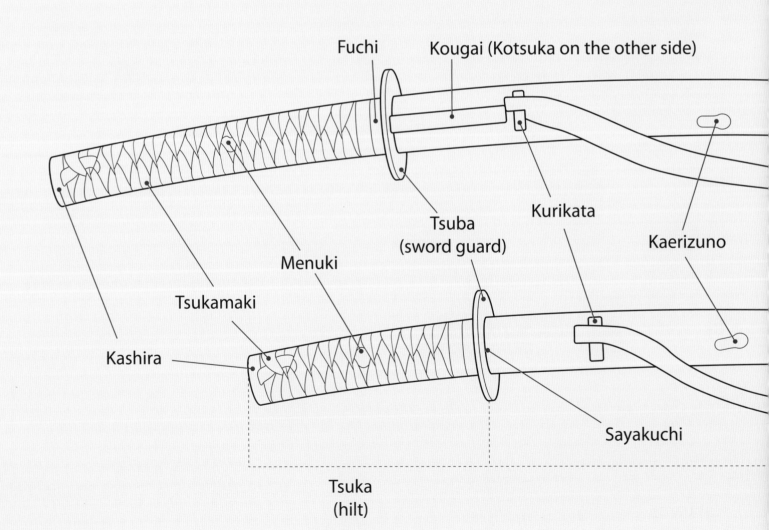

Fuchi

Kougai (Kotsuka on the other side)

Tsuba
(sword guard)

Kurikata

Kaerizuno

Menuki

Tsukamaki

Kashira

Sayakuchi

Tsuka
(hilt)

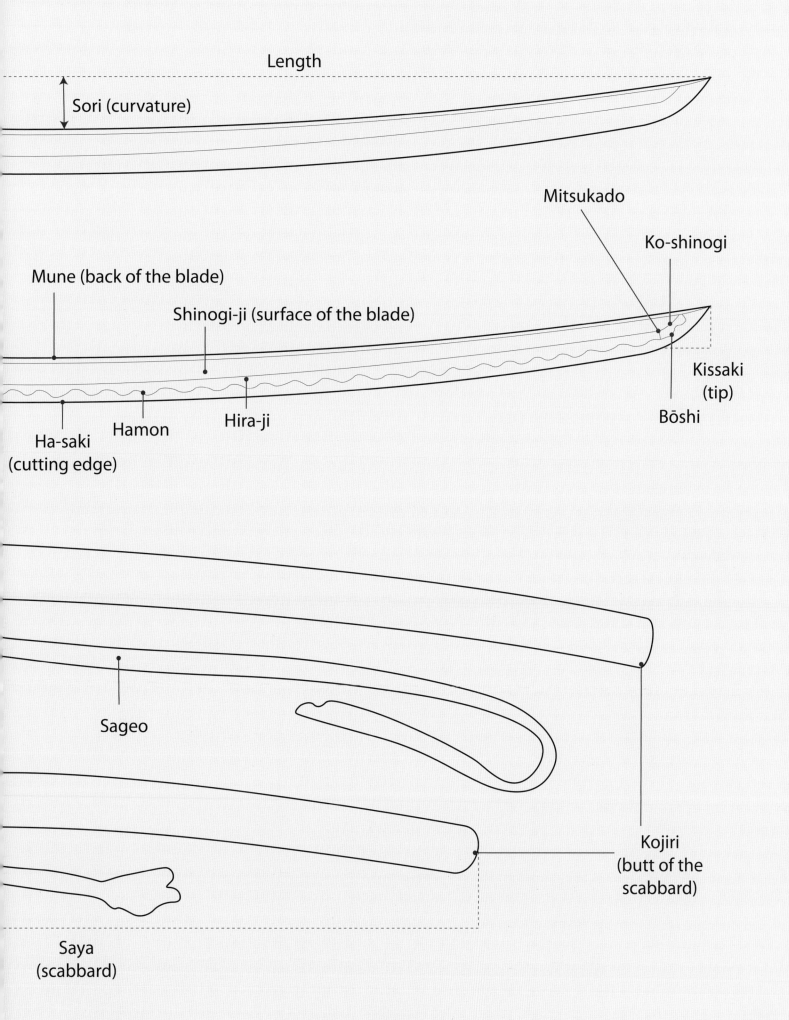

Length

Sori (curvature)

Mitsukado

Ko-shinogi

Mune (back of the blade)

Shinogi-ji (surface of the blade)

Kissaki
(tip)

Ha-saki
(cutting edge)

Hamon

Hira-ji

Bōshi

Sageo

Kojiri
(butt of the
scabbard)

Saya
(scabbard)

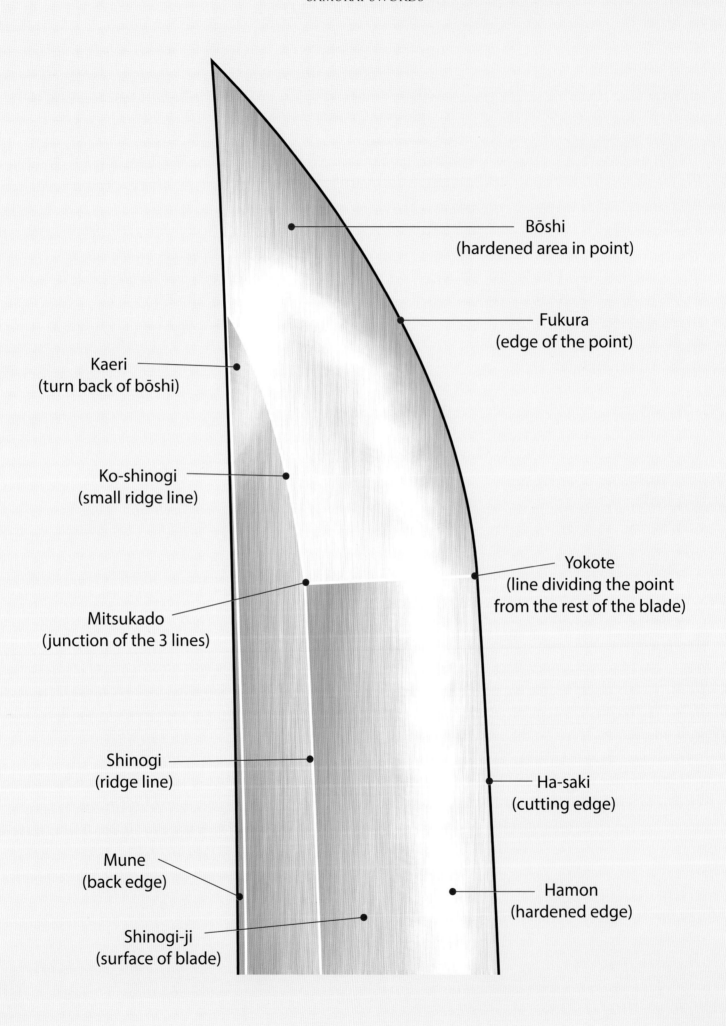

Bōshi
(hardened area in point)

Fukura
(edge of the point)

Kaeri
(turn back of bōshi)

Ko-shinogi
(small ridge line)

Yokote
(line dividing the point
from the rest of the blade)

Mitsukado
(junction of the 3 lines)

Shinogi
(ridge line)

Ha-saki
(cutting edge)

Mune
(back edge)

Hamon
(hardened edge)

Shinogi-ji
(surface of blade)

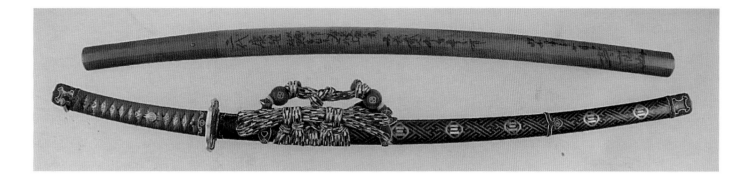

Above An Edo period *ito-maki-tachi* rated as *Juyo Tosu* (important mounting) with its separate blade in *shira-saya*, which has a *saya-gaki* (brushed inscription) stating that the sword is by the second generation Yasutsugu of Echizen Province.

were enormous. They attracted many pupils to Kyoto and to the Horikawa school in particular.

Interestingly, it seems that many swordsmiths emigrated from Seki, the main city of Mino Province at this time, taking their skills to the emerging castle towns. New "schools" or groups of Seki swordsmiths were formed in Echizen Province (the Echizen-Seki) while the Mishina family rivaled Kunihiro's Horikawa school in Kyoto. Overshadowing Bizen, *Mino-den* was to have a great and lasting influence over sword-making in the *Shinto* period. This may have had a political reason since Bizen, in the west of Japan, had supplied Tokugawa's western enemies at Sekigahara, while swordsmiths from Mino Province were suppliers to the eastern troops of the Tokugawa.

It was at this time that the wearing of the *daisho* (one long sword and one short sword, usually with matched fittings) became compulsory to all those of *samurai* rank. Such a law was conclusive proof, if any were needed, that the *samurai* or warrior class had a firm grip on the country, and they were prepared to enforce their authority with their swords if necessary.

The emergence of castle towns attracted all kinds of commerce and craftsmen, including swordsmiths who now had stable centers from which to ply their trade. At the same time, improvements in trade and communications meant that swordsmiths no longer had to mine their own ore, but could buy it from central sources. They were also now free to experiment and try

to rediscover the old techniques of sword-making, lost in the turmoil of the Muromachi period battlefields. With a succession of exclusion laws, the Tokugawa *shogunate* virtually sealed off the country from the rest of the world, prohibiting the entry of foreigners into the country, and the exit of Japanese nationals.

As the Tokugawa or Edo period progressed, and peace was maintained, the urgent requirement for highly efficient blades was diminished, and it became possible to concentrate on the more artistic and decorative properties of swords. This included pictorial *hamon* representing things from nature, as well as *horimono* (carvings on blades) depicting subjects from myth and legend, such as dragons, and with less emphasis on Buddhist and religious themes. However, in the early Tokugawa period, while the warrior ethic was still strong and assertive, there remained a great demand for swords.

Swordsmiths flocked to the new capital of Edo (present-day Tokyo) where the *shogun*'s court was located, as well as to the commercial centers of Osaka and imperial Kyoto. The blades they produced— characterized by their splendid *horimono* and by differently shaped and pictorial *hamon* that were newly adapted or invented as the artistic aspects of swords were emphasized—reflect the bravado of the age and the different atmospheres of the locations in which they were made.

The shape of the early *Shinto* period swords imitated the contemporary and altered lengths of the large swords of the earlier Nambokucho period. These had now been cut down and shortened to accommodate them being worn as *katana* accompanied by *wakizashi*, through the sash at the waist and with the cutting edge uppermost.

Left Sword appreciation was seen almost as a form of *Zen* meditation. Here a refined gentleman admires a sword. Note how he rests the blade on his sleeve rather than touching it with his hand.

Apart from the swordsmiths resident in the great cities of Edo, Kyoto, and Osaka, a number of the better sword-makers of the early Tokugawa period benefited from the patronage of the *daimyo* and were retained in this manner for many generations. Swordsmiths such as Tadayoshi in Hizen (who studied under Umetada Myoju) were retained by the Nabeshima *daimyo* in Saga, while the Kunikane in Sendai were retained by the Date *daimyo*.

Tokugawa Ieyasu himself and his ancestors retained the Yasutsugu line of swordsmiths from Echizen Province, who pioneered the use of the fashionable *Nambam-tetsu* (foreign steel) in sword-making.

As the peace progressed almost uninterrupted into the first half of the 17th century, the number of *samurai* with actual battle experience became fewer and fewer, but they were still expected to be constantly at a high level of readiness. Their very existence as a class supposedly depended on their ability in the martial arts, predominantly skill with swords. To some, this posed the problem of whether or not their sword was able to really be relied on in combat—in other words, would it bend or break, and would it cut efficiently? At the same time a host of laws were enacted by the *shogunate* government, restricting the length of swords. In many cases this meant that existing swords needed to be shortened, and this also worried some that their weapon was no longer effective.

To the concerned *samurai*, the testing of his sword was the obvious response. This seems to have been recognized by the government, who appointed official testers. Execution grounds, especially in Edo, provided

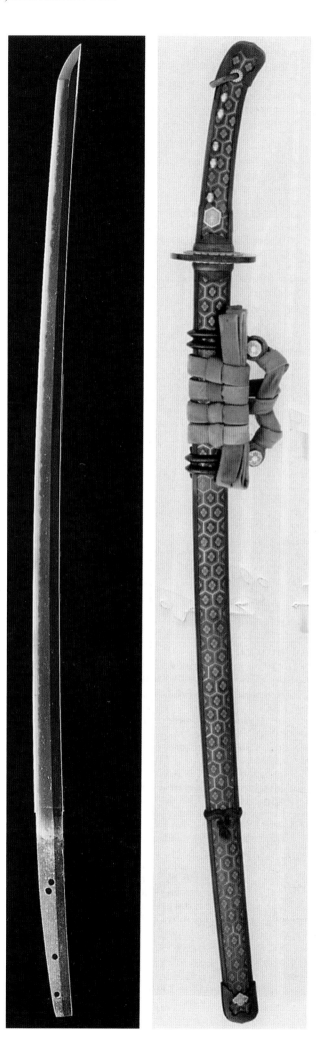

Right A highly decorative 19th century *koshirae* called a *chirashikaemon Efu-no-tachi*. Modeled on an ancient type of *tachi*, this was probably made as a gift or votive offering from the Takeda clan, whose *mon* is displayed. Note the almost complete lack of curvature in the *Kanbun-shinto* (circa 1661) blade that has been greatly shortened.

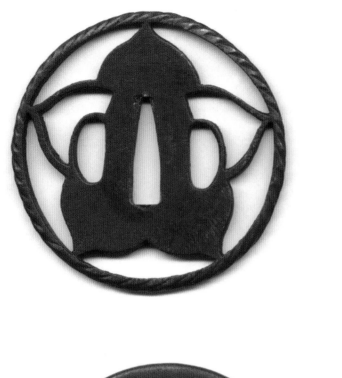
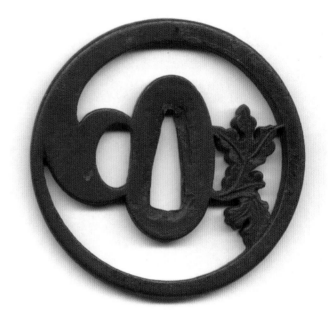
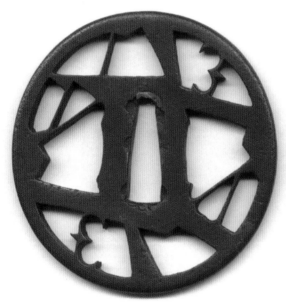
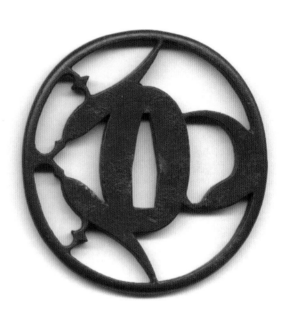

Above A group of iron *sukashi* (silhouette) *tsuba* with various subjects. Such simple iron sword guards were considered to be in good *samurai* taste and better suited for combat than those fashioned of soft metals.

excellent facilities and also (human) "raw materials" for tests that could be considered useful. Especially in and around the Kanbun (1661–1672) and Enpo (1673–1680) periods, many swords were officially tested (*tameshigiri*) at these places and the results of the tests were frequently inscribed on the sword's *nakago* in gold inlay (*kinzogan*).

Despite being a reaction to the raft of new sword legislation at that time, resulting in many sword alterations, *tameshigiri* was also a reflection of the development of *shinai-kendo*. The *shinai* was a bamboo practice sword that was straight, and swords made at that time, especially in Edo, had very shallow curvature in an attempt to replicate the *shinai*. This is still known as the *Kanbun-shinto sugata*, or "the new-sword shape of the Kanbun period."

There seems to have been something of a reaction to this in the following Genroku period (1688–1703), as there was a deep curve to the few swords made at

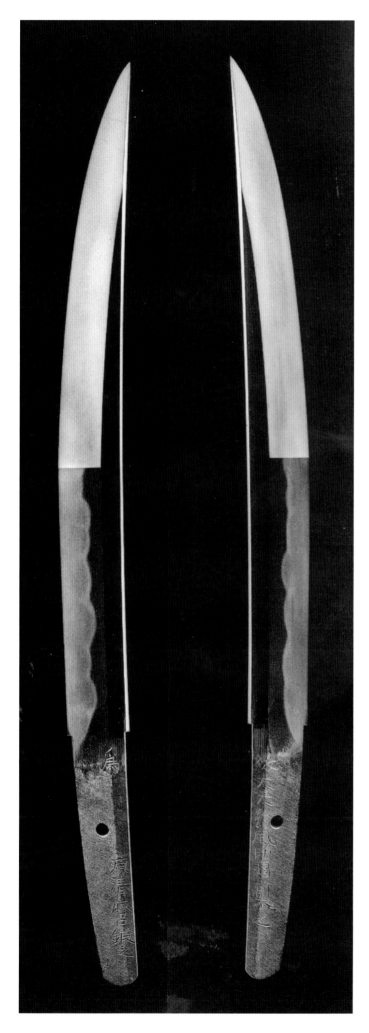

this time. This era is known as one of depravity and the erosion of the *samurai* spirit. It was the height of the famous Yoshiwara pleasure district in Edo and the rise in popularity of the *kabuki*, the ordinary citizen's entertainment. The real power now lay with the merchant class, who were not permitted to wear the *katana* but who often had their social superiors mortgaged to the hilt. They exerted great influence over the production of rich and ornate sword accoutrements such as *tsuba* and *kodzuka*, and were welcome patrons to the artisans.

By the late 17th century there was little demand for swords and no swordsmiths of any great repute were to be found. The merchant class, however, had begun to take over the country's economy, and the *samurai* ethic was greatly diluted. During the first two-thirds of the 18th century the quality of swords was low and few swords were made, other than by the retained swordsmiths mentioned above. Even in Edo and Osaka few swordsmiths could be found, although the production of ornate and highly decorative sword fittings flourished, reflecting the more ostentatious tastes of the merchant class, who formed the main clientele. This was in contrast to the earlier ideal of *samurai* taste, which was more sober, subtle, and refined.

Towards the end of the Tokugawa period in the late 18th to mid-19th centuries, the *shogunate* was under great pressure both from within the country and outside. The seclusion policy was being severely tested as foreigners tried to open trading relations with Japan, and some of the more militant anti-Tokugawa *daimyo* were becoming restless. Mostly, these families had been on the losing side at Sekigahara. As a reaction to this unrest the *shogunate* desperately tried to rekindle the flagging martial vigor of the *samurai*, and in the wake of this there was a renewed interest in the Japanese sword from about 1780.

Left This shaped short sword is known as *Osoraku-tsukuri*. The enigmatic word *Osoraku* means "perhaps." The shape was invented by Shimada Sukemune in the 16th century. This example is by the *shinshinto* genius Kiyomaro, whose group liked this shape in the 19th century.

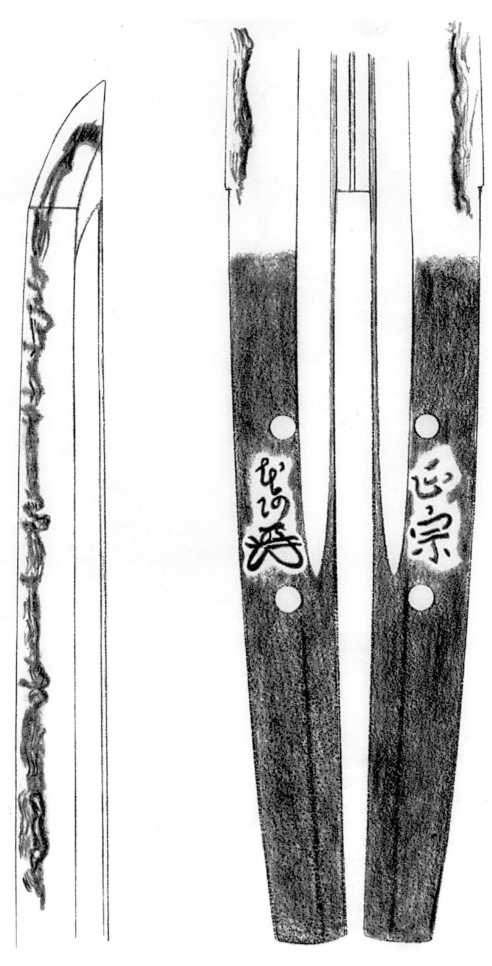

クライブ
H.14・4月・十七日

Shinshinto ("very new swords"—1780–1868)

This resurgence of interest was led by a swordsmith named Suishinshi Masahide. He was a great theorist and preached a return to the sword styles of *Soshu-den* and *Bizen-den*, from the Kamakura and Namboku-cho periods. This was known as *fukoto*. Although a reasonably accomplished swordsmith, Masahide became better known for his writings and research than for his good sword-making. This revival, spearheaded by Masahide, heralded the sword-making period known as the *Shinshinto* period (very new sword period). Masahide, together with his highly talented pupil Naotane, spread the *fukoto* philosophy throughout Japan, influencing many swordsmiths.

large *han-dachi koshirae* (a *katana* mount that was half that of a *tachi*) with long, wide blades and shallow curvature. Such swords became known as *Kinno-to* or "Emperor Supporting Swords"!

Particularly during the Tempo period (1830–1843) the practice of *tameshigiri* seems to have been revived as *samurai* felt that their swords, once again, would inevitably need to be relied on in battle. Several swordsmiths, especially Koyama Munetsugu, an Edo swordsmith whose efforts were directed at reviving and imitating the old *Bizen Ichimonji* style of sword-making, had a great interest in the sharpness of their products. To this end, Munetsugu formed a close relationship with Yamada Asaemon Yoshimasa, the head of the

Left An *oshigata* of the London Victoria & Albert Museum's unauthenticated Masamune, with a gold inlay attribution by one of the Honami family of appraisers. (*Oshigata* by the author.)

Below A decorative lacquer *wakizashi koshirae*, made in the mid-Edo period, about 1700.

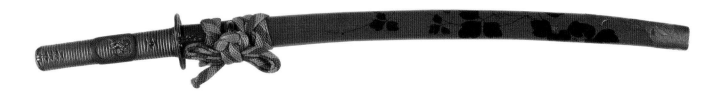

Kiyomaro was another great swordsmith who set up his shop in the Yotsuya area of Edo. His work became so highly acclaimed that he became known as the Yotsuya Masamune. But Kiyomaro was a flawed genius who committed suicide, thus preventing him from realizing the full potential shown in his extant works, particularly his later pieces. In some ways he may be regarded as the Van Gogh of Japanese swordsmiths.

Swordsmiths attempted to recapture the styles and shapes of swords made in the Kamakura and Nambokucho periods, and many fine swords were made at this time. Many of the customers required large, heavy swords with big points, their large proportions giving martial confidence where it may not have been fully deserved. The martial spirit of many *samurai*, often of lowly status within the clan hierarchy of the outer clans, was stirred to support the move to reinstate the emperor to full ruling powers. Many of these favored

family of the *shogun*'s officially appointed cutting testers. Many results of these tests are inscribed on the *nakago* of Munetsugu's fine swords.

The coming of the U.S. Navy's Commodore Perry in 1853, and the forcing of Japan to open her doors to international trade, sparked pressures that would eventually lead to the *shogunate* relinquishing power to the Emperor Meiji in 1868. The Meiji Restoration was soon followed by edicts permitting the cutting of the *samurai*'s topknot and then, in 1876, a strict order was enacted banning all citizens other than the military or police from carrying swords. For some while this appeared to be the end of the history of the Japanese sword.

Gendaito ("modern swords"—1868–1945)

Fortunately, a very few swordsmiths, such as the Horii and Gassan families, managed to keep making blades

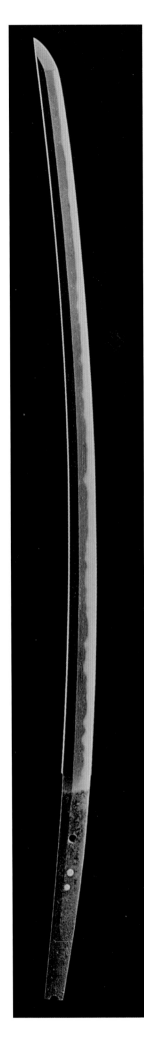

Left and Above A *Juyo Token Bizen tachi* of the Ichimonji school. The *nakago*, although greatly shortened, retains the character *"ICHI,"* standing for No.1. The sword dates from the early to mid-13th century.

and saved the art of sword-making from disappearing and being lost altogether. This was greatly helped by the Meiji emperor himself; he was both an avid collector and patron of Japanese swords. However, the swordsmiths of this time led a precarious existence and, in order to make ends meet and satisfy the demand from the few collectors of the time, many resorted to making fakes or reproductions of swords from famous swordsmiths of the past. Similar difficulties were met by makers of sword fittings, although there were more opportunities for redirecting their skills into making bronze figures, cigarette cases, and other metallic *objets d'art*.

The Russo-Japanese War of 1905 and the rise of militarism in the 1930s once more sparked interest in Japanese swords. All officers of the Imperial Japanese Army and Navy were required to carry a sword. Most of the swords made in the World War II period were machine made and should not be considered true Japanese swords at all. It is these *Showa-to* blades (swords made in the early Showa period, 1926–1945) that are most commonly found in the West; they are valueless as art swords but of interest to militaria collectors.

However, swords made in the traditional manner were still produced during the war and are known as *gendaito* (modern swords). Among the principal centers and best known locations for making such blades was the famous Yasukuni Shrine on the Kudan Slope in Tokyo, as well as the Nihonto Tanren Denshujo founded by Kurihara Hikosaburo (Akihide).

There can be little doubt that some of the swords made traditionally in the early Showa period were the work of skilled swordsmiths, and it may be argued that they were the equal of many *Shinshinto* period artisans. Those of the Gassan and Horii have already been mentioned, but makers such as Kasama Ikkansai Shigetsugu were unsurpassed. This particular swordsmith, said to have had a somewhat awkward disposition, is known to have been commissioned to make swords for important dignitaries. There is even a sword in a western collection that he made

for presentation to Adolf Hitler. This sword sports a magnificent *horimono* of Fudo kaen and is a masterpiece in sword-making when judged by any criteria.

Both these individuals and institutions laid the foundations of the postwar production of swords, which is covered in some detail in a later chapter of this book.

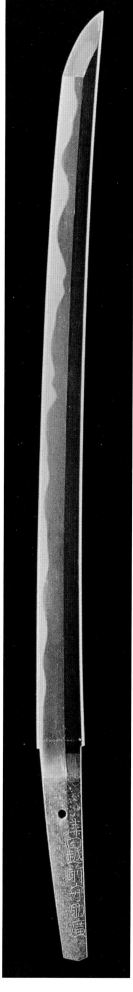

Below and Right Signed *"Tsuda Echizen (no) Kami Sukehiro"* and dated 1669, this sword is the work of a smith who was a leading light in Osaka during the Shinto period. His swords are said to reflect the taste of the rich merchant class.

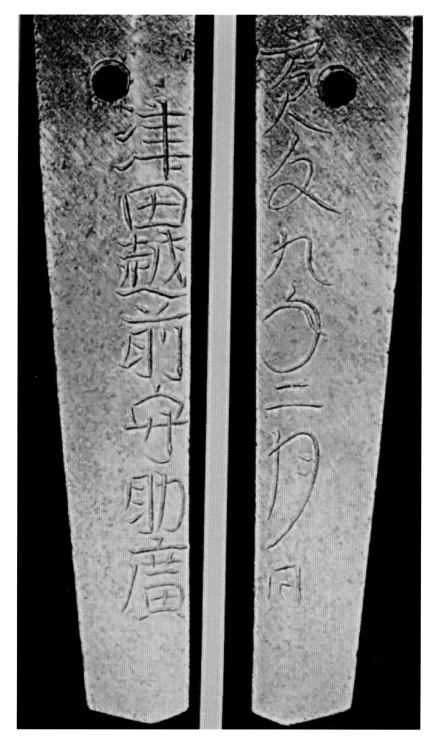

Historical Background to *Hizen-to*

In Japan, it is quite common for a collector of Japanese swords to concentrate on those from his own city or prefecture. This stems from a feeling of empathy with these swords, and local pride, and it restricts the vast collecting area to more manageable proportions. It often enables these collectors to become very specialized in their own fields.

There are no more passionate collectors than those whose focus is on swords from Hizen Province (present-day Saga-ken). They feel, with some justification, that swords produced in Hizen during the Tokugawa period (1600–1868), and which are popularly known as *Hizen-to*, are among the best ever made. They boast of the great

beauty and awesome cutting ability of Hizen swords. For these collectors, the swords of Hizen, and those of the main line of smiths named Tadayoshi in particular, are not inanimate art with antique interest, but the living embodiment of *bushido* and all that that entails.

A few years ago I spent some time in the province meeting sword polishers and collectors, as well as practicing *kendo* in my teacher's *dojo*. I gained an appreciation of *Hizen-to* and have made it something of

Below Map of Japan in 1615 showing the division of the country between *Tozama* (outer) *daimyo* and *Fudai* (inner) *daimyo*. Hizen Province is highlighted.

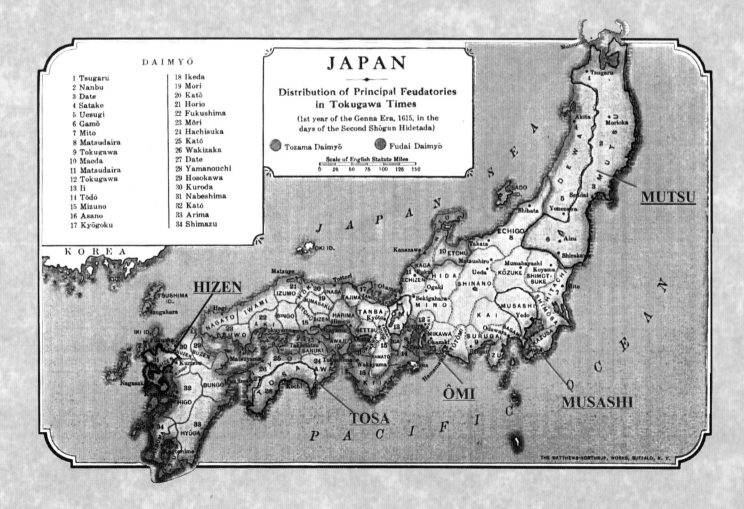

a specialty of my own ever since. This is greatly helped by the wealth of information and many fine specimens available (a member of the main sword-making family was instructed by the government to compile a history of the Hizen swordsmiths from the old clan records in 1888, upon which much of the modern research is based).

During the late 16th century, and near the end of his life, Toyotomi Hideyoshi invaded Korea and in this venture was supported by the Nabeshima military family. The family was rewarded by being allocated the largest share of land in Hizen Province. The province is situated to the north of the southernmost of Japan's main islands, Kyushu. It is surrounded on three sides by sea and is one of the provinces closest to the Asian mainland. Shortly after their return from Korea, the domain was confirmed by the new Tokugawa government, and Saga became the capital of Hizen Province and of the Nabeshima clan.

The clan soon became very powerful and rich, their wealth being based on several thriving industries, including the famous Nabeshima pottery, which is much sought after today. It is said that potters brought

Above A portrait of a retired *samurai* of the Nabeshima han. The *aikuchi tanto* at his waist clearly displays the clan's *mon* or heraldic badge and proudly proclaims his allegiance. (*Courtesy of the British Museum*)

Above It is clear from this detail map how Hizen Province is surrounded on three sides by sea. The capital city of Saga is circled.

back from Korea started this industry, and it may not be a coincidence that the manufacture of pottery and of swords both rely on the skilled control of heat in furnaces. However, arguably of more interest than the pottery was the province's highly successful manufacture and export of swords.

In the early years of Tokugawa rule, independent swordsmiths went to the main cities and castle towns to make and sell their wares to the *samurai* inhabitants. The main centers were Osaka, the mercantile capital, Edo, the military and administrative capital, and Kyoto, the imperial capital. The more fortunate became fully retained swordsmiths of the *samurai* lords, and their families were safely employed, often for many generations, on the feudal estates. Having its own swordsmiths was a necessity for a powerful and important clan such as the Nabeshima.

At the beginning of the Tokugawa period (the Keicho period, 1596–1624), the Nabeshima *daimyo* retained a

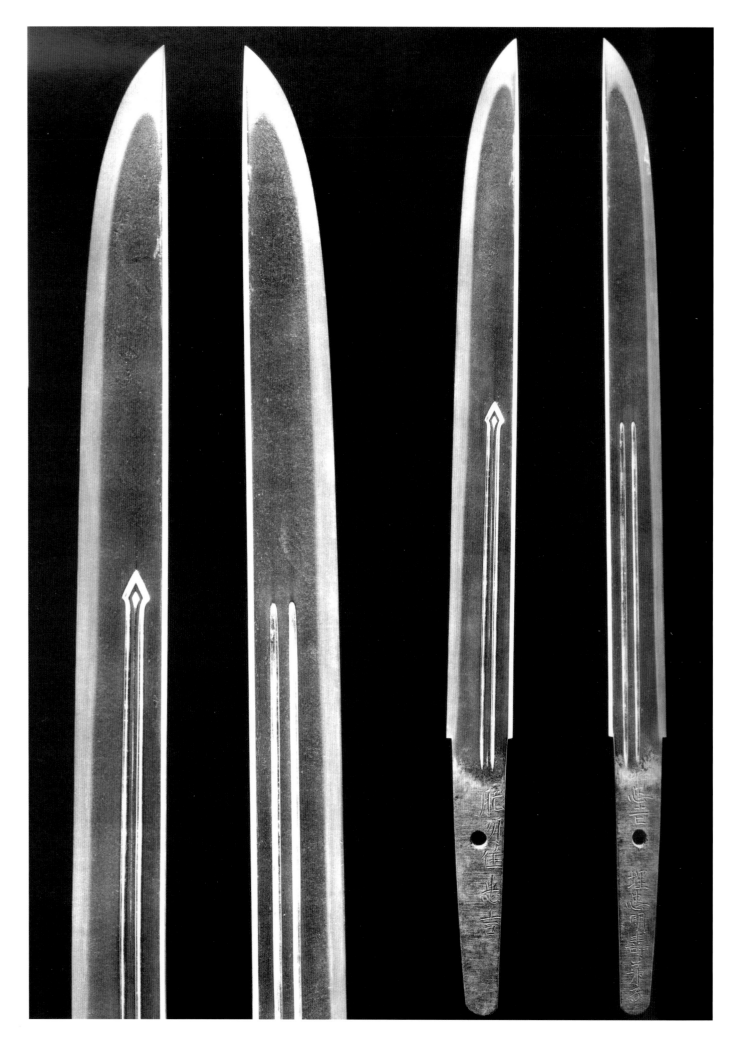

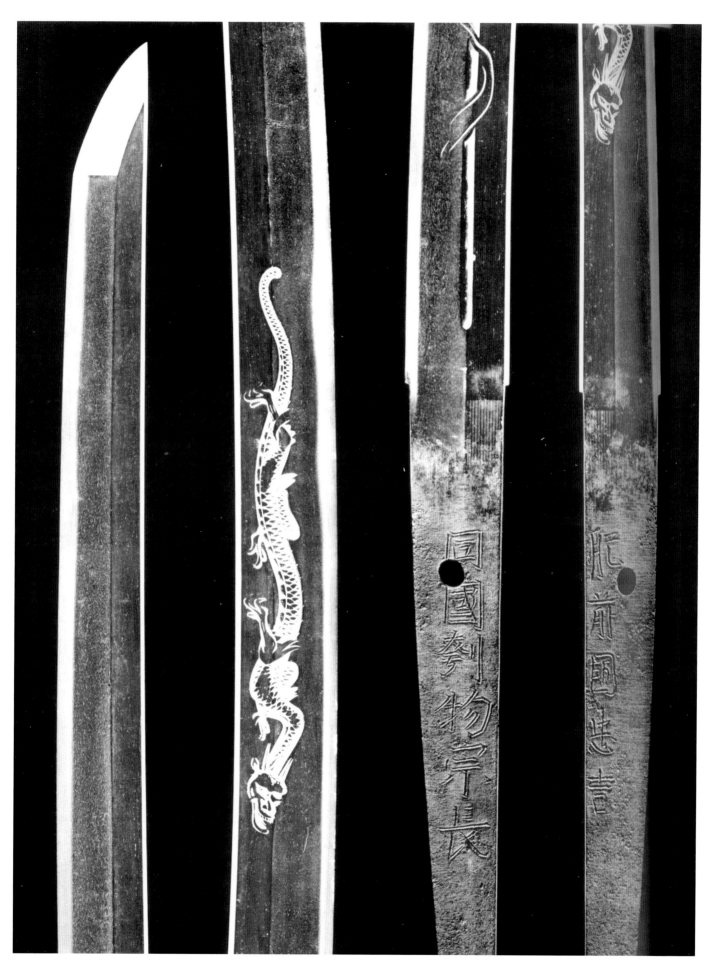

Left The inscription on this blade states that *"This Tadayoshi is a pupil of Umetada Myoju."* It is believed to have been carved by Umetada himself and demonstrates his regard for Tadayoshi's skill.

Above This blade was made by the first Tadayoshi but the carving was executed by Munenaga, a specialist carver and another pupil of Umetada Myoju.

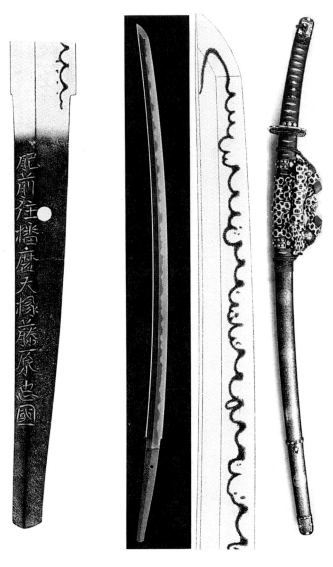

Above A blade by the *shodai* Tadakuni signed *"Hizen Ju Harima Daijo Fujiwara Tadakuni,"* accompanied by an *ito-maki-tachi koshirae.*

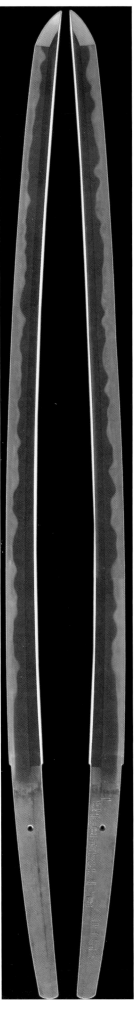

Left The wider and more undulating *hamon* on this sword demonstrates the greater freedom of the sideline smiths such as Yukihiro. It is signed *"Ichi Hizen Kuni Dewa Kami Yukihiro,"* and is by the first generation.

Above This is the *koshirae* for the Yukihiro shown to the left. It is a type of *han-dachi* (half-*tachi*) style of mounting, having a *kojiri* (decorated butt of the scabbard) but, unlike most *han-dachi*, has no other metal mounts on the *saya*.

Right An *oshigata* of a ninth generation Tadayoshi with the *goji-mei* (five character signature) *Hizen Kuni Tadayoshi* common to most of the line except the second generation swordsmith who never used the Tadayoshi name. (*Oshigata* by the author.)

young swordsmith named Hashimoto Shinsaemon, who was born in 1572. Together with his two brothers, Hashimoto Shinsaemon had been taught sword-making from the age of thirteen, by one Iyo (no) Jo Munetsugu, the head priest of an important local shrine and a talented sword-maker himself. The young Shinsaemon, who was from *samurai* lineage, had been orphaned as a child and brought up by his grandfather, who was himself killed in battle.

Before setting up his forge in Saga for the Lord Nabeshima, Shinsaemon had previously studied under a great teacher in Kyoto named Umetada Myoju, who was a genius metal worker making superb *tsuba* as well as making blades with highly artistic carvings on them. Umetada, known as the father of the *shinto* style of

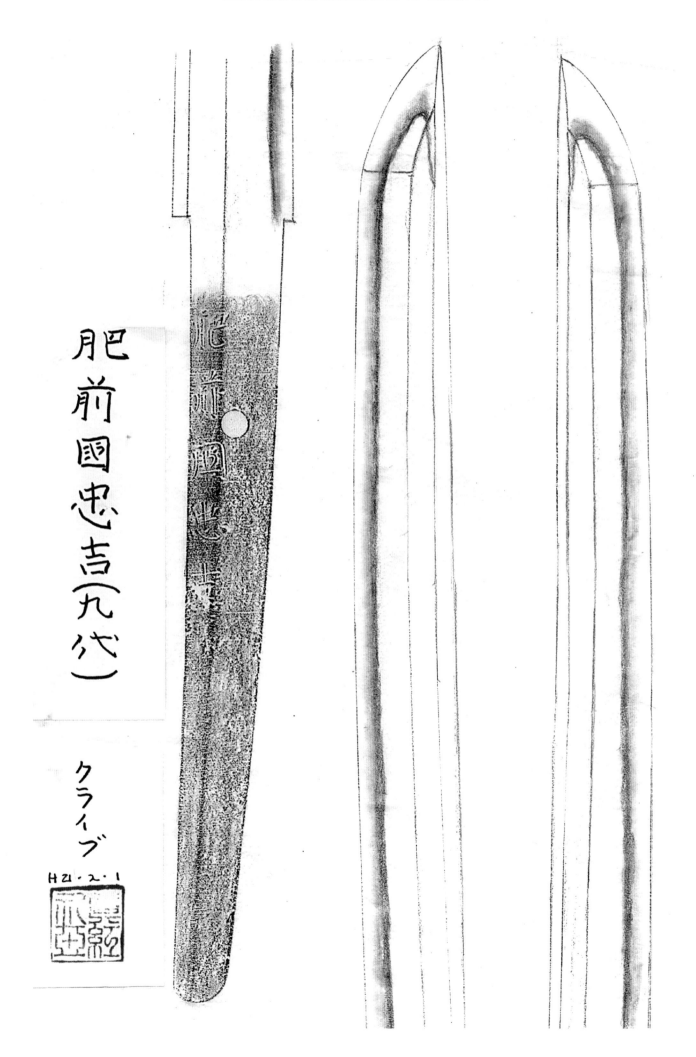

肥前國忠吉(九代)

クライブ

H21・2・1

Above The first of nine generations named Masahiro, this one with the title "Kawachi Daijo." He was one of the sons of the first generation Tadayoshi. All the Masahiro line were first named Masanaga before succeeding to the head of the family and assuming the name Masahiro.

Left This sword is quite robust in shape and has the *suguha hamon* (straight temper line) associated with the *nidai* (second generation) Tadahiro. The sword is signed with his full signature: "*Hizen Kuni Omi Daijo Fujiwara Tadahiro.*"

sword-making, granted the young smith the use of the character TADA from his name, and Shinsaemon became Tadayoshi.

This was a time of renaissance in the history of the Japanese sword. It was the end of the *Sengoku-jidai* (period of the country at war), and the beginning of the Keicho period (1594) is recognized as the start of the so-called *Shinto* (new sword) period of Japanese sword manufacture. It was not now necessary for swordsmiths to turn out large numbers of simply practical swords, as was required during the *Sengoku-jidai*. Now they could take more time to produce better quality blades, emphasizing the more artistic properties of the Japanese sword. Tadayoshi produced many fine swords that were carved with elaborate *horimono* and executed by a fellow student of Umetada Myoju, named Munenaga.

Tadayoshi attracted many students, and the Nabeshima clan exported swords made by the Tadayoshi school right across Japan. Nabeshima Katsushige (1580–1657), the first official Nabeshima *daimyo* and the head of the main clan, ordered three of his many sons to establish so-called branches or sub-fiefdoms of the main family. These were the Ogi fief, given to his eldest son Motoshige in 1617, the Hasuike fief, given to his third son Naosumi in 1639, and the Kashima fief, given to his ninth son, Naotomo, in 1642. Apparently, during the reign of the second Nabeshima *daimyo*,

Right This magnificent blade has superb *horimono* (carvings), and the inclusion of the "Minamoto" character in this first generation Tadayoshi's signature is rare. It reads: "*Hizen Kuni Junin Minamoto Tadayoshi.*" (*Oshigata* by Kikuchi Masato.)

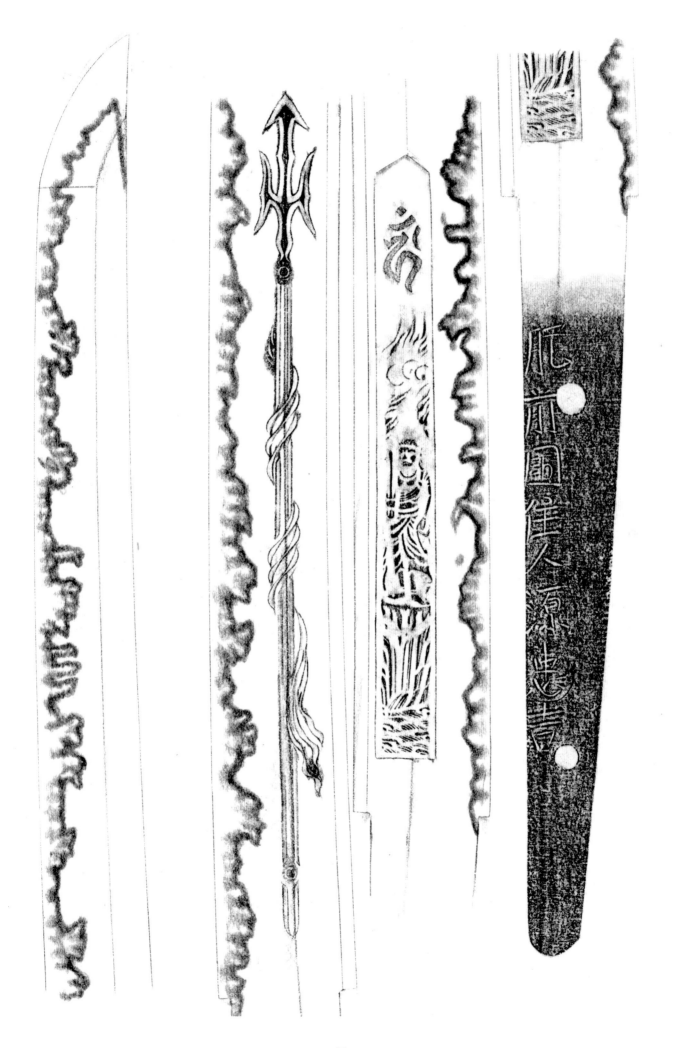

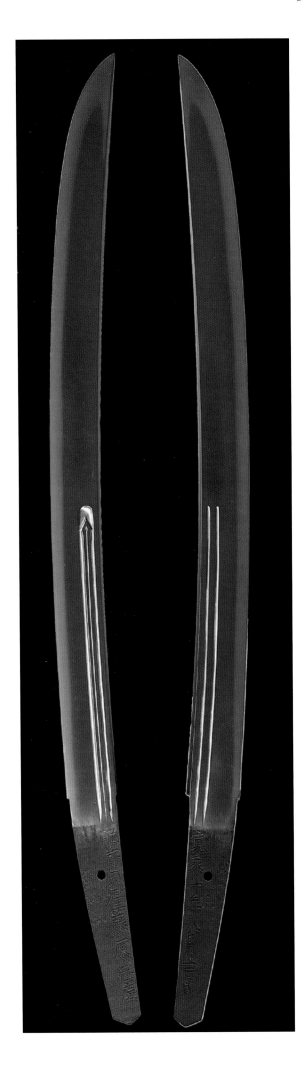

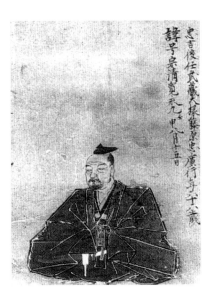

Above An official portrait of the *shodai* (first generation) Tadayoshi, whose personal name was Hashimoto Shinsaemon. It has a date the equivalent of 1623, so he would have been about fifty-one years old at the time.

Left This *hira-zukuri wakizashi* (ridgeless short sword) is signed with the full Tadahiro signature and is dated 1633. As this is one year after the death of the first Tadahiro, we must assume that it is the work of the second Tadahiro when he was only nineteen or twenty years of age, It is a *Juyo Token*.

Mitsushige, the "main fief," incurred the resentment of the branch fiefs in some unspecified way. It is interesting to speculate that the branch lines of the main Tadayoshi family were formed to parallel this arrangement; for instance, it is certainly understood that the Tadakuni branch line were employed by the Ogi fief and the Yukihiro line by another.

The definitive *Hizen-to*, which was really standardized and perfected by the second generation Tadahiro, may be described as having a strong *sugata* (form or shape) with a shallow but even curve, a skilfully controlled *suguha hamon* (straight quench-line), which is comprised of fine *nie* (crystallized martensite) and which ends in a *ko-maru boshi* (small circular quenching pattern in the point). Further, *nie* are sprinkled all over the *ji* (surface of the blade), producing a unique surface pattern known as *konuka-hada* (named after the white rice grain that Japanese women used cosmetically to whiten their faces). Such swords had a reputation for being *saijo wazamono* (supremely sharp) as well as being things of great beauty; as such

they brought much credit both to Tadayoshi and the Nabeshima *daimyo*.

In addition to the main Tadayoshi line, of which there were nine continuous generations producing swords, collateral family lines such as Masahiro, Yukihiro, and Tadakuni were prolific, all working in and around Saga for both the Nabeshima clan and their extended families. By the middle of the 17th century, the reputation of swords from Hizen Province was well respected throughout Japan and their export contributed greatly to the prosperity of the Nabeshima clan. Unfortunately, this fame led to many forgeries, the majority of which are in the Tadayoshi *goji mei* (Tadayoshi's five-character signature) of HIZEN (no) KUNI TADAYOSHI. The signatures of all Hizen swordsmiths are on the opposite side of the *nakago* to most Japanese swords; that is to say, on the *ura* in the style of *tachi*, so-called *tachi-mei*. This applies only to *daito* or long swords, while *wakizashi* (short swords) and *tanto* (daggers) are signed in the conventional manner.

Tadayoshi signed his work in many different ways throughout his career, but the above *goji mei*, or five-

Above The graves of the second to ninth generations of the main Tadayoshi line at the Shinkaku-ji temple in Saga City.

Right A *wakizashi*, or short sword, by the third-generation Tadayoshi who is highly regarded for the quality of his *jihada* (surface pattern). The sword is signed "*Hizen Kuni Ju Mutsu (no) Kami Tadayoshi.*"

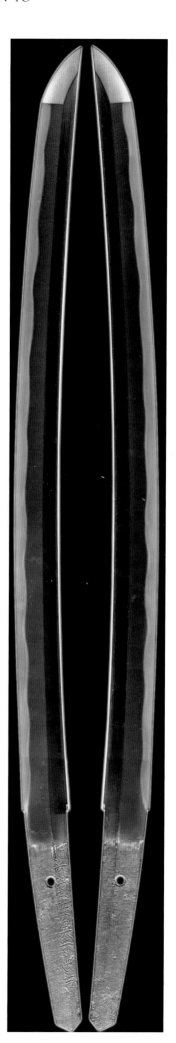

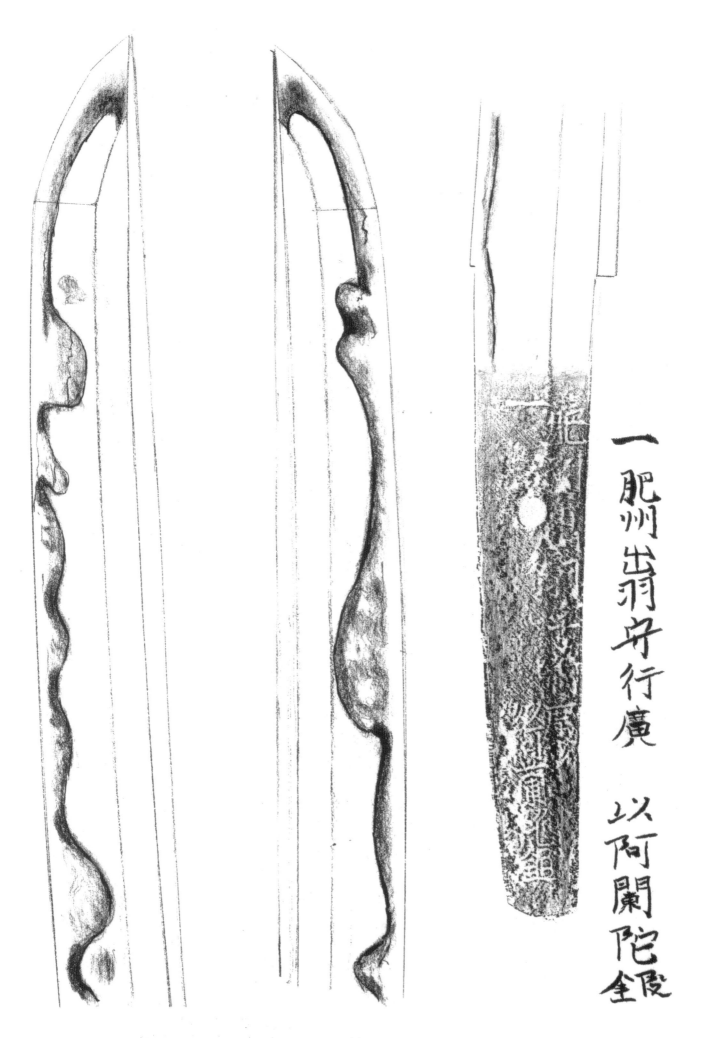

一肥州出羽守行廣
以阿蘭陀金爲

character signature, is the most common. This form of signature was also used by the succeeding generations (except for the second generation, who never adopted the Tadayoshi name and were only ever called Tadahiro). Other types of signature employed by the first Tadayoshi, include his so-called "*Junin mei*," *Minamoto mei*, the *Hi Tadayoshi mei*, and the so-called *Shugen-mei*. It is speculated that this latter one was actually engraved by the Hashimoto family priest, named Shugen. Actually, it was also a *goji mei* but it is thought that he signed it because Tadayoshi was unable to read or write. I do not subscribe to this school of thought since I am sure that even someone totally illiterate would be able to learn something as important as his name. More likely, I think, is that there was a religious consideration for having a priest sign swords.

When Tadayoshi retired as the head of the family in 1624 he was granted the title *Musashi Daijo* and he changed his name to Tadahiro. In his last few years his health deteriorated but his many students and family produced swords in his name. This meant that, in some cases, they made the sword and signed it with Tadayoshi's signature. Known as *Dai Saku* and *Dai mei*, in Japan this is considered as being the same as the master's work and not a forgery, as it might be regarded in the West. It does demonstrate well the close co-operation between the members of the extended family, but makes judging authenticity of signatures a very difficult process.

The first Tadayoshi died in 1632 at the age of sixty-one and was succeeded by his natural son who was only nineteen years old at the time and who took his father's name of Tadahiro. The young man was being taught by several swordsmiths and one in particular was teaching him at the same time as substituting for his father. This swordsmith, named Masahiro, was very influential,

Left A *wakizashi* by the *shodai* Yukihiro. The *hamon* is quite wild and undulating. The inscription reads: "*Ichi* (from *Ichimonji*) Hishu Dewa Kami Yukihiro" and "Oite Oranda Kitae Saku." This last part means it was made by Dutch forging and refers to his time in Nagasaki where he claimed to have studied the Dutch methods of forging guns. (*Oshigata* by the author.)

providing the clan with continuity at this difficult time.

An interesting story is told of this first generation Masahiro and how he received his name. Apparently, he was allowed to sign Tadayoshi's swords with the name Tadayoshi, although no examples exist to confirm this. The story goes that he made such a sword, which was a *tachi* in the *Soshu* style, and this was presented to the lord of the clan. When he saw it the lord is reputed to have said, "*This is a very good sword and looks just like the work of Soshu Masahiro* (a famous 14th century swordsmith working in the Soshu tradition). *I think you should use the name Masahiro from this time on.*") And so Masahiro and the following nine generations did just that.

The second generation Tadahiro, who lived to be over eighty years old, produced many swords throughout his long and productive lifetime. He is credited with perfecting the classical *Hizen-to* in terms of *suguha hamon* and *konuka-hada*. This is almost perfection in the Japanese sword, being strong in shape and forging, clean and effective in the *hamon*, and presenting a work of art that has great practical potential. While the first generation Tadayoshi experimented with several different old styles, swords such as those by the second generation Tadahiro were greatly inspired by the Yamashiro tradition of the Kamakura period, especially the Rai group of swordsmiths. The fame of these Hizen swords spread throughout Japan, and the coffers of the Nabeshima swelled even more.

Several of the collateral lines, while often producing blades with *suguha hamon* (which, incidentally, is considered the most effective when cutting), were also skilled at other styles, particularly *Bizen-den*. Indeed, the *choji* (clove-shaped) *hamon* that is characteristic of Bizen swords was adapted and slightly customized by Hizen swordsmiths.

In particular, a line of smiths named Yukihiro, who worked for the Sakyo branch of the Nabeshima clan, acknowledged this Bizen influence by including the character *ICHI* in the inscriptions on their *nakago*. This stood for *ICHIMONJI* (number one), which the Yukihiros sometimes also spelt out in their inscriptions and was the name of a spectacular old group of Bizen

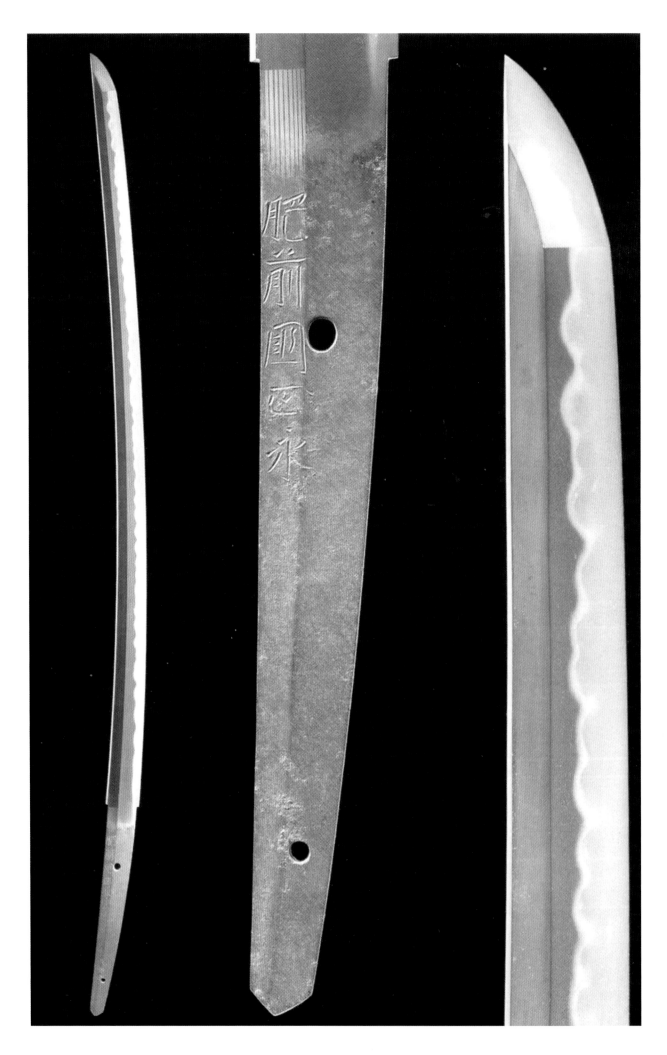

肥前國□永

Left The Masahiro line of swordsmiths used the name "Masanaga" before assuming the Masahiro name when succeeding as head of the family. This is the Masanaga *mei* of the *godai* (fifth generation) Masahiro.

Right A *katana* signed "*Hizen Kuni Junin Tadayoshi*" (the 4th generation). The intricate *horimono* was carved by a specialist carver named Tadanaga.

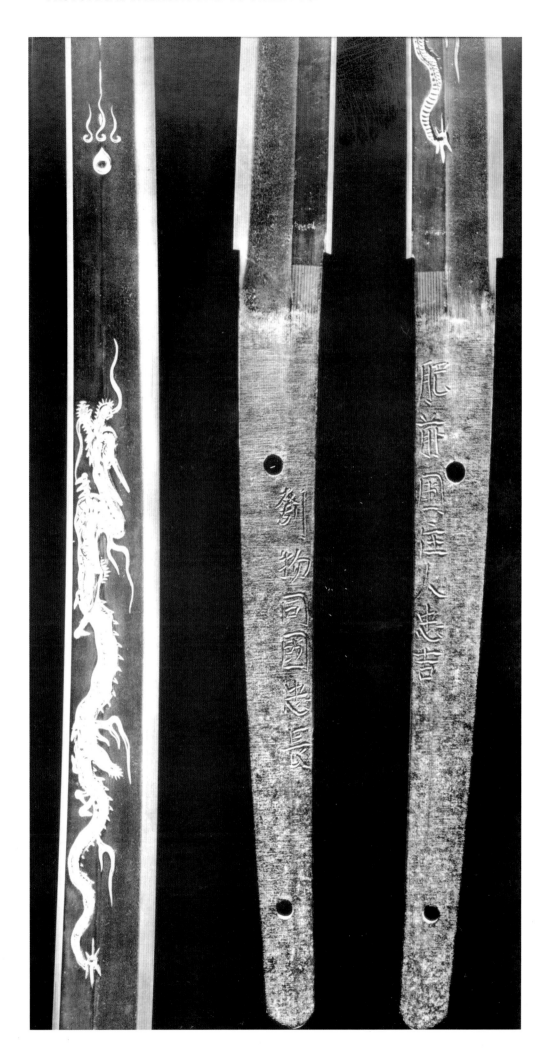

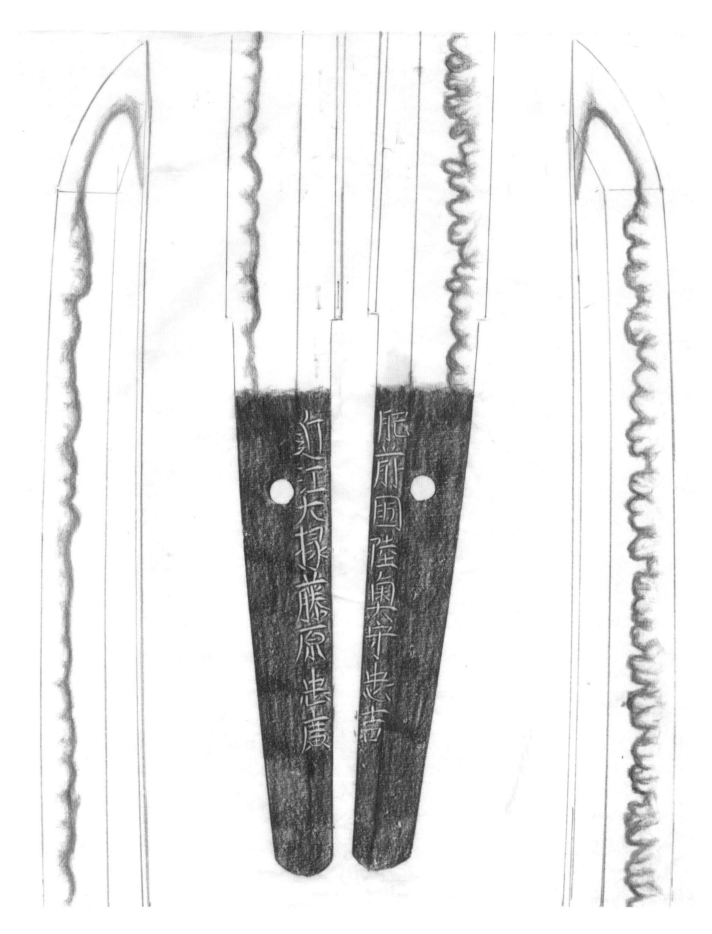

Above This is a *gassaku* blade, the combined efforts of two swordsmiths, that of the second Tadahiro on the left, and of his son, the third Tadayoshi, on the right. The signatures read: "*Omi Daijo Fujiwara Tadahiro*" and "*Hizen Kuni Mutsu Kami Tadayoshi*", respectively. (*Oshigata* by Mr. Noguichi, a Saga polisher, in 1985.)

Right The classic *nidai* Tadahiro *katana* in *suguha*, signed "*Hizen Kuni Ju Omi Daijo Fujiwara Tadahiro*," complete with *inro-saya* and full *koshirae*.

68

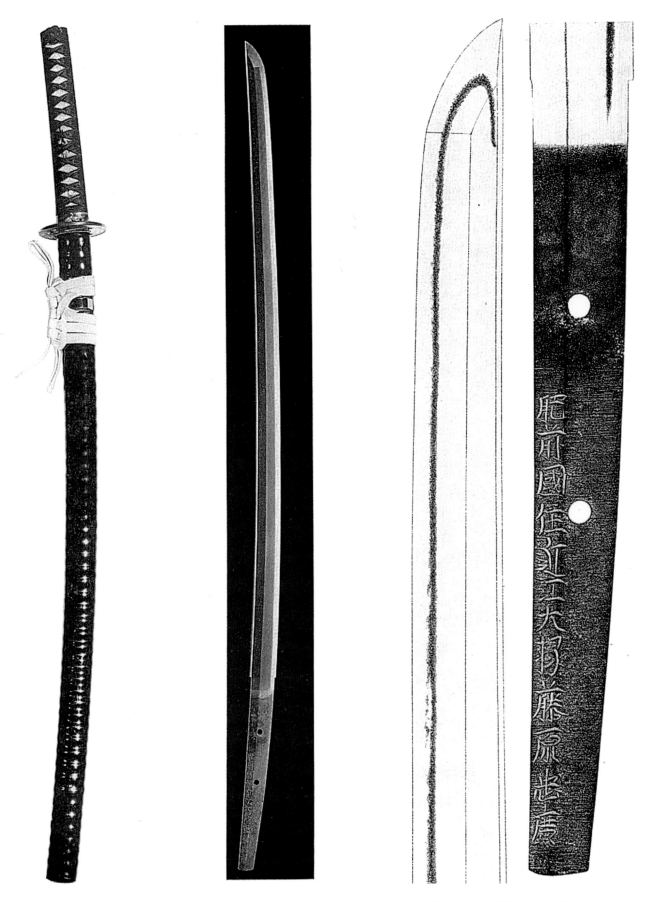

swordsmiths. Yukihiro went up to Edo and studied under Shirobei Noriyoshi of the Ishido school, which was a descendant of Ichimonji.

Nagasaki is within the borders of Hizen Province and

this was the only center of foreign influence in Japan throughout the Tokugawa period, when the rest of the country was closed to foreigners. Through Nagasaki, it appears that some import of foreign iron took place and

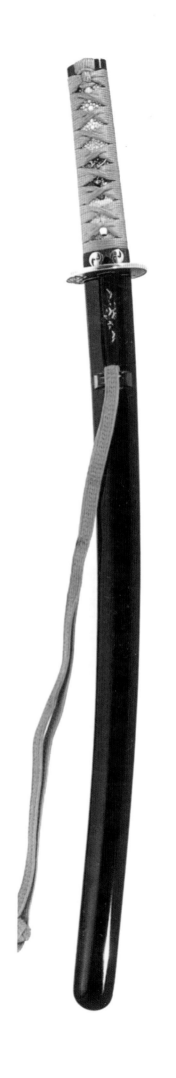

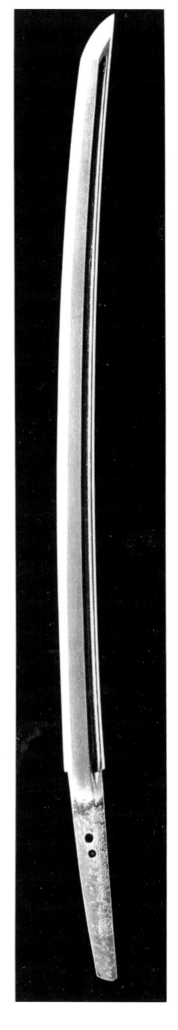

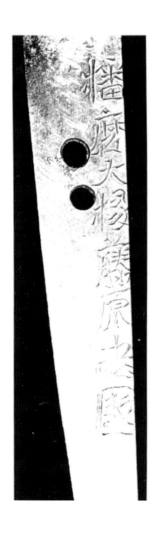

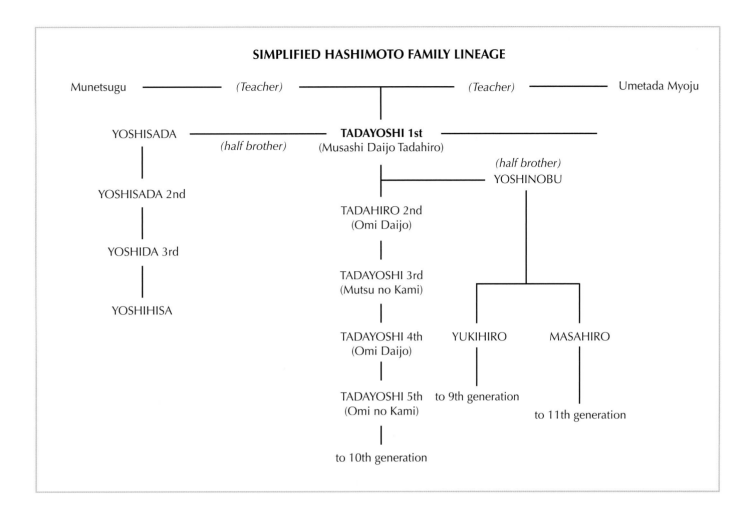

SIMPLIFIED HASHIMOTO FAMILY LINEAGE

was used by some swordsmiths throughout the country, becoming quite fashionable. This may be borne out by inscriptions on *nakago* such as *Nambam Tetsu Saku* (made with Southern Barbarian iron—ie, foreign iron).

The first generation Yukihiro, who was the first Tadayoshi's grandson and brother of Masahiro, often inscribed *Oranda Kitae Saku* on his swords, indicating that it was "forged in the Dutch manner." This swordsmith is known to have gone to Nagasaki in 1650 with two other swordsmiths, Hisatsugu and Tanenaga, to study Dutch methods of making firearms and it is to this that the inscription refers. However, it has been suggested that this may have simply been some kind of marketing or publicity gimmick, since it is difficult to visualize Yukihiro learning any improved sword-making technique in this manner. It would seem that, forever a traveler, he even forged swords in Hiroshima in Aki Province, and this was most likely because he knew

Left The strong, robust shape of this *wakizashi* by the first generation Tadakuni is clear to see, It is accompanied by good *koshirae* and is signed *"Harima Daijo Fujiwara Tadakuni."*

Norifusa, originally from Saga, who was the fief smith in this castle town. Indeed, there seems to have been some kind of affinity between Aki Province and Hizen since a number of swordsmiths moved there from Saga.

Tadahiro, who had gained the title *Omi Daijo* in 1641, died at the age of eighty in 1693. It is known that, during his later years, he was assisted (in much the same way as was his father) by other clan smiths, including the second generation Masahiro whose own father had helped out when Tadahiro was a young man. Tadahiro, in spite of being the first Tadayoshi's son, had never inherited the Tadayoshi name and had always been named Tadahiro. This was the name that most future generations would have while waiting to become the head of the family, at which time they would change their name to Tadayoshi.

The third generation, therefore, became Tadayoshi when he succeeded to the head of the Hashimoto family before his father's death. In fact, the second Tadahiro outlived his son (the third Tadayoshi) who died in 1686 at the age of fifty. There are a number of works

水　舟
日本刀鍛錬のさい焼き入れに使用する水槽であ
つて肥前国忠吉一門が使用していたものである。

と ぎ 石
打ち上げた刀を荒仕上げする足踏み式の回転砥石
であって忠吉一門が使用していたものである。

橋本吉宗桜田町
横尾裕一郎氏寄贈

Above This is the water trough that was used by the Tadayoshi smiths for quenching and hardening their blades. It was rescued and preserved by a swordsmith named Tadayuki, who was a co-worker with the eighth generation Tadayoshi.

extant bearing signatures of both father and son on co-operative works, known as *gassaku*. This Tadayoshi, who received the title *Mutsu (no) Kami* in 1661, is rated as second only to the first generation in terms of skill. Especially appreciated is his fine forging.

As well as the mainline Tadayoshi family and the corollary family lines of the already-mentioned Masahiro and Yukihiro (who received the *Dewa Daijo* title in 1648 and was promoted to *Dewa Kami* in 1663), a fourth important branch was the Tadakuni line of swordsmiths. The first generation of these was the second son of one of first Tadayoshi's younger brother, Hirosada (who had a different mother). Born in 1598, with the personal name of Hashimoto Rokurozaemon, as previously mentioned, Tadakuni was retained as the fief smith by the Ogi family, a branch of the main Nabeshima family, and was granted the title *Harima Daijo* in 1634. He lived a long and productive life and

died in 1691 at the age of ninety-four, although he had been succeeded by the second generation in 1676.

It may be seen from the foregoing that the swordsmiths of Hizen were closely tied by both family and clan obligations. Although this may have been true with other schools in the *Shinto* period, the scale and complexity of the relationships in the extended Hashimoto family are exceptional. Although the mainline Tadayoshi seemed to have had more restrictions placed on their working styles by the clan authorities, and the branch families had greater flexibility, certain characteristics appear common to all. That is to say that the quality and make up of the *hamon* was similar even when its overall shape was quite different (all in *ko-nie*). The *boshi* was nearly always formed by a smooth line parallel to the curve on the point and with a small rounded turn-back (*ko-maru*). Mostly, the branch families produced three different qualities of work— being "top-class" maybe for presentation to a clan elder, "very good" for gifts and presentations, and "average" for the clan's export business.

Above The first teacher of the *shodai* (first generation) Tadayoshi was the priest Munetsugu. The skilled line of smiths worked in parallel with the Tadayoshi line and this photograph, taken in about 1870, is of the ninth generation Munetsugu.

During the middle of the *Shinto* period, around the Genroku era (1688–1703) until about the Anei era (1772–1781), there was little demand for swords throughout the country and for this reason the works of the fourth, fifth, and sixth generations of the Tadayoshi line are quite scarce. There are actually no extant examples known of the seventh generation, who may not have made any swords at all.

The Nabeshima clan had always been somewhat antagonistic toward the ruling Tokugawa clan, having been on the losing side at the definitive Battle of Sekigahara in 1600. Also, their great distance from Edo tended to encourage their rather conservative attitude, and they were termed *Tozama*, or "outer" *daimyo*. At the end of the Tokugawa period (mid-19th century) this manifested itself in their support of the

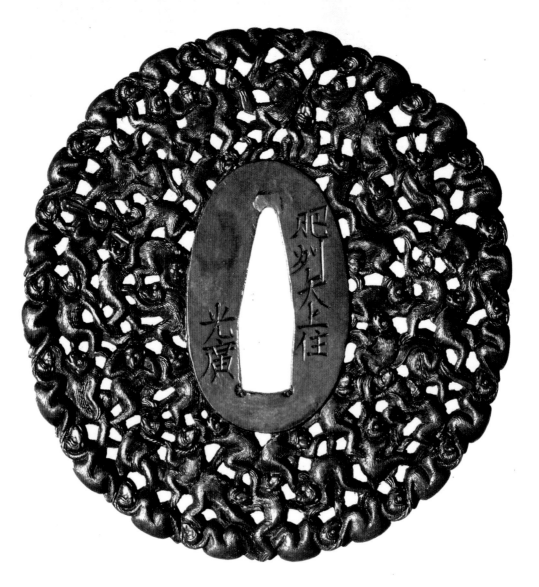

Above, Right and Far Right These three *tsuba* were all made in Yagami, a district of Nagasaki in Hizen, in the early 19th century. There were three generations of *tsuba*-makers named Mitsuhiro who specialized in the "100 monkeys" (left) and "100 horses" (right) decorative metal working. The 100 monkeys *tsuba* at left is in iron and is signed "*Hishu Yagami Ju Mitsuhiro*" (first generation). The 100 horses *tsuba* is also in iron and is signed "*Hizen Yagami ju Mitsuhiro*" (second generation). The center *tsuba*, also showing 100 monkeys, is in *sentoku* (brass), and is signed "*Hishu Yagami ju Mitsuhiro*." The eyes of the subject are highlighted in gold.

imperial cause against the *shogunate* and they played an active role in the restoration of the Emperor Meiji to direct rule.

As a reflection of the perceived danger of foreign invasion, the eighth generation Tadayoshi (adopted son of the seventh generation who died in 1853 and who is widely rated as the third most skillful Tadayoshi), as well as making fine swords, experimented with foreign iron in sword manufacture and undertook cannon production for coastal defenses.

As part of the drive to modernization, in 1871 citizens were banned from carrying swords. Also in this year the death occurred of the contemporary Nabeshima *daimyo* and it may have been these circumstances that persuaded the ninth generation Tadayoshi to give up making swords. Further legislation in 1876 banned the wearing of swords by all but the police and modern army. This brought an abrupt end to sword-making by all but a few stalwarts who saved the art over the next few decades.

The *ku-dai* (ninth generation) Tadayoshi was born in 1832 and was the natural heir of the *hachi-dai* (eighth generation). His personal name was Hyakutaro until he became the head of the family on the death of his father (May 26, 1859). He then adopted the Tadayoshi name and changed his personal name to Shunpei. He was twenty-eight years of age at this time and the majority of his swords are signed with the Tadayoshi

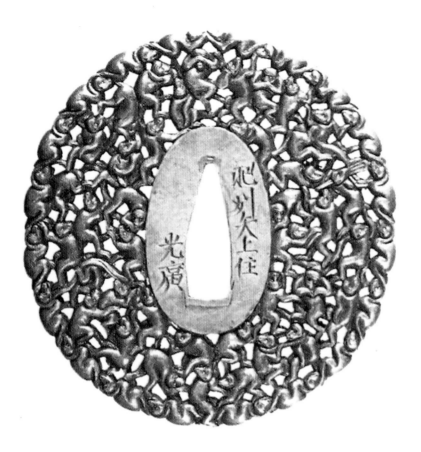

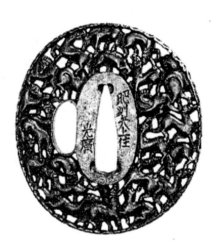

goji-mei of Hizen (no) Kuni Tadayoshi. There is evidence that he made swords with his father, who is generally rated inferior only to the first and third mainline Tadayoshi generations.

It is interesting that Yokoyama Manabu, a well known expert in *Hizen-to*, suggests that the *ku-dai* Tadayoshi, made many more exceptional swords than his father ever did, and that his work is often confused with that of his father. Further, he suggests that *ku-dai* Tadayoshi's high quality work may have been attributed to the *hachi-dai* until quite recently, contributing mistakenly to the latter's reputation and fame.

As previously stated, the ninth Tadayoshi gave up making swords in Meiji 4th year (1871). Many circumstances and events at this time of great upheaval may have contributed to this, including the death of the Nabeshima *daimyo*, the tense political situation, anti-sword legislation, and personal illness. He died at the young age of forty-nine, on December 27, Meiji 13th

year (1880). His workmanship clearly demonstrates that the later mainline generations of Hizen swordsmiths maintained the high standards and reputation of those who came earlier.

Finally, I have a pretty little *tanto*, which is complete with its *koshirae*. From the workmanship, it seems to be a later *Hizen-to*, but it has the *mei* (signature) of the second generation Tadahiro (Omi Daijo Fujiwara Tadahiro). It seems that, in the *Shinshinto* times (1780–1870), the sword business may not have been quite so good for the Nabeshima as it had been previously. Consequently, some swords made in the Hizen forges at this time had earlier famous signatures inscribed on their *nakago*. Unlike the *Dai Saku* and *Dai Mei* of earlier times, even though they are well made and are real *Hizen-to*, the motivation was for profit and they are, therefore, classified as *gimei* (false signatures) and fakes. It is easy to be fooled by such things, as I was when I bought the *tanto*!

The Modern Japanese Sword from a Western Perspective

It was the new imperial government, with the Hitorei edict of 1876, that finally banned the wearing of the Japanese sword by all but the police and the new conscript army. In spite of Saigo Takamori's futile Satsuma rebellion in the following year, a large motivation for which was the erosion of *samurai* privileges, the ban remained. It was the wearing of the *daisho*, or pair of swords, that had defined the *samurai* since the beginning of the Edo period over 250 years previously; without the swords, the *samurai* ceased to exist as a social class. Swordsmiths became redundant overnight, although many had seen the ban coming and taken up making kitchen knives and agricultural implements. Similarly, makers of fittings such as *tsuba* were hard hit by the new legislation and were forced to diversify.

In the years of the late 19th century, very few swordsmiths could earn a living exclusively from forging blades, and the few that did usually made copies of *koto* (old swords) for the collectors of the time. A very few were even commissioned by the foreigners who lived in the so-called Treaty ports of Yokohama and Kobe. Although the Emperor Meiji was a patron of the sword and appointed *Gassan Sadakazu* (the first generation) and Miyamoto Kanenori to the status of "*Teishitsu Gigei*" (the equivalent of today's *Ningen Kokuho*— "Living National Treasure") few orders for swords were made until the militarists began to take hold of Japan in the Taisho and Showa periods.

It was only then, in the 1930s, with the rise of military fascism, that the *gunto* (army sword) was popularized. Its dimensions were generally regulated to about 2 *Shaku* 2 *Su*, (approximately thirty inches). The swords of the *Nihon To Tanren Kai* of the Yasukuni

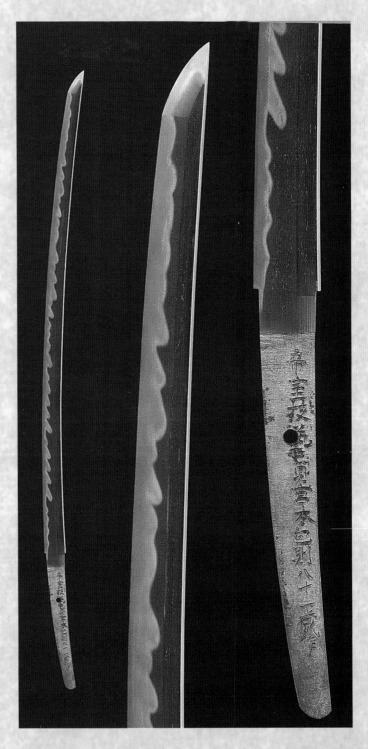

Above Miyamoto Kanenori (1831–1926) made this sword in 1910. The inscription includes the words "*Teishitsu gigei-in*," stating that he was an "Imperial craftsman." (*Courtesy of the British Museum.*)

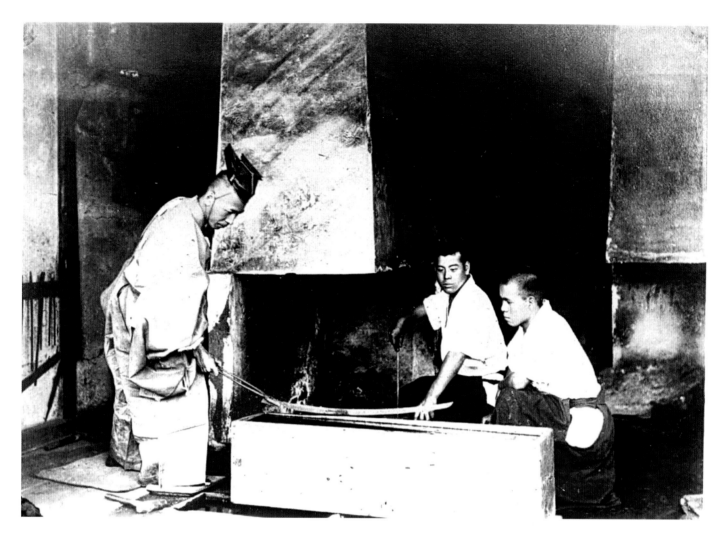

Above Photographed around Taisho 10th year (1921), Kasama Ikkansa Shigetsugu quenching a blade in the process of *yaki-ire*, watched by his two students, on the left Miyaguchi Toshihiro and on the right Sakai Ikkansai Shigemasa, both of whom would become accomplished swordsmiths.

Shrine in Tokyo, together with the swords of the *Denshusho* (see below) and those of Horii Toshihide from Muroran and Kasama Ikkansai Shigetsugu, are among the best and most representative of the pre-Pacific War Showa period (i.e. 1926–1941). Such traditionally forged and water-quenched blades are known as *gendai-to* (modern swords).

Especially worthy of mention here is Kurihara Hikosaburo, a politician in the *Diet* (Japanese parliament) who was most influential in promoting Japanese swords. An amateur swordsmith himself, using the art-name of "Akihide," he founded the *Nihonto Tanren Denshusho* (The Japanese Sword Forging Academy) in the Akasaka district of Tokyo, and organized many sword displays and exhibitions.

Most of the swordsmiths and students at the *Denshujo* had "Aki" as the first character of their names, as in Akimune, Akifusa, and indeed Amada Akitsugu (today's "Living National Treasure"), who trained there as a young man. Kurihara Hikosaburo died in 1954.

Another character was Toyama Mitsuru, who was a famed ultra-patriot and "godfather" within a secret society. Even in his eighties he assisted in sword-making as a *sakite* (hammerman assistant) and swords were frequently made on his Tokyo estate. It was people such as those mentioned here who helped to set the firm basis for postwar sword-making.

Also in this period and throughout the Pacific War (1941–1945), poor quality swords were mass-produced as weapons for the Imperial Japanese Army and Navy. All officers were required to carry a sword as part of their uniform and to inspire them with a sense of *bushido*. But, as always in Japanese history, when there was a massive demand for swords, quality was the first casualty. These swords were often made by hastily

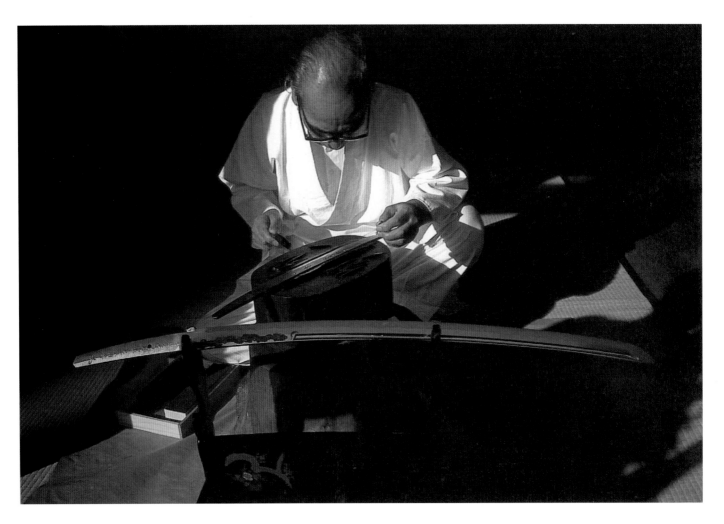

Above The late Gassan Sadaichi, formerly a Living National Treasure, carving a *horimono* for which his family are justly famed.

recruited blacksmiths, who had but a rudimentary knowledge of sword-making and who appeared "*like the sprouting of bamboo shoots after the rain.*"

Unlike the previously mentioned *Gendai-to*, such swords have little or no artistic merit. They often carry a stamp with the *kanji* "SHO" from Showa, or the *kanji* "SEKI" after the town that was the main production center. Such blades are usually signed in a very loose and unattractive manner, and the *nakago* are generally poorly finished.

On these blades a *hamon* (hardened edge) may seem to be present. However, on *Showa-to* it is produced by quenching the blade in oil rather than in the traditional water. The use of oil allows the quenching process to be carried out at a much lower temperature, thus avoiding the risk of flaws such as *ha-giri* (edge cracks) appearing. The "*hamon*" thus produced is not a true or

real *hamon* but only a pale imitation. With the lack of proper materials and short-cuts in the forging process, it is difficult to call these blades, known as *Showa-to*, true Japanese art swords. Such swords are often collected by those whose interest lies in Japanese militaria and the military history of this period.

When the occupying forces came to the Japanese homeland in 1945, the making of Japanese swords, as well as the practice of the martial arts, were banned in order to democratize Japan and remove the militaristic influences of the recent past. Many outstanding and important swords were either looted or destroyed by the occupation forces. No distinction between those swords with artistic and historical merit and *Showa-to* were made, and so valuable and historic swords were lost forever through ignorance.

It was not until several years later (1949) that there was any easing of this ban. The occasion was a special dedication to the Ise Grand Shrine, which takes place every twenty-five years and had done so for the preceding thousand years. For this ceremony about sixty

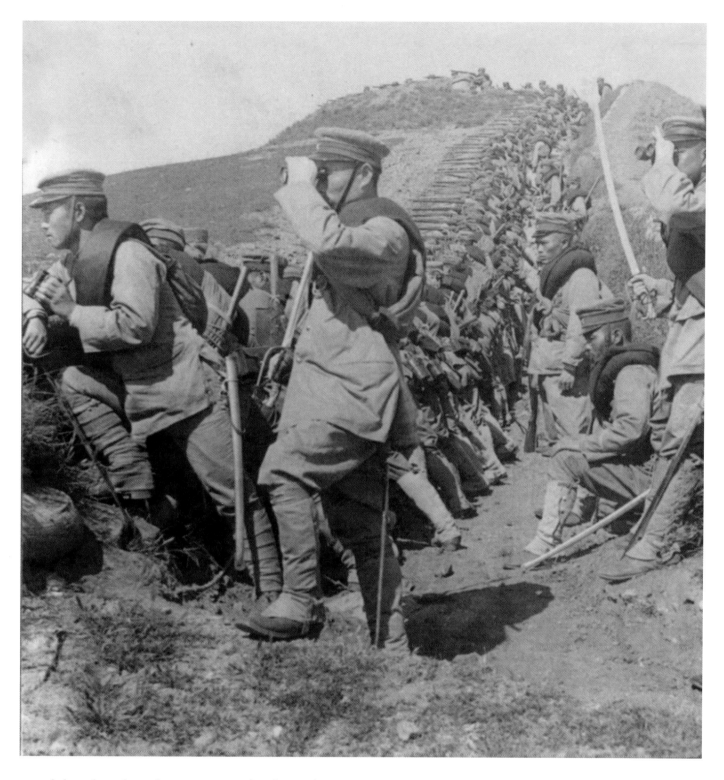

Above Japanese forces entrenched in Manchuria during the Russo-Japanese War of 1904–1905, anticipating an attack by Russian cavalry. Note the swords worn by officers.

swords by selected smiths were required to be made and permission was granted for this to be done. These swords did not have the normal curved shape but were of the ancient style known as *kiriha-zukuri chokuto*. Some measured from 31.5 to 37.8 inches in length.

It was, of course, a great honor for the swordsmiths, who were allowed to resume their craft for this special occasion. They included Miyaguchi Toshihiro, Takahashi Sadatsugu, and Miyari Akihira (the latter two were subsequently made "Living National Treasures") as well as Ishi Akifusa, Nigara Kunitoshi, Endo Mitsuiki, and Sakai Shigemasa. Sato Kanzan Sensei stated that the 1949 ceremony was the first important stimulus given to the swordsmiths of Japan in the postwar period.

In 1953, a new law allowed the resumption of sword-

Above A blade by Kasama Ikkansai Shigetsugu, who died in 1964. Especially fine is the *sugata*, or form, of this sword, which was made as a special order on the estate of Toyama Mitsuru in 1939.

Left Two of the great patrons of the Japanese sword in the early Showa period. Holding the sword is Kurihara Hikosaburo, together with the ultra-patriot Toyama Mitsuru.

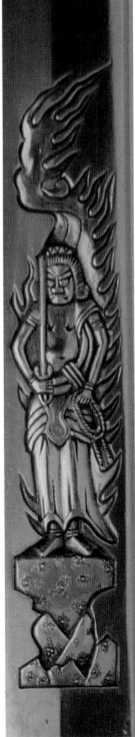

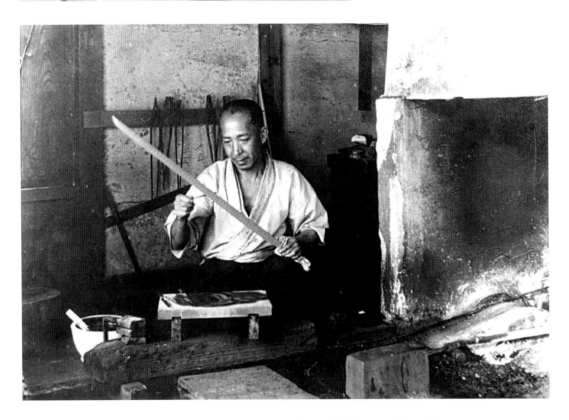

Above Photographed in about 1930, the master swordsmith Kasama Ikkansai Shigetsugu prepares a sword for quenching by applying the clay in the process of *tsuchi-oke*.

Right Skillfully carved by Ikkansai Kasama Shigetsugu, this is a *horimono* of Fudo-kaen. Fudo is a Buddhist divinity who holds a rope in his left hand to bind the demons and a sword in the other to punish them. He was considered to be the patron saint of swordsmen.

Above Amada Akitsugu in a tense and dramatic moment as he is about to quench a sword in the process of *yaki-ire* that will produce the *hamon*. A mistake now might mean that all the previous work was wasted.

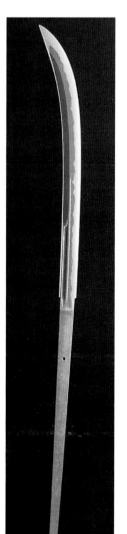

Left A *tachi* blade with *suguha hamon* and a *bohi*, which finishes in the *nakago*. It is by the Living National Treasure swordsmith and is signed *"Amada Akitsugu Saku."*

Right The "Living National Treasure" Amada Akitsugu, who is still an active swordsmith, at his forge in Niigata.

making, and the *Nihon Bijutsu Token Hozon Kyokai* (The Japanese Art Sword Preservation Society—the NBTHK) was formed in 1960. The crisis had passed and the Japanese sword was saved from complete destruction. Today the NBTHK does much important work, which includes the operation of a smelter, or *tatara*, that produces the raw material (called *tamahagane*) for forging a sword, the running of the Japanese Sword Museum in Tokyo, and the organizing of the various artisans' annual competitions.

Another important function of the NBTHK is to foster communication between various artisans of the Japanese sword. This is quite different from earlier times when schools of swordsmiths jealously guarded their manufacturing secrets. After World War II virtually an entire generation of swordsmiths was lost and the survivors had to communicate with each other in order for the arts to survive. In Showa 30th year (1955) the first postwar competition and exhibition of *shinsaku-to* (literally, "newly made swords") was held.

Apparently the quality of pieces submitted was, understandably, not particularly good at this time.

The annual contest organized by the NBTHK covers many aspects of the arts of the Japanese sword, including sword-making, blade polishing, scabbard-making and metalworking. These competitions, as well as giving swordsmiths something to strive for, serve to give the Japanese collector or customer for a sword the confidence of having instant provenance from a recognized and successful artist. When blades are entered for the competition they are all ranked from the

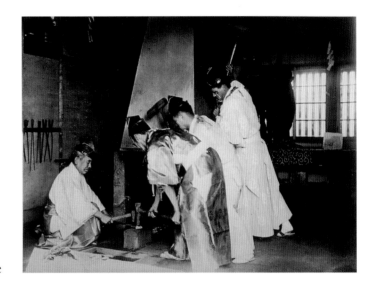

top to the bottom. This ranking is very important since it gives relative values to each smith's work for the next year. When a swordsmith has consistently ranked in the top few, he is awarded the rank of "*Mukansa*." This means that a *Mukansa's* work, although entered into the competition, is not subject to being judged. Above the rank of *Mukansa* is that of *Ningen Kokuho* ("Living National Treasure"). Currently, two swordsmiths who were previously *Mukansa* hold this rank, being Amada Akitsugu and Ozumi Toshihira.

In the modern age the Japanese sword had lost all its purpose as a weapon of war. Consequently its artistic rather than practical properties, which had always been appreciated by the knowledgeable and educated Japanese, now began to be emphasized even more. However, most of the properties of a good sword may be traced back to the sword's traditional role as a weapon. A sword must be of good shape and balance,

Above Swords were made at the the Yasukuni Shrine between 1933 and 1945, as shown here. Known as *Yasukuni-to*, they are of a much higher standard than many others made at this time and are highly valued by Western collectors.

Left An *oshigata* of an early 20th century blade by Munemitsu, also carved with the name of *Shumpukan* (Hall of the Spring Wind). This refers to a poem by Basho, which likens the cutting action of the Japanese sword to the "flash of lightning in the spring wind." It is an emotive name in Japan and is the name of many *Kendo dojo*. (*Oshigata* by the author.)

Right The first swordsmith to be designated Living National Treasure was Takahashi Sadatsugu, who was given this award in 1955, two years after the resumption of sword-making after World War II.

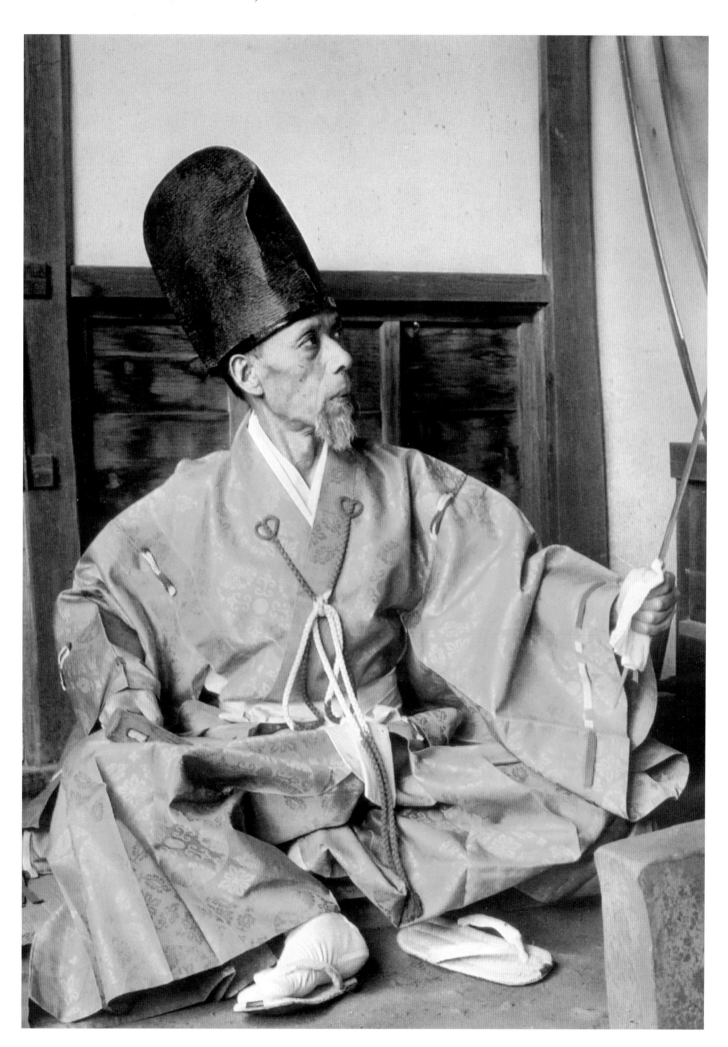

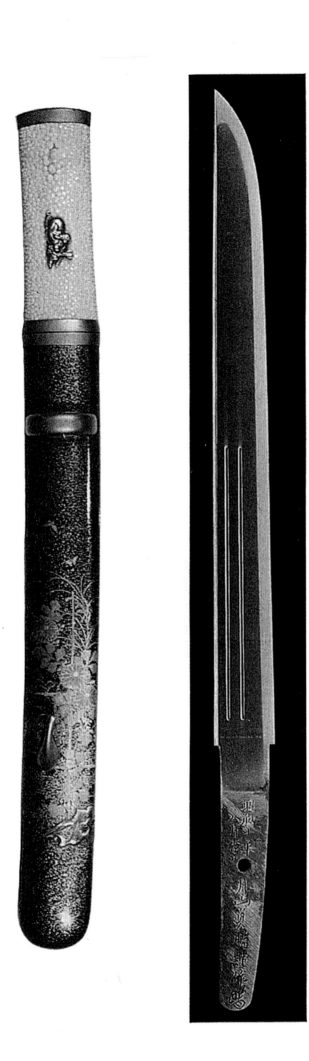

Below A *tanto*, complete with *koshirae* by the early Showa head of the Gassan family, Sadakatsu, dated Showa 10th year (1935).

Right A *tanto* by Takahashi Sadatsugu who, as stated in the inscription, also carved the *horimono*. The sword is dated Showa 35th year (1960).

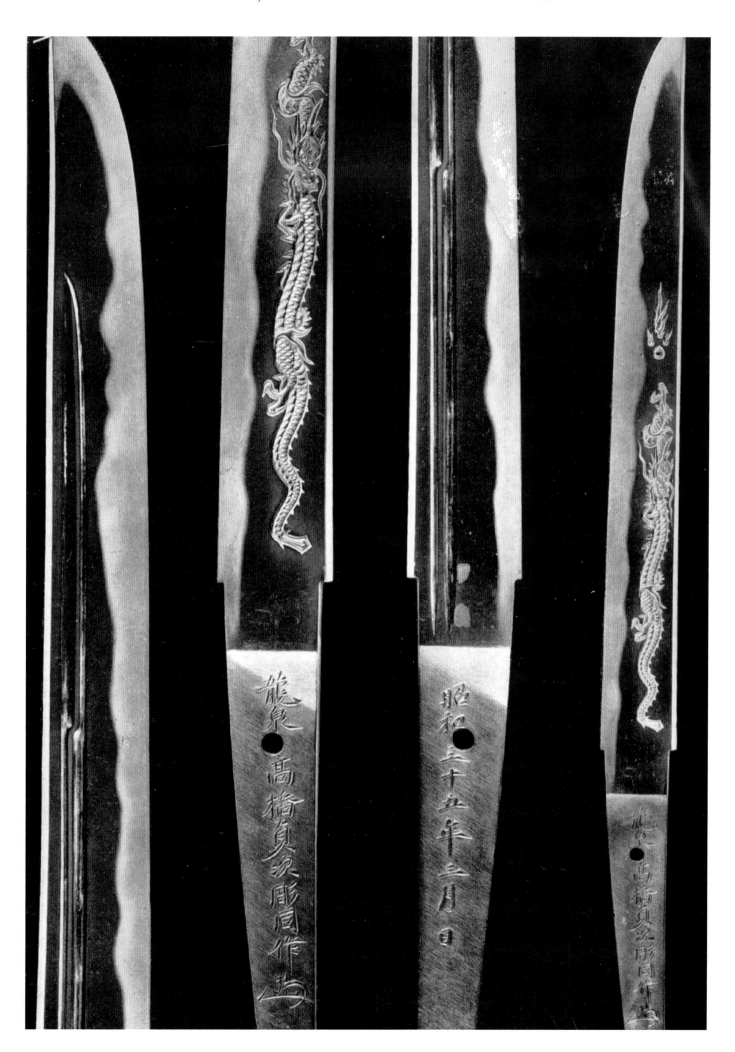

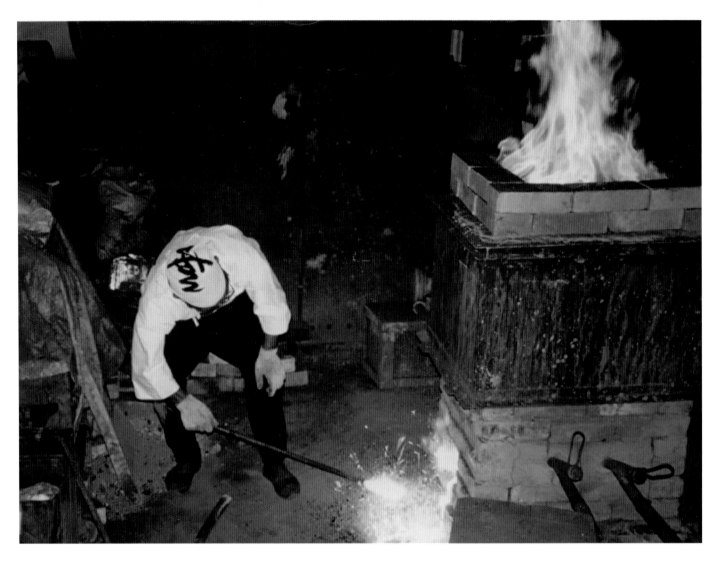

Above A few swordsmiths prefer to build their own *tatara* or smelt to produce their *tamahagane*. This one is at Amada's forge in Niigata.

be made of good steel, have flexibility and a sharp edge, as well as being attractive to look at in detail.

During the Tokugawa or Edo period, many swords were submitted to cutting tests to see if they measured up to these standards, and some testing took place in the earlier Showa period. A few years ago, the *Mukansa* swordsmith Yoshindo Yoshihara was challenged to make a sword that would be severely tested on live TV and he did so. The sword that he made was of a robust construction and in the Bizen *choji-midare* style. The tester, Mr. Kawabata, *kendo* consultant to the NBTHK, agreed to cut an old Japanese metal helmet in what was known as *kabuto-wari*. The test was successful and cut deep into the helmet in what would have been a fatal strike had it been worn at the time. Afterwards the

blade was examined and, apart from slight scuffing, it remained intact. It had proved the integrity of this modern sword and the skill of the swordsmith. Events such as this and the annual competitions, as well as shows put on by various commercial and retail outlets, have helped to greatly improve the standard of *shinsaku-to* since 1954.

Swordsmiths are licensed by the government and are allowed to make no more than two long swords per month. This number was arrived at by observing the swordsmith Akihira Miyari who apparently was a slow and methodical worker who would produce only two good swords in a month. Many swordsmiths and artisans that I have spoken to believe that this is a very low figure and many present-day swordsmiths would be quite capable of producing more than two swords

Right Honami Kishu, a member of the old family of polishers and appraisers.

Above Kawabata *sensei* makes a spirited cut in the *kabuto-wari* sword test on live TV. The sword was made by the popular sword-smith Yoshindo Yoshihara.

Right The highly talented swordsmith Fujiyasu Masahira, who always dresses in a traditional manner.

per month. This rule is also designed to prevent the manufacture of cheap weapons with no artistic value. The rules, which are still in effect, are:

1. Only a licensed swordsmith can produce a Japanese sword (any cutting instrument with a blade over six inches, a *hamon*, and a rivet hole in the tang). Edged weapons less than six inches in length and lacking a rivet hole are considered knives, or *ko-gatana*, and are not subject to regulation. A license may be obtained only by serving an apprenticeship under a licensed swordsmith for a minimum of five years.

Above The swordsmith Ono Yoshimitsu on a recent visit to London. He is known for his constant study of the National Treasure sword named Yamatorige, which he has reproduced many times. He studied under the Yoshihara brothers, Yoshindo and Shoji.

2. A licensed swordsmith may produce a maximum of two long swords (over two feet) or three short swords (under two feet) per month.

3. All swords must be registered with the Agency of Cultural Affairs.

Today, most newly made swords (*Shinasku-to*) are sent straight to the polisher, *habaki* maker and *shira-saya* maker, although some are mounted in modern *koshirae*. Many swords are now made in the Bizen style, which is popular with Japanese collectors. I was fortunate to see Sumitane Masamine's (now deceased) *Ichimonji-utsushi* (copy of the old Ichimonji school) when he visited London several years ago. This sword had a very flamboyant *choji midare hamon* in the style of the Kamakura period Fukuoka Ichimonji school, and it may be that this "National Treasure" swordsmith's skill in *Bizen-den* influenced many other younger swordsmiths of the time. Today, similar influence has been exerted by Amada Akitsugu's swords in particular.

When looking at such swords we may search for and sometimes actually see *utsuri* (a kind of reflection of the *hamon* in the surface of the blade). It seems that in the challenge to equal the swords of bygone days, the quest to reproduce *utsuri* is very important. Although a kind of *utsuri* may sometimes be found, to me this often resembles the *shirake utsuri* of Muromachi period Kaga or Sue Seki blades, or *shinshinto utsuri* and only very few are able to produce a convincing Bizen *midare utsuri*, for instance.

This postwar period has been compared to the

renaissance of Japanese swords that heralded the advent of the *Shinshinto* period in the late 18th century. There are some valid comparisons. Both periods followed a decline in Japanese sword production and both periods seek to recapture past glorious ages of the Japanese sword, as well as innovating great changes in production methods. I think the current changes in sword-making are at least as drastic as these earlier changes, and possibly more significant. I hope they will not be accompanied by the same eventual decline and that today's artists manage to train sufficiently skillful students who are able to preserve and continue the arts.

It seems that the Japanese sword establishment is still a very conservative body and that many of the older generation believe it is impossible for foreigners to really appreciate the Japanese sword, since it is a peculiarly Japanese cultural asset. When I started collecting swords in the mid-1960s very little information was available to foreigners who could not read Japanese. There was also a feeling that those few who had any knowledge would jealously guard it and not pass it on. I have never been sure whether this was because they were never confident about their facts and did not wish to be "exposed," or whether it was considered commercially sensitive information. Either way, it was an unhealthy and secretive attitude that pervaded.

Fortunately today, within the younger generation of sword people from Japan, many of whom have traveled abroad and been exposed to Western collectors, there is a far less conservative attitude, as well as a great deal of information available through useful and informative translations, the internet, and other cultural exchanges. A significant number of prestigious museum exhibitions, both in Europe and the USA, are good examples of genuine Japanese friends co-operating with foreigners to bring the beauty of the Japanese sword to a wider audience.

At least one person from the West, sadly now dead, became a qualified swordsmith after serving a Japanese

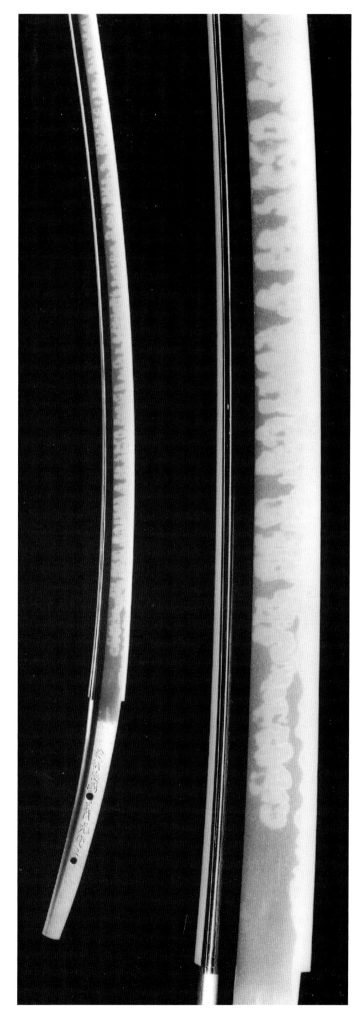

Right A copy of *Yamatorige* by Ono Yoshimitsu. The deep *choji hamon* is that of the old Bizen Ichimonji school.

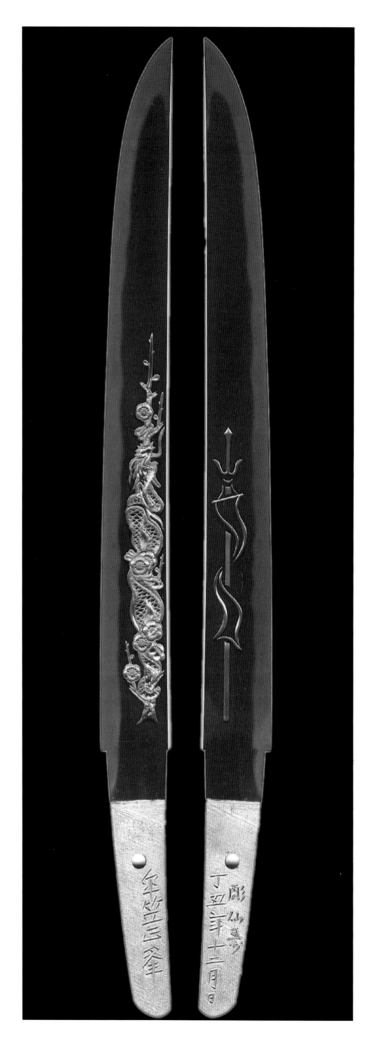

apprenticeship, and it surely cannot be too long before some other *gaikokujin* (foreigner) is entering the annual sword-making competitions. It is no more far-fetched for a foreigner to become a *Mukansa* swordsmith than one becoming a *Yokozuna* in another very conservative and traditional Japanese activity—*sumo*—and this happens regularly. The number of people in the West involved in the making of Japanese swords is staggering. There have been English artisans submitting *tsuba* to the annual competitions in Japan, while there are thriving polishing businesses both in Europe and the USA. Expert lacquer work is also being done in Europe, as are the making of *habaki* (blade's collar) and *shira-saya* (scabbards), and *tsukamaki* (handle wrapping), while sword dealers and *kendo/iai dojo* abound.

Shin-ken

So-called *shin-ken* are modern swords that are made for *iai* practice and are sold complete with *koshirae*. A swordsmith must be registered and is allowed to make only two swords per month. Such a limited production level means that blades by the top swordsmiths (*Mukansa* level and above) are in limited supply and high demand. Consequently, they are also very expensive, costing in excess of US$15,000 for a blade (extra for the *koshirae*—sword furniture or mounting). Of the *shin-ken* that I have seen, most are not particularly attractive from a visual point of view since they tend to be crudely forged by semi-professionals or amateurs. They have poor *jihada* (surface pattern) and the *nie* (martinsite crystals that make up the *hamon*) are coarse, dark, and untidy, and often the configuration of the *hamon* lacks form and control, while any activities seem to be unnatural or forced. The *koshirae* have poor quality metal mounts and often cheap cast *tsuba*, while the *saya* are seldom properly lacquered.

Having said that, they are perfectly adequate for the purpose for which they were bought, but it would be unwise to consider them as art swords. In *iai-do*,

Left The fabulous and very detailed *horimono* on this *tanto* were carved by the swordsmith himself, the late Sumitane Masamine

92

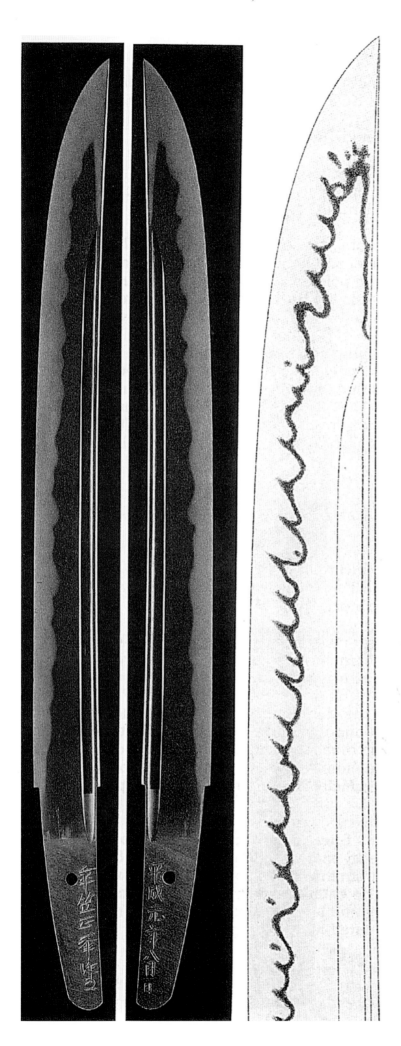

Left and Above Another *tanto* with *saka-choji* (slanting) *hamon* by the late Sumitane Masamine. The blade is dated Heisei Gannen 1st year of Heisei (1989).

Above A fine modern *aikuchi-tanto koshirae*. There are a number of skilled makers who are determined to preserve this traditional craft.

Above The late Haruna *sensei*, 8th Dan *iai-do* in competition, performing a *soete-tsuki* (thrust) using his high quality *shin-ken*.

with the blade being constantly handled and at risk of damage, there is no requirement to have a good and expensive blade, but I would have my doubts about their survival should any actual cutting with a *shin-ken* be attempted.

In the international Japanese sword market, a price of "only" US$4,500 to US$6,000 buys very little, and these seem quite high prices for a *shin-ken*. To put *shin-ken* into perspective, they may be compared with those swords known as the *kazu-uichi-mono* (literally things made in numbers) that were made in the 16th century for purely practical reasons. This is further complicated by the existence of convincing replica swords now being produced in China.

As the *shin-ken* represent a not inconsiderable investment and *iai* people are persuaded to buy these types of swords by the *sensei*, it is interesting to recall a parallel discussion being conducted as the new millennium dawned in Japan. I had been involved in helping to translate a sword book from Japanese. This book was trying to show how the Japanese sword community would progress into the 21st century and the format was a series of interviews with active swordsmiths, polishers, dealers, and collectors, as well as discussions between these individuals.

One of these interviews was between a young swordsmith and a *kendo* and *iai* teacher of some repute. The *kendo* teacher seemed to be rather conservative in his views, even to the extent of abhorring the use of

Left The outstanding modern swordsmith Matsuda Tsuguyasu, demonstrating *mei-kiri* (name carving) at the annual sword show, Dai To-ken Ichi, in Tokyo.

carbon-graphite *shinai* (practice swords, normally made from bamboo) and nylon *hakama* (traditional dress) as not being traditionally Japanese enough for him. He also recounted that in a warm-up practice before a major demonstration at the Butokan in Tokyo, he and his students between them broke no fewer than twenty ordinary *bokuto* (also wooden swords) that were inferior to the ones they made themselves. He is obviously quite serious about his *kendo*.

The swordsmith, from Chiba-ken, recalled that he was asked to make *iai-to* for a *sensei* but the *sensei* was very specific about the sword he required. He pointed out that a Japanese sword should not be made with just one thing in mind (such as a stout blade for *tameshigiri*, or a lightweight one for *iai*): all swords should be able to meet all the requirements demanded

of them, he argued. The *kendo sensei* demonstrated the inadequacies of the swordsmith's first attempt, with his permission, by testing the sword to destruction on a metal bar. The swordsmith, who needed the work, felt that, by making *iai-to* for this *sensei* and his students, he had to compromise his high standards from the "art swords," which he really wished to make. However, it is estimated that of all swords made in Japan now, only twenty percent are truly "art swords" and the rest are probably made for the booming *iai* practitioner's market. This is incredible, since it means that much of the prosperity of the Japanese sword community in Japan is reliant on swords made for *iai*. Of course, this is only an informed estimate and takes no account of the trade in antique swords, which is arguably very large, although pretty slow at the moment and subject to economic fluctuations.

However, if more swordsmiths see their bread and butter coming from the martial arts, then this may have serious consequences for the quality of the work they produce. The quality of so-called *shin-ken* made for *iai* is universally seen as lower than that for the art swords. It is felt, therefore, that both the swordsmiths and their customers must compromise, and the quality of *iai-to* must be raised. Although, even now some buyers may pay five-figure sums or higher simply for the blade of their *shin-ken*, this may become the norm rather than the exception as we progress through the 21st century.

I find it difficult to envisage *iai* people paying heavily for their *iai shin-ken* but, unlike the current *shin-ken*, these would be more likely to be appreciating

Below A selection of "false swords," the tools of *kendo* and *iai-do* practitioners. Top to bottom: a blunt reproduction of an *iai* sword, known as an *iai-to*, together with its scabbard; then a large (*bokken*) sword and a small (*ko-dachi*, *bokuto*) sword, both in solid wood, used in *kendo* and *iai-do*; then a *ko-dachi shinai* (small bamboo *shinai*), followed by a fullsize bamboo *shinai*; then a modern carbon-graphite *shinai*; and finally a large, heavy *saburi*, or practice wooden *bokuto* used to develop stamina.

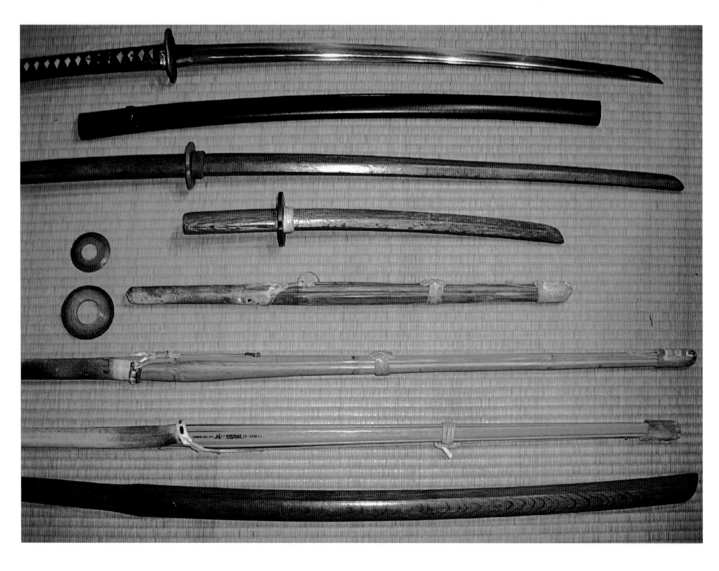

Above The Japanese Sword Museum in the Yoyogi district of Tokyo is the headquarters of the NBTHK—Nihon Bijutsu Token Hozon Kyokai/ the Japanese Sword Preservation Society. The NBTHK holds annual competitions for sword-and *tsuba*-making, as well as polishing. It also conducts regular *shinsa*, or sword appraisals, and its exhibitions are always worth visiting. Many serious sword collectors in the West are members of the NBTHK.

assets rather than diminishing ones. The Japanese *sensei* mentioned above, who practices certain *kata* forms where the swords of both practitioners actually clash with force, says that he must have complete confidence in his sword, and such blades cannot be made too cheaply. Such demands are important since they force the swordsmith to keep the practical functions of the sword in mind when making a blade, so that the finished object maintains its integrity as a sword. They act as a discipline, especially as far as the *sugata* (shape) of the sword is concerned, as well as the correct formation of the *hamon*.

Fine old swords are around today only because they have been looked after and carefully preserved by many generations of previous owners. To think they may have come to their final resting place in the hands of a *gaijin iai* practitioner is too awful to contemplate. Stories abound about accidents and damage to swords in *iai* practice, and to cause irreparable damage to an old blade would be a tragedy. At least modern *shin-ken* are replaceable.

The NBTHK today

Since it was formed several decades ago, in the troubled times following Japan's defeat in the Pacific War, the NBTHK has provided both Japanese and western collectors with far more than simply a *shinsa* (judging and appraisal) service that issued their so-called "papers." Apart from its original function during Japan's occupation by the Allies, of saving as many "art swords" from destruction as possible, it has evolved and expanded. Unfortunately, this expansion has also included an increase in the bureaucracy, common with many aspects of life today, especially in Japan.

One of the NBTHK's many important functions

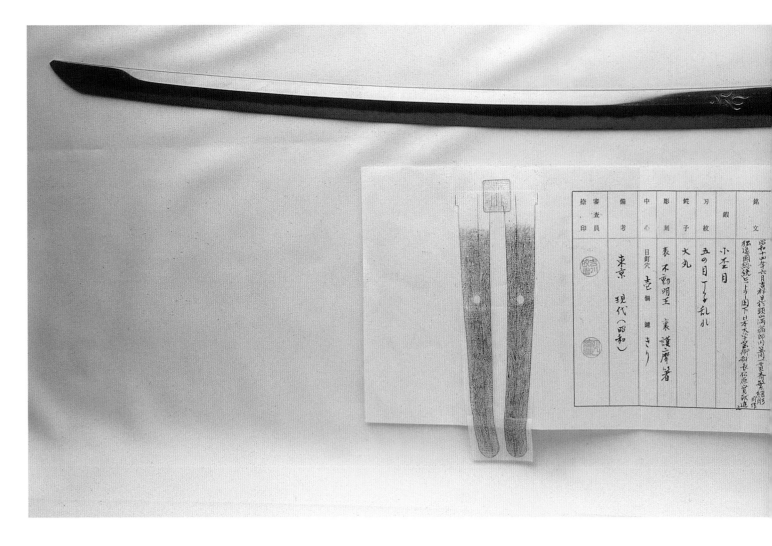

today is the operation of the *tatara* (furnace) at Shimane. This provides *tamahagane* (raw material for sword-making) for all Japan's registered swordsmiths who require it. The operation of the *tatara* provides this material in the traditional manner and so preserves an ancient tradition.

Today's swordsmiths co-operate with each other to a far greater extent than in the prewar period, and especially unlike during the pre-Meiji Restoration times. It was the NBTHK that provided a structure in which this co-operation was able to manifest itself. This was done mainly by organizing competitions for sword-making and other associated cultural pursuits. There is no doubt that the encouragement and opportunities that the NBTHK have given to a variety of artisans, including fittings makers, *saya* makers, polishers, hilt wrappers, and *habaki*-makers, as well as swordsmiths, of course, have saved these traditional arts from extinction by neglect. In particular, this encourages a younger, postwar generation to appreciate and learn

Above This is a typical certificate issued by the NTHK (actually in New York in 1997, in respect of a *gendaito*), authenticating that a sword has been judged by experts in a *shinsa* and been given their official written appraisal.

about Japan's cultural past, a difficult task in modern Japan's "Playstation" society.

It cannot be denied that the commercial aspects of Japanese swords are always a consideration, but they have been since ancient times. Was it not the Tokugawa *shogun*s who regularly rewarded meritorious service with gifts of swords? They certainly were not the first.

All the swords entered into the *shinsakuto* annual competition are graded from top to bottom, establishing each swordsmith's ranking in the list for the forthcoming year. This is bound to have commercial implications relating to the price he can charge for his work. This also applies to a greater or lesser extent to other artisans, such as polishers. There can also be no doubt that striving for higher status, such

kanji

as reaching *Mukansa* levels, improves technique and results in a higher quality of workmanship.

Another well-known function of the NBTHK today is to run the Japanese Sword Museum at Yoyogi, Tokyo, in which many fine swords are stored. The museum profiles both old and new swords with a more or less continually changing display, and it certainly provides something of a Mecca to any western collectors visiting Japan. The museum is also a convenient venue for holding workshops for many aspects of Japanese sword conservation and education.

The NBTHK's educational efforts include publishing their monthly magazine, *To-Ken Bijutsu*. A full English language edition was published in the 1970s, packed with great gems of information. Unfortunately, this version of the magazine ceased publication after some sixty issues, due to lack of support from the English-speaking sword world. Thanks to the efforts of the European Chapter of the NBTHK, translations of the up-to-date *To-Ken Bijutsu* are to be had on subscription.

Also open to western collectors, of course, are the fabulous NBTHK conventions, where the chance to see great swords first hand is an opportunity not to be missed.

The question of "papers" issued for swords seems always to be a somewhat contentious subject. The desire for written confirmation of a sword's authenticity by an acknowledged expert is both a natural and traditional thing. Various experts, such as the Honami family whose papers carry great authority, have issued *origami* for centuries. Today, some polishers or other organizations, in addition to the NBTHK, issue various certificates.

These papers, as well as attesting to authenticity, may also be an indication of quality. They are not a substitute for personal research; indeed, it may be construed that submitting a sword, especially an unsigned work, is part of a collector's research efforts. Today, NBTHK papers also fulfill a kind of log book function, having space to fill in ownership and ownership transfer details, and these papers carry great credibility both in Japan and abroad. It is not surprising, therefore, that dealers, especially in Japan, require swords to go through *shinsa* if they have any chance of being being sold to them. If a sword is actually offered for sale without any papers, it must raise questions about whether or not it has in fact failed *shinsa*! While I realise there have been cases of corruption and forgeries of *origami*, a scandal that did much harm to the NBTHK's reputation many years ago, I am confident that the *Hozon* system that replaced the old system, is "clean."

Today, the NBTHK derives its main income from *shinsa* fees, especially *Juyo* and *Tokubetsu Juyo shinsa* (important and especially important swords), which may have long term ramifications since fewer swords are annually submitted. The NBTHK holds *shinsa* solely in Japan, unlike the NTHK (Nihon Token Hozon Kai—Japanese Sword Preservation Society) and the hierarchy may need to reassess this situation depending on how important they feel foreign collectors are. In the meantime, it is difficult to see how the Japanese sword society could function in Japan without the umbrella provided by the NBTHK.

Japanese Polearms

Japanese legend tells us that, one day, when the Earth was still very young, the heavenly deity Izanagi took his spear and approached the primeval soup that formed the world. He dipped his spear into the soup and several droplets coagulated on its blade. These were the same droplets that, when they fell to Earth, formed the islands of Japan. It is said that the Japanese people who came to inhabit these islands realized from this that the spear was a holy weapon of great importance to them, since they owed to it the very formation of their homeland.

The spear is one of the oldest weapons in the world, dating back to cave men who both hunted and made war with it. For centuries it was the main weapon of the warrior, since there were obvious advantages in having a long pole between him and the target. However, the Japanese version was used only by that nation's warriors, and was a reflection of the fighting techniques of those ancient times.

By the early 9th century, the tactics of massed spearmen had been perfected in the battles against the Ainu, the aboriginal inhabitants of the Japanese islands. As sword-making techniques from continental Asia had by now been completely absorbed and improved upon, they were easily modified in the production of *yari* (spears). Principally, the blades of these *yari* were straight (*su-yari*) and of course they had a sharp point, but both of the parallel sides were also sharpened. This indicates that, as well as stabbing or thrusting, the sharpened sides could be employed for cutting or slashing, adding a further range of techniques to the spearman's repertoire.

The quenched and hardened edge that we are familiar with on Japanese swords, known as the *hamon*, was incorporated in the manufacture of *yari*. It will be remembered that the *hamon* is present in order that the cutting edge is able to take and retain a hard and sharpened edge, which has less of a risk of chipping and breaking. The forging also mimicked that of the swords, but significantly the grain of the body of the *yari* (the *jihada*) is usually *masame* or straight-grained. I say significantly, as this is considered a characteristic of the swordsmiths of Yamato Province, and since the 8th century capital of the country was at Nara in that province, it is clear from where the original *yari* makers came.

The *yari*, in ancient times, was the weapon of the lower-class foot soldier and only rarely the favored weapon of the more noble *samurai*. However, in those early days, from about 800 to 1200 AD, another significant military body was a force to reckon with. The importation of Buddhism between 600 and 750 AD attracted many militant warrior monks, known as *yamabushi* (literally, mountain-warriors). The ancient imperial capital of Nara, followed by Kyoto, was the center of this religious movement and many monasteries were built there. As the frontier was moved back, further monasteries were built in the newly acquired territories, and they needed defending. All such establishments enjoyed tax-free status enshrined in an imperial mandate, and such privileges often required spirited defense.

The *yamabushi* were highly skilled in the martial arts and were frequently to be found wearing swords and full armor. They employed and retained skilled

Right *Nippongo*, the most famous *yari* in Japan, with an amazing dragon *horimono*, is part of the Kuroda family's collection.

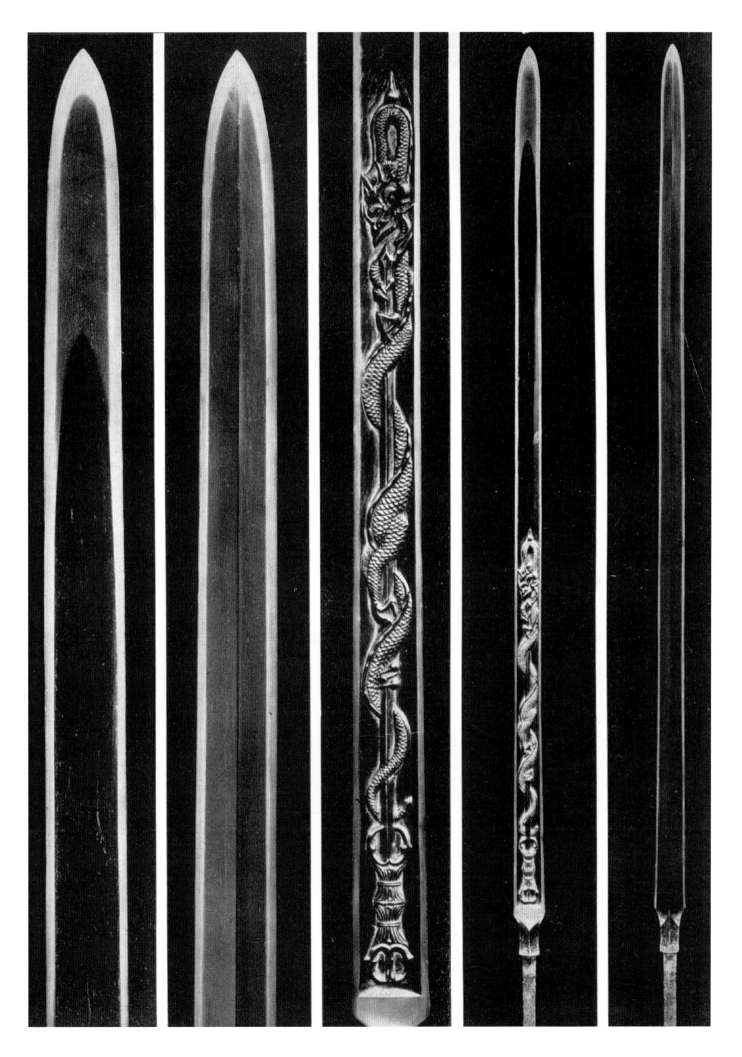

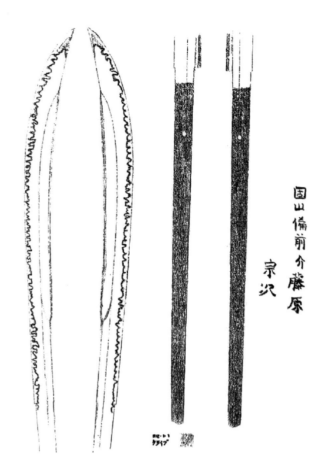

of the *Yamato-den* tradition, as well as those of Bizen Province. A certain technique, whereby a figure of eight was described in a whirling action, was apparently almost impossible to counter at close quarters and gave the users a sense of invulnerability.

The famous story of a monk named Gochima-no-Tajima illustrates this well. The Minamoto warriors were under immense pressure at a river called Ujigawa, which was close to Kyoto, and Tajima was ordered to defend the bridge and prevent the enemy's advance. According to the *Heike Monogatari* ("The Tales of the Heike" or "Taira"): "Gochima-no-Tajima, throwing away the sheath of his long *naginata*, strode onto the bridge, whereupon the Heike fired arrows at him fast

Above *Naginata* by the *shinshinto* swordsmith Koyama Munetsugu, who was the leading swordsmith in the Bizen style during the mid-19th century. This example has been awarded *Juyo Token* status by the NBTHK. (*Oshigata* by the author.)

swordsmiths and virtually all those of *Yamato-den* (one of the five main schools or traditions of sword-making) were retained by these monastic organizations. Such was their prowess in warfare that the *samurai* lords of the time would employ these fearsome warriors. Certainly, in the famous late 12th century Gempei Wars between the opposing clans, the Minamoto and the Taira, both sides employed many warrior monks. Probably the most famous was chief retainer of the Minamoto hero, Yoshitsune, who was the warrior monk Saito-Musashi-bo-Benkei.

The favored weapon of these gentlemen, including Benkei, was called the *naginata*. This was a halberd with a large curved blade and a single cutting edge, mounted on a pole, whose length could vary. Actually, a "*nata*" was an agricultural implement and the addition of the adjective "*nagi*" simply means "long." Of course, these polearms were also made by the sword- and *yari*-makers

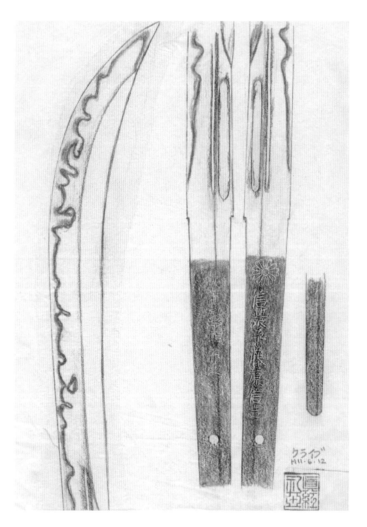

Above Judging from the *hamon*, this *naginata* appears to have been made in Osaka and is signed with a *Kiku* (chrysanthemum) and *Shinanao (no) Kami Nobuyoshi*, probably the second generation. The inscription on the *nakago* also states that it is made of *namban tetsu*—iron from the Barbarians from the south! (*Oshigata* by the author.)

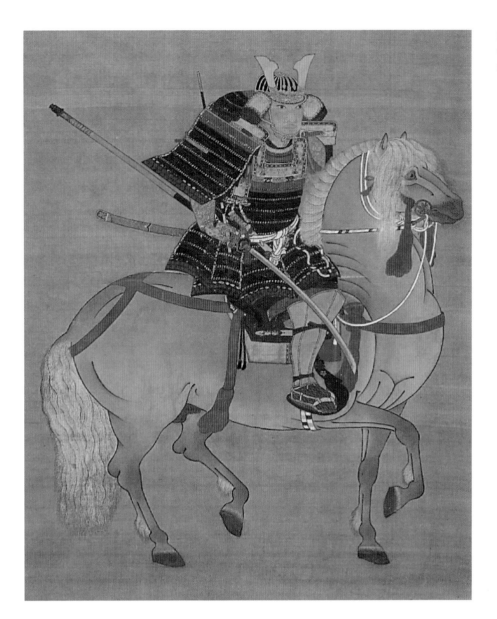

and furious. Tajima, not at all perturbed, ducking to avoid the higher ones and leaping over those that flew low, cut through those that flew straight with his whirling halberd, so that even the enemy looked upon him with admiration. Thus it was he who was dubbed "Tajima the Arrowcutter." The hero Tajima was subsequently represented in many art forms including prints and ivory carvings.

Also used in the Namboku-cho period were *nagamaki*. Essentially the same as the *naginata*, the *nagimaki* tended to have a less exaggerated curve and owed more in shape to the sword. The blades were, therefore, longer and straighter and the pole tended to be shorter. In my own collection there is a 19th century copy of an early *nagamaki* that was made in the Bizen style. This has a twenty-inch blade and a *nakago* (or tang) of equal length. The pole is relatively short and bound like a sword handle for the last part. Unusually, it also has a *tsuba*. The *nagamaki* was said to have been most effective when used to cut a horses' legs and dismount the rider!

The *naginata* and the warrior monks became less important entering the Muromachi period, and the prominence of the *yari* reasserted itself. The monks became less disruptive during the first part of this era, but were known to have caused many problems to Oda Nobunaga in the latter half of the 16th century.

All polearms were of a similar design. At the base was an iron *harumaki*, which, as well as acting as a counterweight to the blade and indeed could be used offensively, protected the base of the pole when grounding it. Some *yari* poles also had a cross-piece known as a *hadome*. This would be used for parrying swords or other spears, or tripping an adversary.

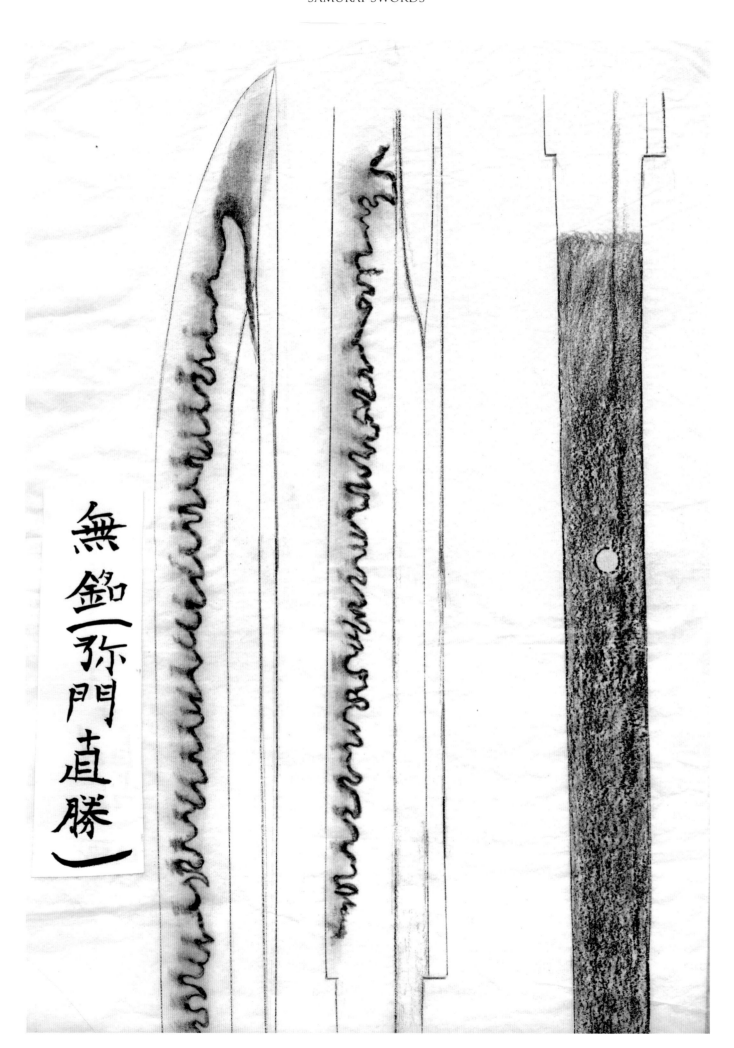

無銘（弥門直勝）

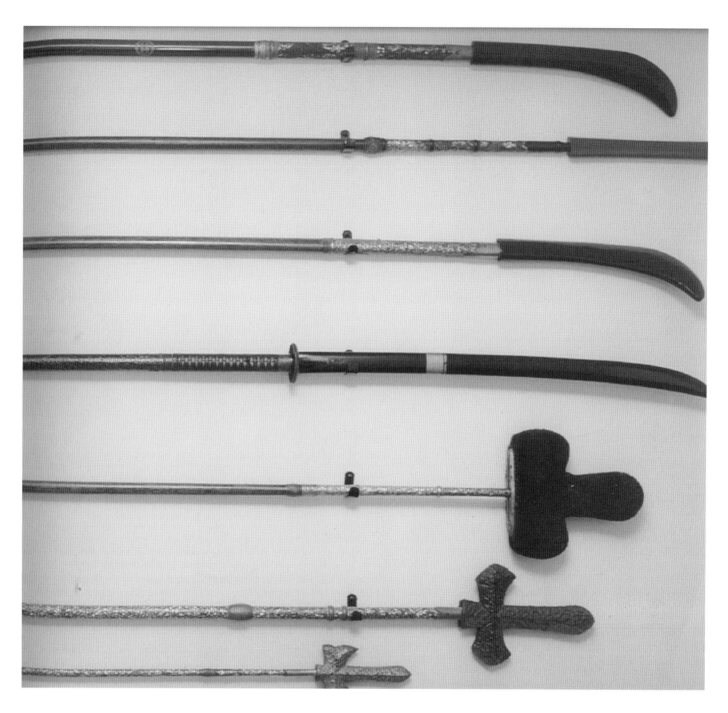

Above This collection of polearms includes two *naginata* (top and third down); fourth from the top is a *nagamaki* that has a *tsuba*; the bottom three are *jumonji-yari*, the top one of which has a bear-fur-covered *saya*.

Left This *mumei* (unsigned) *nagamaki* is attributed by the NBTHK to Yamon Naokatsu. As a 19th century piece it was more likely to be ceremonial than a practical weapon. (*Oshigata* by the author.)

Towards the blade end of the pole was a hand stop made of whipped rattan or hemp cord.

In the following way the famous swordsman Miyamoto Musashi described the essential strategic differences between *naginata* and *yari* in his definitive book, *Go Rin no Sho*:

"The *naginata* is inferior to the *yari* on the battlefield. With the *yari* you can take the initiative; the *naginata* is defensive. In the hands of one of two men of equal ability, the *yari* gives a little extra strength. *Yari* and *naginata* both have their uses but neither is very beneficial in confined spaces. They cannot be used for taking a prisoner. They are essentially for the field."

A very common design of *yari* in the later part of the Muromachi period is popularly known as the *jumonji-yari*, named after the Japanese character for 10, which is *JU* and is a cross. The romantic story of

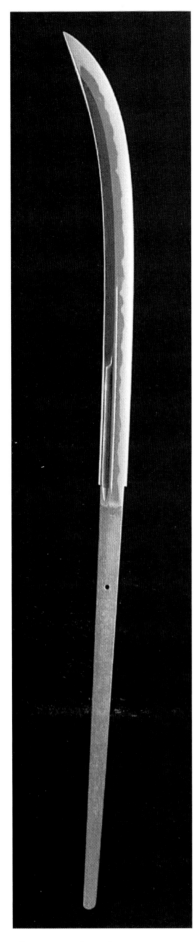

Above An early 17th century *naginata* by the Osaka swordsmith Kawachi (no) Kami Kunisuke.

十字槍　銘　広光（無の字槍）

Above A regular *jumonji* or *magari-yari* by Hiromitsu, a Soshu swordsmith.

its invention was that Inei (1521–1607), master of the *Hozoin so-jutsu* (spear fighting), was holding his *su-yari* (straight spear) and gazing at the reflection of the crescent moon in a pond. His *su-yari* bisected the moon's reflection, and he was then inspired to commission the Kanabo group of swordsmiths, who made a specialty out of making *yari*, to produce many *jumonji-yari*.

Actually, in the latter part of the Muromachi period, the *yari* seems to have become socially accepted by the higher class of *samurai*. There were even seven "famous spearmen of Japan." One of these, Kato Kiyomasa, a renowned general from Higo Province in Kyushu, joined forces with Hideyoshi in his invasions of Korea in 1592 and 1598. He was well known for his expertise

Left A cow-horn-shaped *jumonji yari* by the revivalist swordsmith Naotane, dated Bunwa 9th year (1813).

Above The sharply upturned arms of this *jumonji-yari* are said to resemble the horns of a cow; it is therefore known as a *gyuka-kuugata yari* (cow-horned shape). It is signed *"Oite Buyo Hojo Masamitsu Saku."* (*Oshigata* by the author.)

with his *jumonji*-style *yari* that had uneven lengths to both sides of the cross-section. His daughter brought the famous spear with her as one of her wedding gifts when she married Kishu Norinobu.

While in Korea, Kiyomasa was unexpectedly attacked by a huge tiger and he thrust the animal in the mouth with the spear. The legend insists that the enormous beast bit through the blade, breaking off one of the protruding arms in the process.

This style variation is known as *katakama-yari* and, complete with its mother-of-pearl shaft, is preserved in the Tokyo National Museum. Although having no maker's name inscribed on the *nakago*, it is an extremely fine blade that was made in the mid-Muromachi period.

"If you drink saké at all
Drink as much as you can to earn this spear
The trophy of drinking...."

These are the opening lines of a famous folk song sung by the *samurai* of the Kuroda Han, and it demonstrates the fame of a beautiful *yari*. Undoubtedly the most famous extant *yari* in Japan, owned by the Kuroda family, is variously known as *Nippongo* (number one in Japan *yari*), *Nomitori-no-yari* ("The Drink to Win Yari"), and the *Kuroda-bushi-no-yari*. It is over thirty-one inches in length, and is a long *su-yari* with a very elaborate and detailed *horimono* of a dragon. The spear was originally an imperial gift to the last Ashikaga *shogun*, Yoshiaki, who was deposed and retired in 1573.

Other, possibly more reliable, sources say that the *yari*, indeed an imperial gift, had been presented by the Emperor Go-Yozei directly to Toyotomi Hideyoshi in recognition of his military prowess. Hideyoshi, being a commoner by birth, was overwhelmed by this imperial recognition and it was he who named it *"Nippongo."* He took it everywhere he went. The emperor was so impressed by Hideyoshi's devotion to and appreciation of the spear that he gave it the court title of *"Sanmi,"* an act without precedent. The effect of this was to give

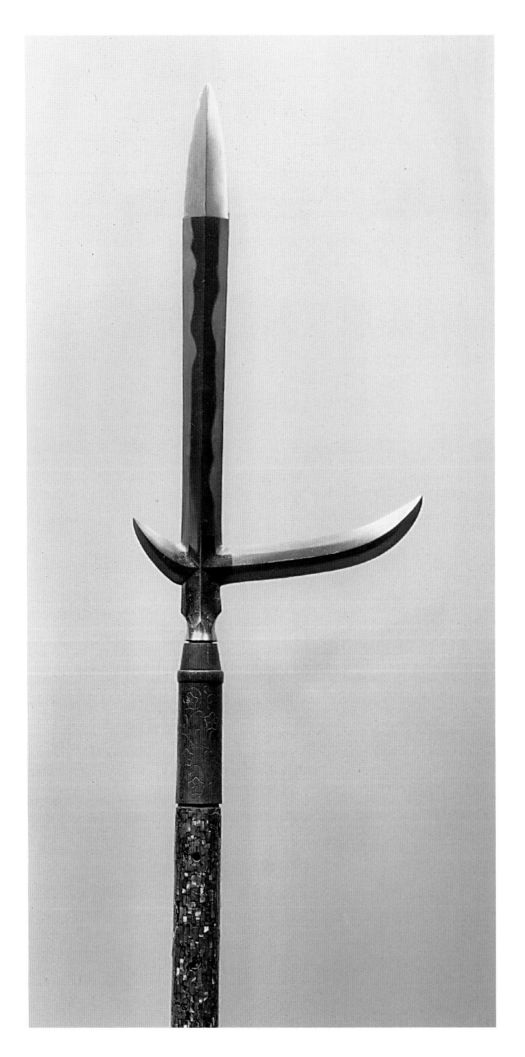

imperial sanction to pretty well everything Hideyoshi did when the *yari* was present.

It then seems that the *yari* was presented by Hideyoshi to Fukushima Masanori on a temporary basis only, but Masanori refused to relinquish it, turning down an alternative offer of a fief worth 50,000 *koku* of rice. Hideyoshi reluctantly finally allowed him to keep the *yari*. After the Battle of Sekigahara in 1600, Masanori replaced Mori Terumoto as lord of Hiroshima in Aki Province. Masanori treasured the spear greatly, in the same way as had Hideyoshi, but, being arrogant by nature, he demanded that even great generals bow to the *yari* since it was a *Sanmi*.

Masanori became most unpopular and was avoided by his contemporaries whenever possible. Like many of the rough and tough *samurai* of the time, he was partial to heavy drinking. One day, when Masanori had been drinking heavily, a messenger named Mori Taihei arrived from the Kuroda clan. The tale continues that Mori was invited to join Masanori in a saké drinking session, which the Kuroda *samurai*, being on official clan business, politely declined. However, Masanori had already been drinking heavily and attempted to shame the Kuroda retainer into joining him, becoming quite abusive and insulting in the process, and calling Mori a coward. In spite of this, Mori Taihei kept himself under control and refused to react. Finally Masanori blurted out, drunkenly, that if Mori joined him in a drink, he would give him anything he wanted. Being no doubt aware of the existence of the *yari*, Mori capitulated and had three large glasses of the liquor. Then, holding Masanori to his word, he demanded the *yari* as a gift. The unfortunate Masanori had no option but to agree and was unable to persuade Mori to reconsider.

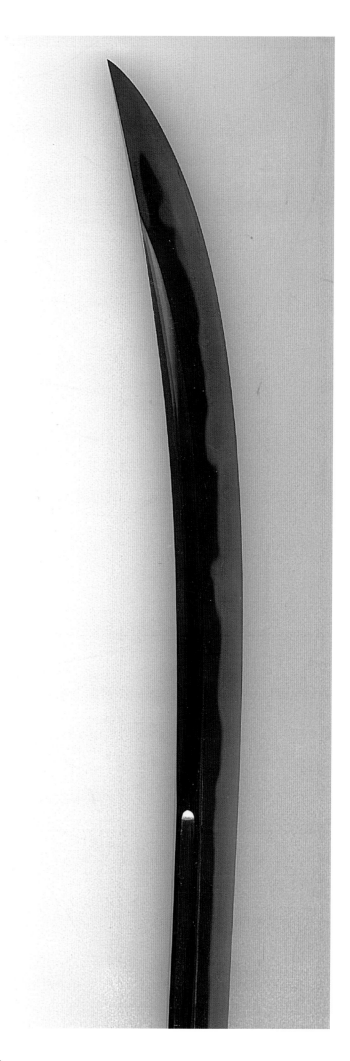

Left Popular legend has it that a tiger in Korea damaged this *yari* that was owned by Kato Kiyomasa in the late 16th century. With the uneven side projections, it may be termed as a *kata-kama jumonji yari*.

Right A well polished *naginata* signed *"Hida (no) Kami Ujifusa,"* who worked at the end of the Koto period (around 1600) and was one of the many Mino swordsmiths who moved to Owari Province at this time.

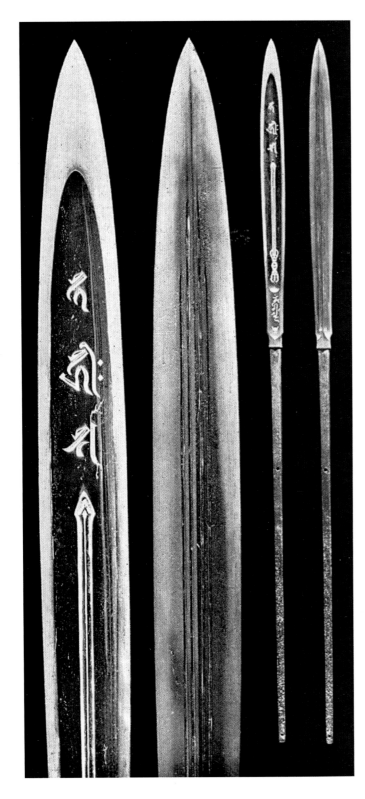

Above *Tombogiri* (Dragonfly Cutter) is signed "Fujiwara Masazane Saku." It ranks as one of the three most important *yari* in Japan (the others being *Nippongo* and *Otegine*.

The *yari* had now become the property of Mori Taihei and was given the nickname of *Nomitori-no-yari* or "Drinking Trophy Spear," and songs were sung in its praise. The legend is further embellished by Mori Taihei apparently losing the *yari* to another Kuroda *samurai*

named Goto Matabei. This supposedly occurred in Korea when Mori Taihei, trapped by a tiger that threatened his life, would be given assistance by Goto Matabei only if he were given the *yari*—a proposal to which Mori Taihei was forced by the dire circumstances to agree!

Fortune did not keep smiling on Goto Matabei, however, and he became estranged from Kuroda Nagamasa, leaving the Kuroda clan with nothing but the clothes on his back. The *yari* stayed with the Kuroda, where it has remained as a family treasure to this day. (Incidentally, it was a favorite piece, often copied by the late Living National Treasure, Sumitane Masamine, and he took one of these magnificent copies to London when he visited in 1991.)

Like *Nippongo*, the *Tombogiri* (Dragonfly Cutter) is considered one of the eminent "Three Spears of Japan." It was the favorite weapon of Honda Hachiro Tadakatsu (1548–1610), a leading general under Tokugawa Ieyasu. Also called *Kagero-giri* (Mayfly Cutter), the spear's blade was so sharp that popular legend holds that when a dragonfly (or mayfly presumably) flew into it, the insect was cut in two. The spear was mounted on a twenty-foot pole embellished with blue *aogai* (mother-of-pearl) when Honda took it into battle in support of Tokugawa Ieyasu at Mikawa in 1573, and again at the Battle of Nagakute in 1574, following the murder of Oda Nobunaga.

The *Tombogiri* blade was made by Fujiwara Masazane. It is 17.24 inches long and is of the *sasaho-zukuri* or leaf-shaped form. It is tastefully decorated with a simple *su-ken* (straight sword) and *bonji* (Sanskrit characters) on the *omote* or front side, and small *hi* (grooves) on the *ura* or reverse. It is now part of a private collection in Japan.

Both *naginata* and *yari* continued to be made during the Edo period. Although there were a few specialists makers, most swordsmiths occasionally turned their hands to their manufacture. However, as the Edo period was one of peace, the necessity for functional weapons diminished and most *naginata* lost their relatively strong shape from the previous periods, although some special

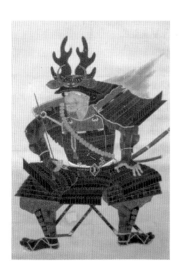

Left Honda Heicharo Tadakatsu, a favorite general of Tokugawa Ieyasu, was the owner of the famous spear *Tombogiri* (Dragonfly Cutter).

Below A short, straight *yari* of triangular form by the famous 16th century swordsmith Muramasa.

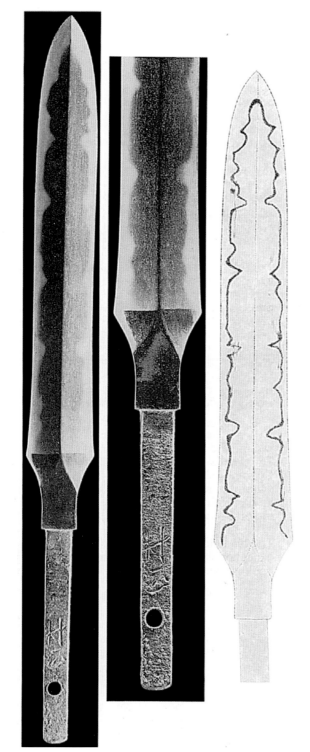

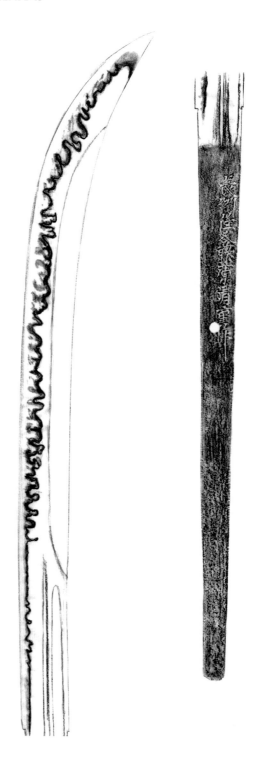

Above A *naginata oshigata* that shows the extreme *saki-zori* (point curve) of the later *naginata* that were favored by women. This 19th century example is signed "*Choshu Ju Fujiwara Kiyoshige.*" (*Oshigata* by the author.)

order pieces were very good. This may also be seen in the mounts of the polearms, which were required more for ceremonial use. Of special interest were the *saya* (scabbards) of *yari* and *naginata*. These were many and varied in design and the material in which they were made. Often they were ornately lacquered, and I have one that is covered in black bear fur.

The custom of regular attendance at Edo, imposed on the feudal lords by the Tokugawa *shoguns*, was an opportunity for the provincial *daimyo* to demonstrate their importance. On the procession to Edo, a reflection of the lord's favor was the position of *yari-mochi* (or *yari*-carrier), who would be proudly carrying a *yari* displaying the clan's *mon*, or device. Also, many poles from the later Edo period are ornamented with

aogai. Unfortunately, this is rather frail and tends to flake off when handled today.

The *naginata* tended to become a much lighter weapon, and often the degree of curvature at the point was very pronounced. Although, like the *yari*, these *naginata* might be carried in the processions to Edo, they became associated with women from the *samurai* class. Indeed, even today, the martial art of *naginata-do*

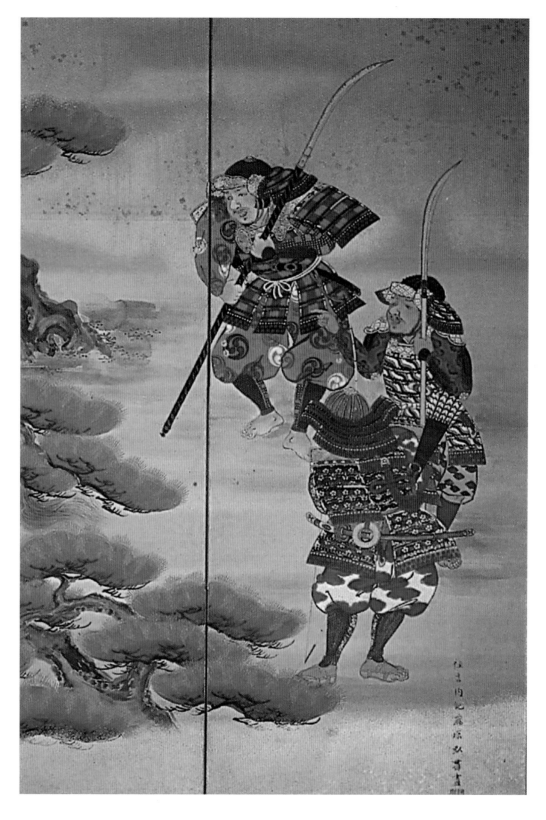

Left Unmounted and heavily armored, two *samurai* carrying *naginata*, which are very curved towards the point. These *samurai* are carrying only short swords, while the archer in the foreground also wears a *tachi*.

Far Left *Sode-garami*, or sleeve entanglers, were police restraint weapons that were usually kept at the fifty-three customs barriers on the *Tokaido*, the main road between Edo and Kyoto.

is largely practiced by women; I have experienced the amazing power and dexterity with which a relatively small Japanese lady with her *naginata* can overcome a much larger opponent.

The main route for travel in old Japan was the highway between Kyoto and Edo, known as the Tokaido. *Daimyo* processions from the provinces, as well as many assorted civilians, were constantly going

back and forth along the *Tokaido* and the other main roads of Japan. However, the *shogunate* was always on the look-out for those who might oppose their autocratic rule or were simply common criminals. Therefore, along the length of the *Tokaido* were spaced fifty-three checkpoints or customs barriers. These were immortalized in Hiroshige's series of woodblock prints. Here the Tokugawa police monitored everyone moving

Right The *sode-garami* (sleeve entangler) was a police restraint weapon designed to tangle in the loose sleeves of the day, rather than a *samurai's* weapon.

Right The *sode-garami* (sleeve entangler) was a police restraint weapon designed to tangle in the loose sleeves of the day, rather than a *samurai's* weapon.

along the road, especially those entering or leaving the capital. At each of the stations these police had a collection of weapons that were essentially restraining implements, rather than killing weapons, although they did have their fair share of swords and guns.

Every station had a number of polearms known as *sode-garami* (literally "sleeve entanglers"). Comprising a series of spikes and hooks mounted on a long pole, some looking like garden rakes, these were made to entangle the loose sleeves commonly worn at that time. These implements would be kept on racks where they were immediately ready for use. Today they may be seen at places such as the *Tokaido* checkpoint at Hakone.

As Musashi stated, *yari* and *naginata* were weapons of the field and not much good in confined spaces. Since there were no battles to be fought after the siege at Osaka Castle in 1614, their use was mainly ceremonial. However, another piece in my collection demonstrates a variation of the *yari*, specifically made for use in a confined area. It is mainly of smaller proportions overall and is known as a *makura-yari* (pillow *yari*). This has a red lacquered, ribbed pole with an iron *harumaki* at the base. The small, straight blade has a socket rather than a tang to secure it to the pole, which is actually a feature of very early *yari* but was occasionally made at other times and is called a *fukuro-yari*.

In the earlier time of constant wars, the *fukuro-yari* was reckoned to have both good and bad properties from a practical point of view. On the negative side, it was felt to be too light to cut well, and the lack of a long *nakago* inside its pole weakened it and made it susceptible to being cut through or damaged from

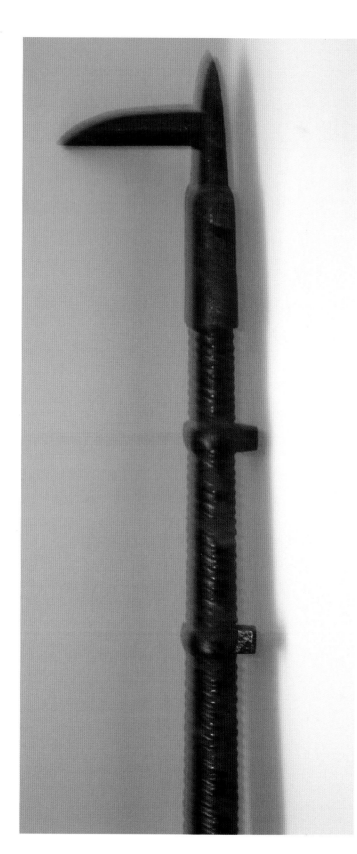

Far Left A *fukuro* or socketed *yari*, circa 1670, signed on the body of the socket *"Minamoto Nobukuni Kanetsugu."*

Left A 19th century *hoko*, which is most likely to have been used as a fire-fighting tool rather than an offensive weapon. Two loops on the pole were to accommodate a banner of some description.

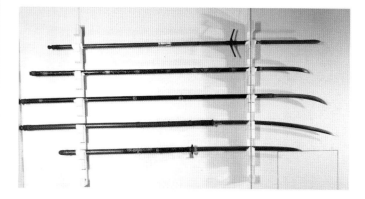

Above A display of polearms at Yasukuni Jinja, Kudanshita, Tokyo. The top *su-yari* has a *hadome*, or parrying bar; the next two are *naginata*; the bottom two are different styles of *nagamaki*.

a sword attack. On the other hand, this style was favored by the *daimyo* Kuroda Nagamasa (see above), who endorsed the view that his troops could easily replace broken shafts by cutting a bamboo that could be inserted into the socket.

According to Knutsen's *Japanese Spears*, "There may be truth in the assertion that Kuroda Nagamasa commissioned the Nobukuni swordsmiths in Chikuzen Province, modern Fukuoka-ken, to produce *fukuro-yari* owing to the fact that so many socketed *yari* are signed Shinto Nobukuni." The *makura-yari* mentioned above would seem to support this contention, since it is signed on the socket: Minamoto Nobukuni Kanetsugu (circa 1670).

Below Signed "*Mino (no) Kami Fujiwara Masazane,*" this is actually the work of the third generation Masazane. However, as the second generation died very young and this smith was adopted by the first generation, he is considered the second generation by most authorities. This group was famous for their *naginata* and *yari* production.

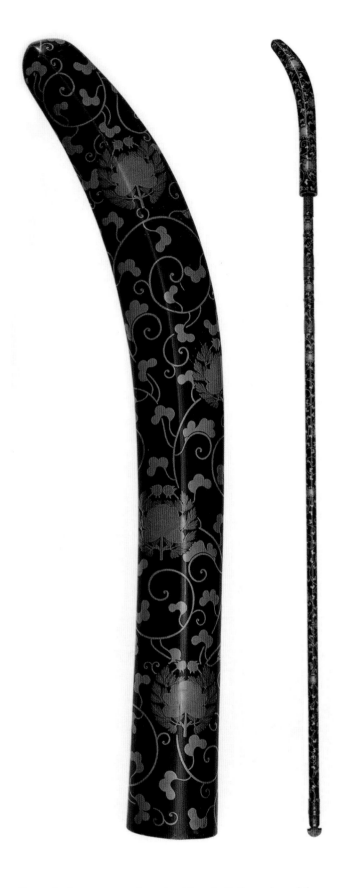

Above An important *naginata koshirae*, both the pole and the *saya* having been lacquered in the early style of gilt tendrils throughout.

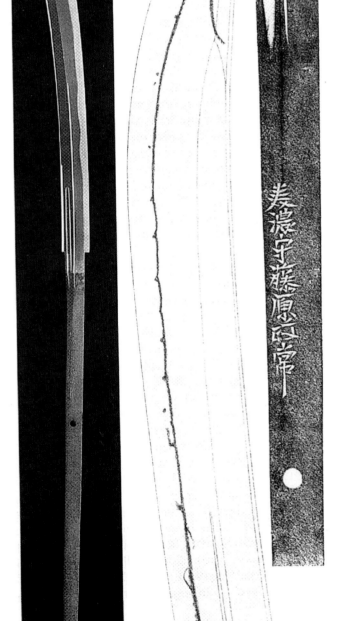

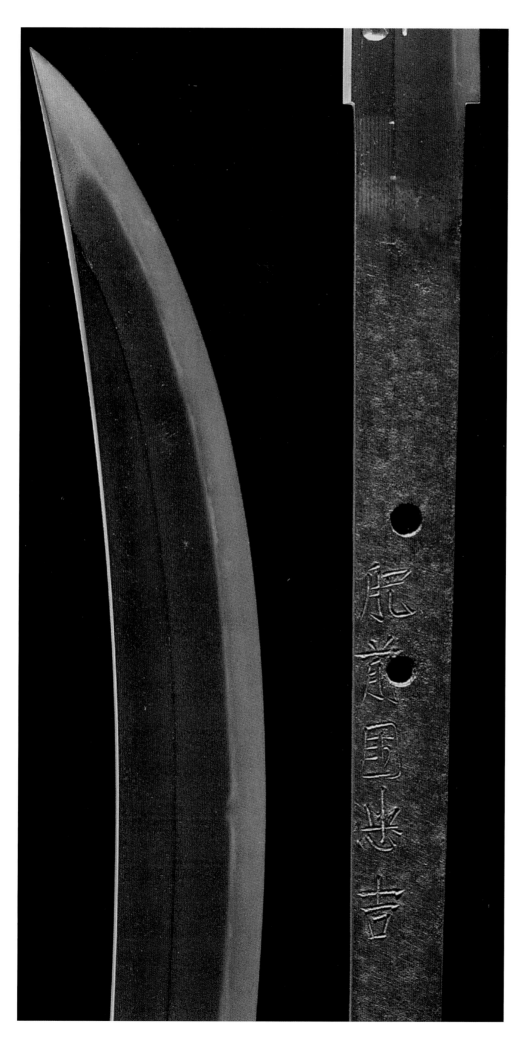

Left This early 17th century *naginata* bears the *goji-mei* (five-character signature) *"Hizen Kuni Tadayoshi"* and is *Juyo Token*.

Above A Kuniyoshi print of the *ronin* Horibe Yahei Kanamaru, a skilled spearsman. Although seventy-eight years old, he fought hard on the night of the "Revenge of the 47 Ronin." According to Knutsen, "the blade was made by Monju Hokyu in the Genroku period (1687–1710) and so it seems likely that Horibe Yahei purchased this spear specially for the revenge." The poem on the banner on his *su-yari* reads:

Though I had thought I had lived too long without merit,
The joy of it now, this moment of old age!

Right A *naginata naoshi* (*naginata* altered to become a sword). It has lost any inscription it may have had but is attributed to Norishige and is a *Juyo Token*.

Far Right *Naginata naoshi* refers to a *naginata* that has been converted into a sword by filing down the *mune*, or back side, and shortening the *nakago*. In this example the smith's signature has been inserted into the new, shorter *nakago*.

Another Edo period variation on an old theme is the *hoko*. Ancient *hoko* usually have a small vertical blade and another that extends out at the side. This is of a hook-like shape with the cutting edge on the lower part, but there are many variations on this theme.

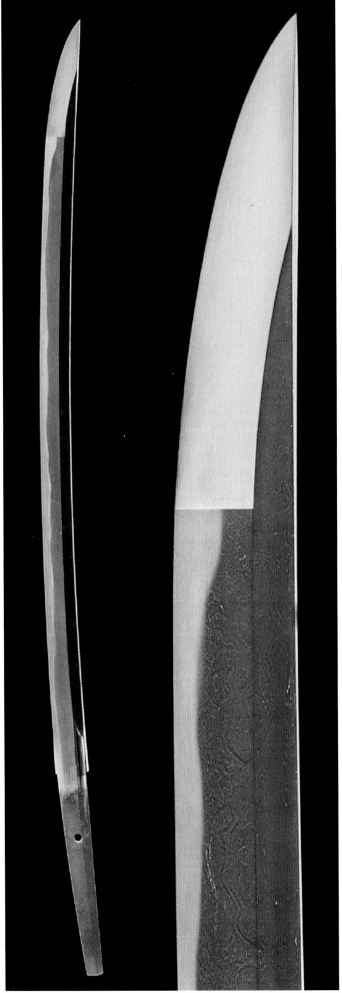

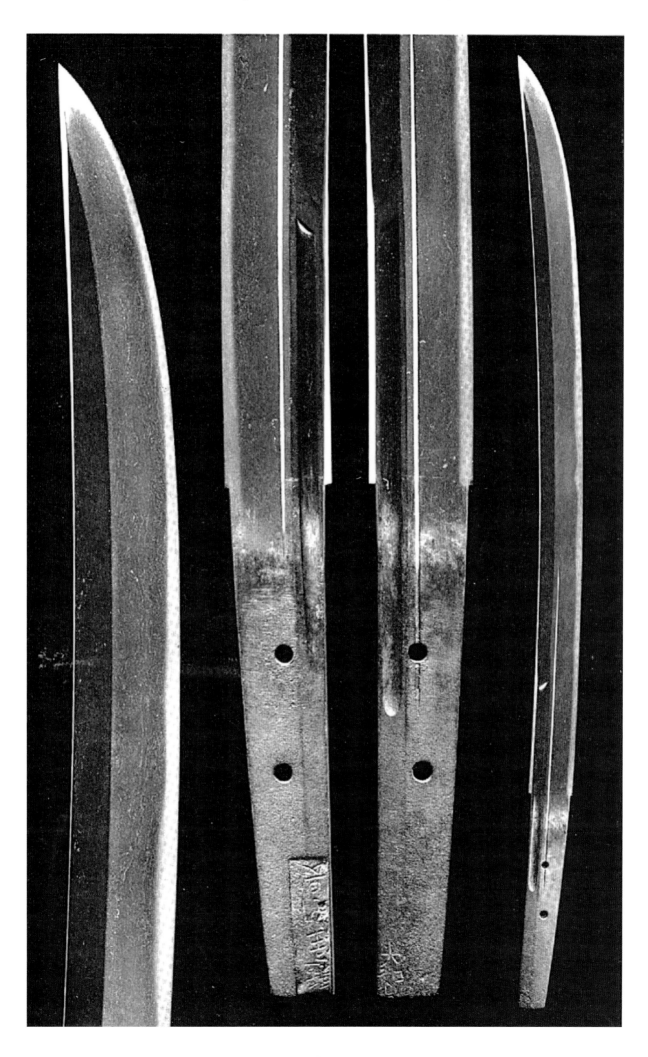

Right A selection of various *yari* and *naginata*, demonstrating a small part of the variety of shapes and designs, some of which do not appear to have been very practical.

Far Right Much artistic license has been exercised by Japanese artist Yoshitoshi (1839–1892) in this depiction of a *samurai* armed with both sword and *naginata*. (*Courtesy of the Library of Congress.*)

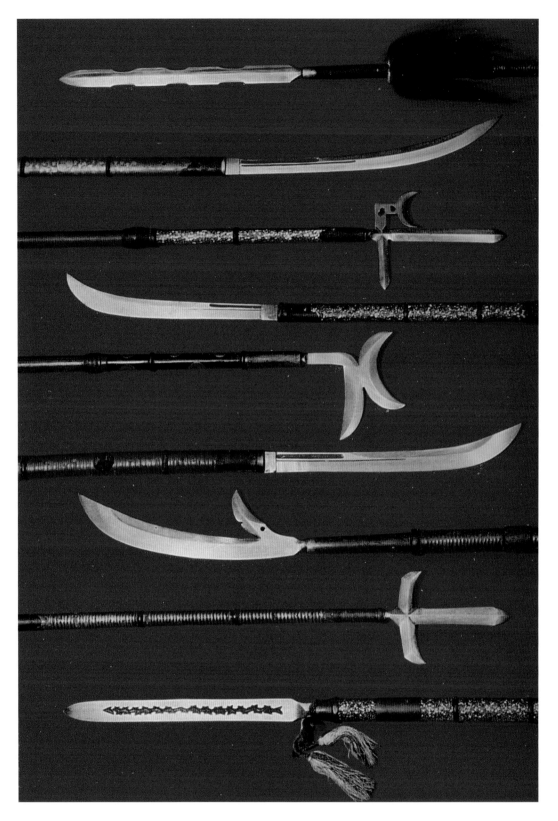

Mine has a blade that, although it actually has a tang, appears to be socketed for effect. Further, the blade has no sharp edge at all, and is lacquered completely black. On the pole there are two iron loops that appear to accommodate a banner of some description. I believe this to be a late Edo period firefighter's *hoko*, the function of which was to pull down the burning timbers of a house.

From the beginning of the Edo period, many *naginata* were shortened and converted to swords, losing any signatures that may have been on the original *nakago*. Such blades are known as *naginata-naoshi*. Some swords were actually made to look like *naginata-naoshi*. Usually during the conversion, much of the curvature at the point would have been reduced and this would remove any *kaeri* (or "turn-back") of

大石主税藤原良金

無禄　部屋住

良雄の嫡男ふして母ハ但州
豊岡の藩石束源五
兵衛の女ふり良金
十四才ふて國難ふあひ
父の命に志らろて優
雙言の列ふ入り翌年
九月小野寺と共ふ武州川嵜よて
元服し討入の時ハ
鞴手の首長として
まいく功動をうしう
死そる時十六才辞世
極楽のたいひと仙助君とられに
一ゆ弥陀をそ人て四十八人

刃上樹劔信士

same maker. In the past, this was understandable since it may have been very difficult to transport a weapon on an eight-foot pole right across any real distance, but this is less of a sustainable argument today. Whatever the reason, when compared with swords, polearms may be obtained at a healthy discount.

Above This *naginata* has been greatly shortened to mount it as a sword but fortunately none of the blade itself has been altered. The *saya-gaki* by a Honami family member attributes it to Hojoji Tanshu Kunimitsu in the 13th century.

Right Nineteenth century woodcut artist Yoshitoshi's impression of a *ronin* resting on his spear, his sword sheathed. (*Courtesy of the Library of Congress.*)

Below A lightly armored *ashiguru*, or foot soldier, carrying a large *naginata* with a deep curve towards the *kissaki*, or point. The only other weapon appears to be a small *tanto* at his waist.

the *boshi* or *hamon* at the point. The *boshi* that was left, therefore, would go straight off the back edge, with no *kaeri*, and so should be relatively easy to spot.

Today, there are only a very few *naginata* or *yari* of exceptional quality available to the western collector. Generally speaking, polearms are not rated to the same degree as sword blades, even when made by the

Swords: Types, Construction, and Testing

It is still said that the making of a Japanese sword is both a religious and demanding experience for the swordsmith. According to *shintoism*, the old religion of Japan based on nature, everything in the world has a spiritual aspect, even the mountains and forests, the rivers and rocks of the country, and these spirits are called the *kami*. When making a sword, the basic elements of fire, earth, water, wood, and air are all involved, so it is hardly surprising that the sword will be imbued with natural things and possess a *kami* of its own. It is the swordsmith who brings all these elements together. With his labor and spirit, and aided by the *kami*, he is able to create a thing of outstanding beauty and mystical power. In the past, and maybe still today in places, he would ritually purify himself with cold water before beginning the process, abstaining from eating meat or drinking alcohol, and declining the favors of the opposite sex.

The process starts with *tamahagane*, which is the raw material for sword-making. This comes from *satetsu* or natural sand iron, rich in many of the rivers of Japan, which is smelted in a traditional smelter called a *tatara*. From the resulting *tamahagane*, only the best quality is selected for sword-making and the rest is used for kitchen knives, teapots, and the like. Nowadays, the *tatara* is run by the NBTHK in Shimane, and the *tamahagane* is distributed to licensed swordsmiths by that organization, although some highly respected swordsmiths prefer to smelt their own *tamahagane*.

Right The forge is darkened so that Gassan Sadaichi is able to judge the temperature of the sword, the shape of which he is refining as he is about to quench it in the *yaki-ire* process.

Below *Tamahagane* is the basic raw material for the production of Japanese swords. It is smelted from the natural sand iron in a *tatara* (traditional smelter).

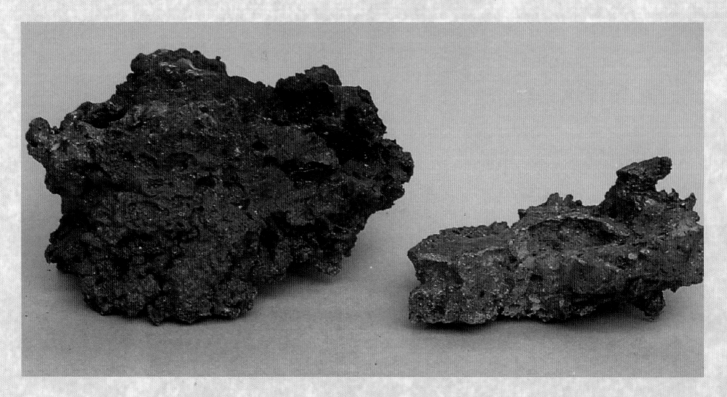

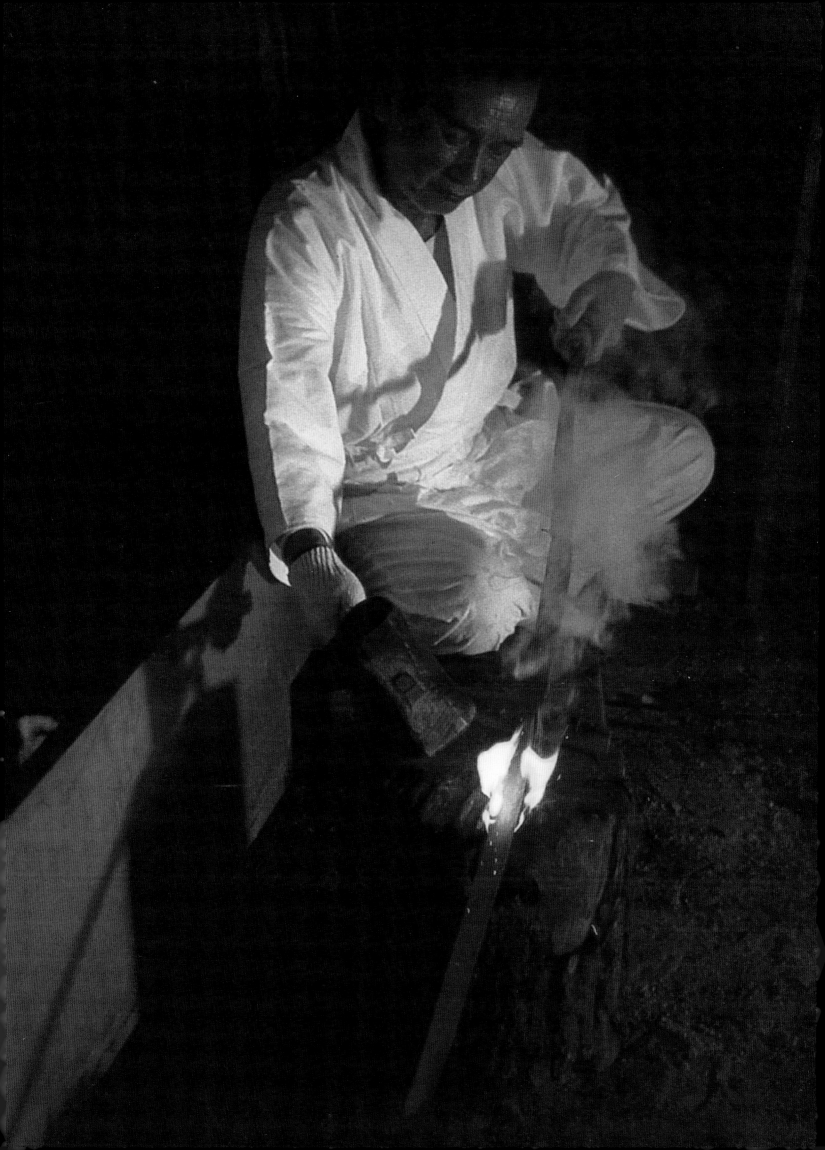

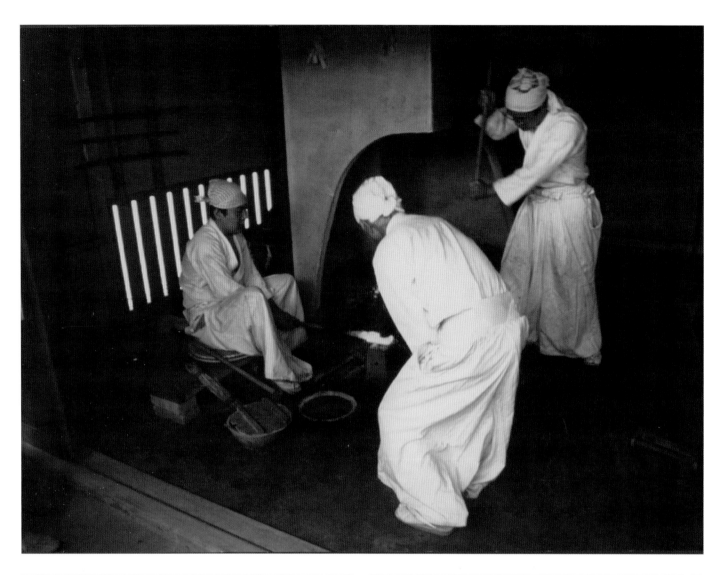

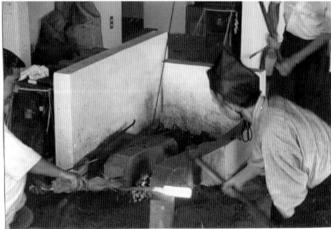

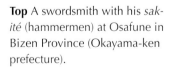

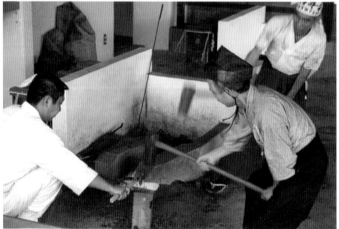

Top A swordsmith with his *sak-ité* (hammermen) at Osafune in Bizen Province (Okayama-ken prefecture).

Above Left The smith holds a *kiri-tegane* (cutting hammer) on the hot block while the *sakité* hammers it so that it is almost cut in half.

Above Right The hot ingot overlaps a block so that it may be conveniently folded over the edge and hammered out again.

When he is ready to work, the smith hammers the *tamahagane* into a thin piece some 3mm in thickness and then breaks it into small pieces. Then, judging only by eye, he will divide the pieces into those suitable for the outer skin of the sword (*kawagane*) and others for the core (*shingane*). The *kawagane* pieces need to be of higher carbon content and, therefore, harder, than those of the *shingane*. This process is called *mizuheshi*.

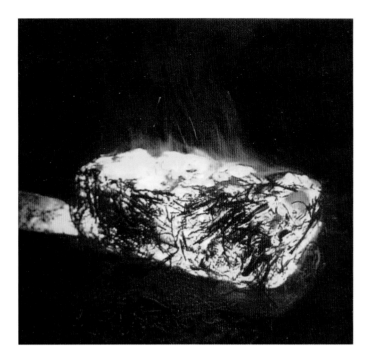

should not exceed fifteen folds; after this the steel will degenerate and lose carbon. While the hammering is taking place, the billet is frequently brushed with straw, which acts as a flux and helps retain the carbon.

At the appropriate time the billet is hammered into a U-shape and the softer steel that has been similarly forged is inserted into the resultant groove, forming the core of the sword. The two billets are then welded together and the combined ingot is beaten out into the rough shape of a sword; such a blank is called a *sunobe*.

The creation of the *hamon* (the hardened edge) is possibly the most important part of the forging since it is this that distinguishes the Japanese sword from all others. The *hamon* is created by the application of a

Above The block of steel is folded up to fifteen times before being shaped into a sword. The application of straw as a flux helps the individual layers to fuse together.

Right The smith frequently brushes the block with straw so that carbon content is maintained. These scenes are from the workshop in Seki, Mino Province (Gifu-ken prefecture).

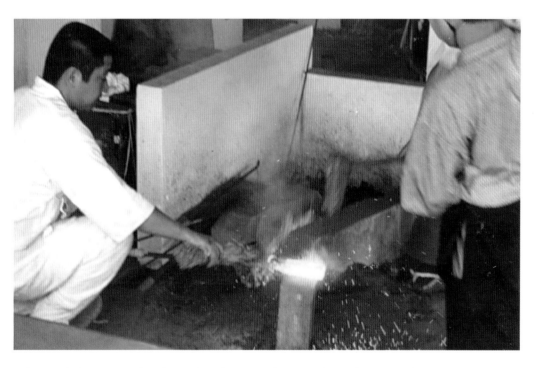

The selected small pieces are then piled on top of each other and heated to approximately 1,300° C, when they begin to fuse into one piece in what is known as *tsumi-wakashi*. It is here that forging or *tanren* commences and often *sakité* (hammermen) will be required to assist, although in many modern smithies an electric power-hammer is deemed more economical and just as efficient. The block that has been formed will be hammered out and folded a number of times and the direction and technique of the folding will eventually determine the surface pattern of the sword, the *jihada*. It is considered that the folding and hammering process

clay slurry to the sword blank. This is known as *tsuchi-oke*, and the swordsmith applies it in different thicknesses, creating his desired pattern of *hamon*. Towards the edge the clay will be more thinly applied than in the body of the blade.

When the clay has been applied, the sword is reheated to about 700°C and, at the right moment, it is plunged into a trough of cool water. Where the clay has been applied thickly the cooling process is slower than where it is thinly applied, and here harder steel is formed. This process, *yaki-ire*, causes many stresses and strains in the blade, and any inadequate forging or poor workmanship

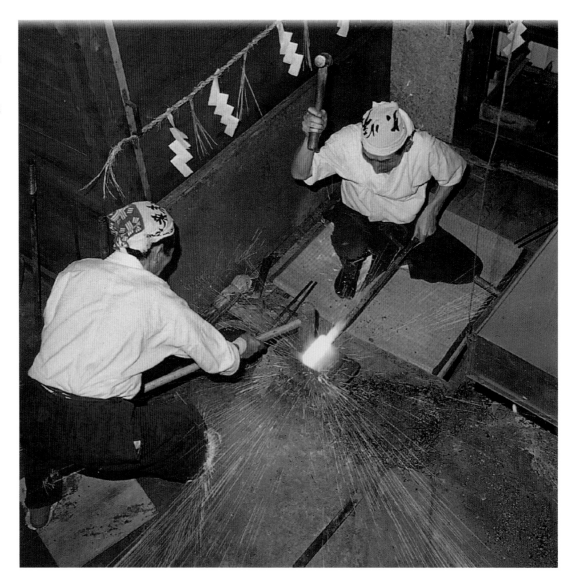

Right The sparks fly as *Ningen Kokuho* (Living National Treasure) Amada Akitsugu and his *sakité* engage in the strenuous work of forging the *tamahagane* at his forge in Niigata.

will become apparent at this time; it could mean that all the previous labor has been wasted.

If the blade has survived the *yaki-ire* the swordsmith will refine and perfect the details of the blade's shape with rough polishing stones. This work is called *kaji-togi* (smith-polish), and also prepares the sword for any further embellishment, such as the carving of grooves (*hikaki*) or *horimono*. The sword is now ready to be sent to a professional polisher and hopefully the polish will not reveal any flaws or other problems. When it is finished and returned to the smith, the blade is signed by the swordsmith (*mei-kiri*) with his name and any other information he wishes to include. The blade is now complete and ready for a *shira-saya* (storage mount) or any *koshirae* that may be made for it.

This basic physical process applies to all Japanese swords, daggers, and polearms. However, there are a number of variations in the form, shape, and size of swords (the *tsurikomi*), summarized as long swords—*katana*—short swords and daggers, *tanto*.

Long swords

These fall broadly into two main categories: *tachi* and *katana*.

Originally, the *tachi* were straight swords known as *chokuto*, but after the fully developed Japanese sword appeared at the end of the Heian period, the *shinogi-zukuri* curved blade appeared. This *tachi* is a light, single-edged blade that tends to be longer, lighter, and more slender than other swords. It was worn with the cutting edge down and was designed for single-handed use while mounted on horseback. The oldest long swords from before the Oei period (before 1396) tend to be *tachi*. Swords longer than about thirty-five inches are known as *o-dachi* (long *tachi*), and some were later shortened tounder twenty-four inches, when

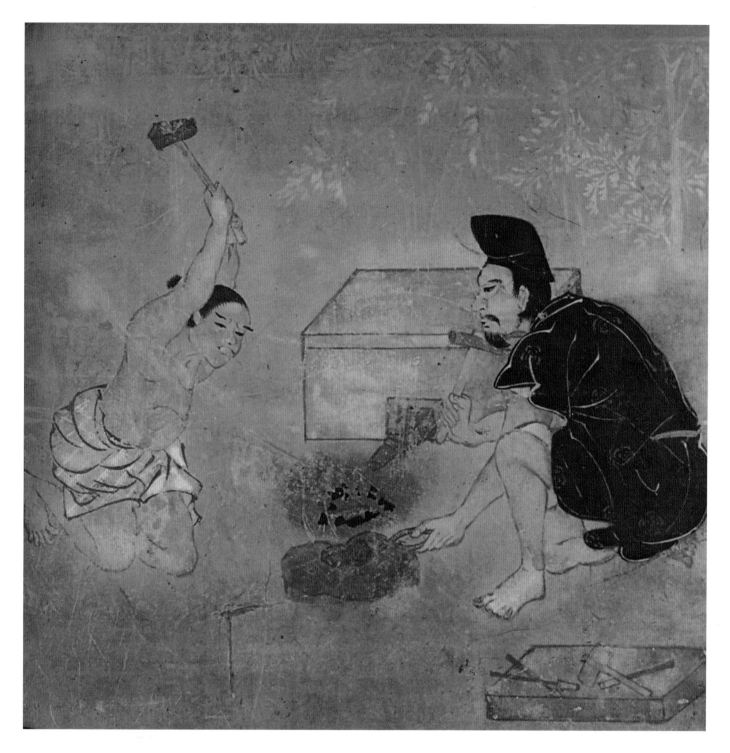

Above An Edo period swordsmith with his *sakité*. The wooden box in the background is his bellows. During the Edo period some swordsmiths were retained by wealthy *daimyo* while others worked independently.

they become *ko-dachi* (small *tachi*). All *tachi*, after the transition from early straight swords, have a *shinogi* or ridge line.

Ko-garasu-maru (Little Crow) is known as such a transitional sword, reputed to have been made in the early 10th century by Amakuni. Unusually, it has a cutting edge that runs down the *mune* or back edge of the sword, and most of the curvature is still in the *nakago* or tang, rather than the blade itself. This sword was an heirloom of the Taira family and is now part of the imperial collection. It is included here because the

style was adopted in the Bakamatsu period (the last years of the Tokugawa *shogunate*) and used by loyalist troops.

Katana

The *katana* is the most common long sword. It is normally over twenty-four inches long and has a *shinogi* (ridge line). *Katana* are very rarely found without a

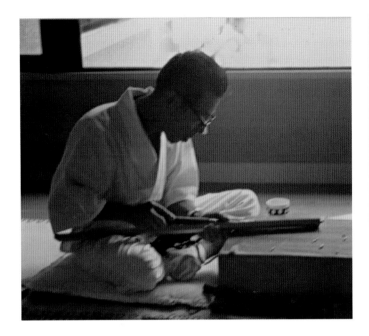

Above *Sayashi*, or scabbard-maker, working with the swordsmiths at Seki in Mino Province (Gifu-ken prefecture).

shinogi, when they are called *hira-zukuri* (flat). The *katana* is worn with the cutting edge uppermost and thrust through the *obi* or sash; the *mei* will be on the outer side of the *nakago* (the *sashi-omote*), that is, the opposite side to the *tachi*. As always there are exceptions to this practice. Generally speaking the *katana* will have less *sori* or curvature than the *tachi* and will be altogether of a more sturdy construction. However, there have been many subtle changes in the shape and length of the *katana* throughout the history of the Japanese sword.

Short swords and daggers

Sometimes referred to as the "companion sword," the *wakizashi* was carried by the *samurai* and accompanied the *katana* to form the *daisho*. It was usually similar in shape to the *katana* but between about twelve and twenty-four inches in length. Although usually with a *shinogi*, there are *hira-zukuri* (ridgeless) examples of *wakizashi*. Made from the Muromachi period onwards, the rump left after shortening of a long sword might result in a *wakizashi* older than this.

Very rarely, the shape known as *osoraku-tsukuri* is formed as a *wakizashi*. Here the point takes up between forty and fifty percent of the entire length of the blade. Although there are a few that were made during the

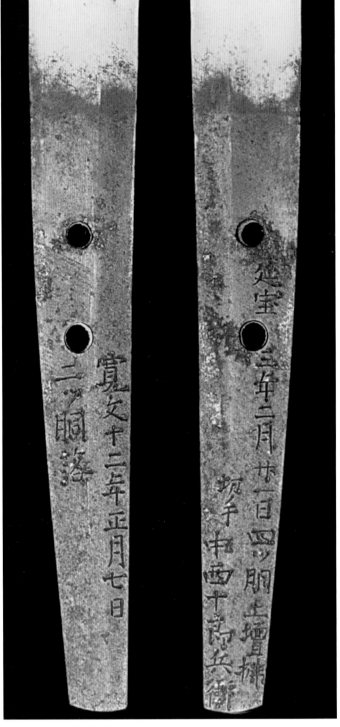

Above A *wakizashi* with the results of two cutting tests carried out in 1672, when it cut through two bodies, and in 1676 when it cut four bodies. The test was carried out by Nakanishi Jurobei, and the unsigned blade is attributed to Kiyomitsu of Kaga Province.

koto times (before 1600), the majority seem to have been made in the *Shinshinto* period, especially by the Kiyomaro school of makers.

Tanto

The greatest variety of shapes are to be found in *tanto* (daggers). Unlike the *tachi*, *katana*, and *wakizashi*, *tanto*

are rarely found with a *shinogi*, and those that are were generally made in the 19th century and tend to be of inferior quality. Some of the variations in *tanto* form are as follows.

Hira-zukuri tanto: this is the most common and has a flat surface with no *shinogi* or ridge line.

Katakiri-ha tsukuri: usually flat on one side with a *shinogi* on the other, very close to the cutting edge. Although an ancient style, these were occasionally made in the early *Shinto* period and again in the late *Shinshinto* period.

Kissaki-moroha tsukuri: similar in conception to the *ko-garsu maru* mentioned above, these have cutting edges on two sides. Such blades were first made in the late *koto* period (late 15th/early 16th centuries) by swordsmiths from Bizen, Osafune, such as Harumitsu and Sukesada. I have also seen examples from the later Yokoyama Bizen school, made in the late 18th century. Today these blades are quite rare.

The *shobu-zukuri* shape means the iris-leaf shape. There is no *yokote* at the point and so the *shinogi* runs right through to the point, giving an overall

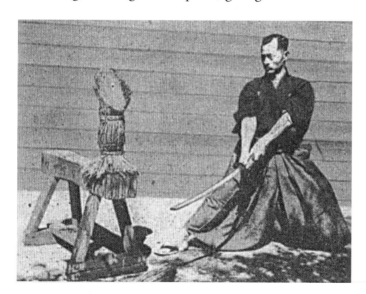

Above The *kendo* teacher Hakudo Nakayama demonstrating the *kesagiri* cut, which cut diagonally from the shoulder through to the hip. He was active in the early prewar Showa period.

Top Right An Edo period factory making small sword accessories such as *ko-gatana* and *tsuba*. The figure holding up a *tanto* is fitting it with *habaki* and *seppa* (collars and spacers).

Right The execution ground at Edo in about 1860, with three heads on display. It was here that many cutting tests were conducted.

found on *naginata*.

With the *unokubi-tsukuri*, the *shinogi-ji* (the part of the blade above the *shinogi* or ridge line) is thinned down and tapered towards the *mune*, or back of the blade in the middle section. The bottom part of the blade and the *kissaki* are normal, and from above the *kissaki* looks like the head of a bird on a long neck, hence the name *unokubi*—cormorant's neck.

Having gone through the "ordeal" of making the sword, the swordsmith, or his *samurai* customer, could be forgiven for wondering if the sword was sharp enough to meet all eventualities. The effectiveness or efficiency of his weapon is obviously of paramount importance to any soldier or warrior, whose life might depend on it. This is quite understandable and it was necessary for the owner of the weapon to have complete confidence in it.

So it was for the *samurai*, but for most of their history, certainly up to the latter part of the 16th century, constant warfare was enough to test most forms of weaponry. This included bladed varieties such as *yari*, *naginata*, and of course swords. Discarding a broken or blunted instrument was not a problem since new ones were constantly coming from the forges of swordsmiths, principally from the provinces of Bizen (present-day Okayama prefecture) and Mino (present-day Gifu prefecture). However, with the dawn of the great peace heralded by the victory of Tokugawa Ieyasu, at the definitive Battle of Sekigahara in 1600, and the establishment of the Tokugawa *shogunate*, the everyday opportunity to use a sword was greatly reduced.

Since the end of the *Sengoku-jidai*, or period of the country at war, fundamental changes in sword-making had occurred. Mostly, swords had previously been purely practical things, and often shortcuts had been made in the production process, while economies were made in the materials used. Of course, there are swords of great antiquity that are unsurpassed in excellence, but the vast majority were not of this standard, especially in the Muromachi period (1450–1580). Without the pressures of producing large

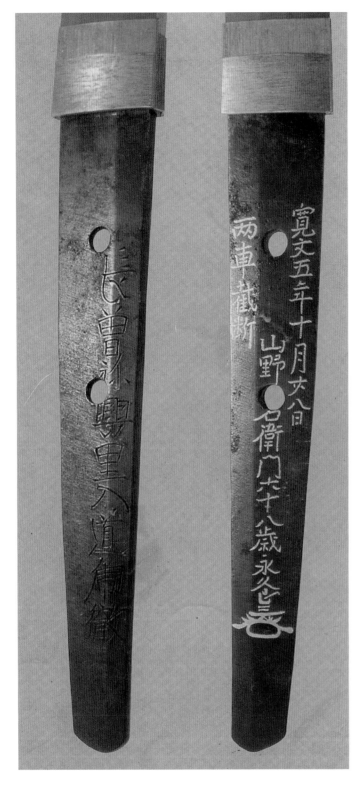

Above The *nakago* of a *katana* blade inscribed *"Nagasone Okisato Nyodo Kotetsu"* and a *kinzogan saidan mei* (gold inlay result of a cutting test). The test, dated Kanbun 5th year (1665), was conducted by Nagahisa, who was a Yamano-family tester, when he was sixty-eight years old. It was not unknown for genuine test results to be found on *gimei* or fake blades.

impression of the slim iris leaf. Often, these *tanto*, in common in both *tanto* and *wakizashi* in the Muromachi period, have a groove or *hi* similar to that

quantities of blades for the hundreds of thousands under arms, swordsmiths could concentrate on making better and more artistic blades.

Influenced by the prevailing Momoyama culture in Kyoto, the imperial capital, swordsmiths at the end of the 16th century began to make more decorative or artistically pleasing swords. The more picturesque *hamon* or hardened edge, as well as more ornate *horimono*, with fewer religious subjects, were obvious manifestations of this. Now that raw materials were increasingly distributed from central sources, the metal or *jigane* ceased to show the individual regional characteristics of earlier times and now demonstrated a uniformity not seen before. However, in the early 1600s, while the

center of commerce, and here swordsmiths established themselves to supply the affluent merchant classes as well as the resident *samurai*. In addition to these three cities, some fortunate swordsmiths were directly retained by some of the great *daimyo* or feudal lords, positions both they and their ancestors often held for many generations.

The *shogunate* enforced the peace with an authority based on military strength, and it would be no exaggeration to call this a "police state." Many rules and regulations affected all aspects of life, and social classes were fixed absolutely with social mobility almost unheard of previously. At the top of this structure were the warrior class, the *samurai*, who formed about ten

Above A *naginata* and a *jumonji-yari* in their specially strengthened and modified mounts prepared for *tameshigiri* (cutting tests).

living memory of real combat still existed, swords were shaped like shortened versions of the oversize blades of the 14th century, a time that might be referred to as a "golden age" of sword manufacture.

As the Tokugawa *shogunate* became established in their capital, a small town in the east of the country named Edo (present-day Tokyo), many swordsmiths flocked to this expanding location to take advantage of the prevailing martial atmosphere. At the same time, the imperial capital of Kyoto attracted a good number of swordsmiths whose families originated in the sword-making culture of Mino province. Meanwhile, close to Kyoto, the city of Osaka was becoming a thriving

percent of the total population. The wearing of the *daisho* or pair of swords was compulsory and defined the status of the *samurai* as a warrior.

As the peace progressed almost uninterrupted into the first half of the 17th century, the number of *samurai* with actual battle experience became fewer and fewer but the *samurai* were expected to be constantly at a high level of readiness. Their very existence as a class supposedly depended on their ability in the martial arts, predominantly skill with swords. To some, this posed the problem of whether or not their sword was able to really be relied on in combat: would it bend or break, and would it cut efficiently? At the same time, a host of laws were enacted by the *shogunate* government, including restricting the length of swords. In many cases it seems this meant that existing swords needed to

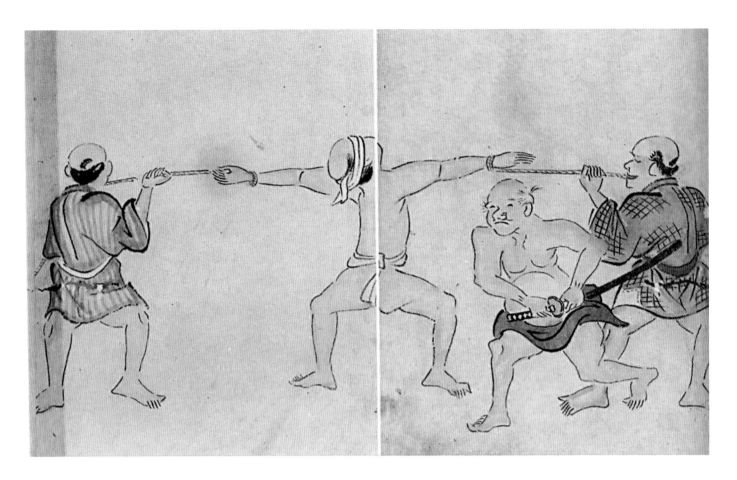

Above The blindfolded victim is held with arms outstretched so that the tester, drawing the sword as though it were a *tachi*, is able to cut a reverse *kesagiri* from hip to shoulder.

be shortened, and some *samurai* were concerned that their weapon was no longer effective.

To the *samurai*, the testing of his sword was the obvious response, and this seems to have been recognized by the government, who appointed official testers. The execution grounds, especially in Edo, provided excellent facilities and also "raw materials" for tests that could be considered useful. Many swords were officially tested at these places especially in and around the Kanbun (1661–1672) and Enpo (1673–1680) periods. This may have been due to a raft of new sword legislation at that time that resulted in many sword alterations. It was also a reflection of the development of *shinai-kendo*. The *shinai* was a bamboo sword that was straight; swords made at that time, especially in Edo, had very shallow curvature in an attempt to replicate the *shinai*. This is still known as the *kanbun-shinto sugata*, or "the new-sword shape of the Kanbun period."

A few *samurai* resorted to the illegal form of testing known as *tsuji-giri*, or street-cutting. The owner would lurk with his sword in some dark street corner and cut down the first innocent passer-by. Ironically, the best authenticated case of *tsuji-giri* was performed on a famous Edo swordsmith named Hankei, some of whose swords themselves were inscribed with the results of cutting tests. Although this was a grim situation, such instances appear to have been so common that a number of amusing stories are told about the practice. In one, a *jujitsu* instructor was walking in town when he saw a *samurai* on a street corner who suddenly drew his sword to cut him down. From a safe distance the intended victim acrobatically executed three somersaults and poked out his tongue at the *samurai* and went on his way.

In another, a lowly beggar sleeping on the roadside was struck several times during the night by a *samurai* wielding worthless, blunt swords. On waking, the beggar grumbled, "There is no peaceful rest even for a worm such as myself; bad men have beaten me [not cut me!] during my sleep." These tales also illustrate the arrogant contempt in which the *samurai* held the lower classes.

The main and official testers in Edo were the Yamada family, who enjoyed the *shogun*'s patronage. They devised a series of progressively difficult cuts that were to be performed on a corpse, although there are records of tests having being made on live bodies! In fact, the black humor of this situation may be seen in an incident quoted in the appendix of *Huncho Gunkiko*. In an estate in Dewa Province a powerfully built robber, who performed as a puppet showman during the day and a robber at night, was caught and condemned to death. The tester, named Shoami Dennosuke, was instructed to cut the robber in *kesagiri* (from shoulder to hip). The robber was prepared in the stocks and apparently the following dialog took place:

> Robber: "Is it you that will cut me down?"
> Shoami: "Yes; you must be cut alive as you are sentenced."
> Robber: "In what way will you cut me?"
> Shoami: "I shall cut you in the *kesa* style."
> Robber: "It is too cruel to be cut through alive."
> Shoami: "It is the same before or after death."
> Robber: "If I had known it before, I would have swallowed a couple of big stones to spoil your sword."

After execution, by beheading or occasionally by crucifixion, a body was released to the tester, who was a skilled swordsman. In conjunction with the sword's owner it was decided which cut was to be used, and the body was arranged accordingly. If the sword to be tested was owned by the *shogun*, then many official witnesses attended the test and strict formalities were observed. But this does not seem always to have been be the case. The handling of the corpse was by members of the Eta or *hinin*, the outcasts or untouchable class, since in Buddhist lore such work was considered "unclean."

It seems that the most popular cut, through the waist area, was *dō*, for which the body was arranged on an earth mound called the *dodan*. The limbs of the corpse were tied onto wooden stakes, while the torso rested on the mound and the cuts then made. Often, more than one body might be piled on top of each other so that a

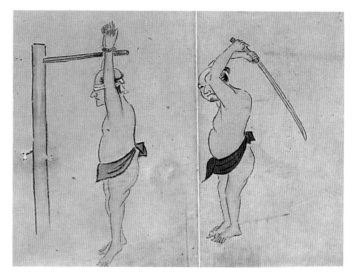

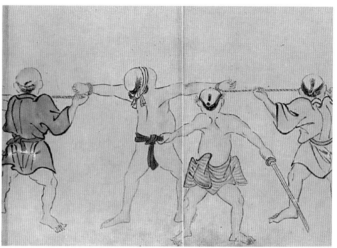

Top The body is arranged for the tester to cut from crown to crutch.

Above The tester adjusts the target as he prepare to cut *kesa-giri*, from shoulder to hip.

multiple *dō* could be cut in a single cutting action.

Another cut was the previously mentioned *kesa-kiri*, which is still favored in modern *tameshigiri*, as well as in *iai-do*. In this cut, the blade enters the shoulder at the base of the neck and exits the body at the hip, following the line of the collar of a Japanese robe, the *kesa*. This is particularly difficult since there is a considerable amount of body to cut through. For *kesa-kiri* a different position must be adopted and the corpse or target needs to be vertical rather than horizontal, as with *dō*. Considered the hardest of all cuts was *ryo-guruma*, a cut through the hips, which of course are almost all bone.

The sword blade itself was mounted in a strong

wooden handle, and it does not seem that the sword's ordinary *koshirae*, or mounting, was ever used when testing. This was probably because there was a risk of damage and, anyway, it was only the blade that was being tested. After the test was completed, the results were often inscribed in detail onto the *nakago*, or tang, of the sword. This was often inlaid in gold, and adds considerably to the value of the blade. Such inscriptions are often seen on the work of the Edo swordsmiths from the Kanbun period mentioned earlier. Swordsmiths such as Yamato (no) Kami Yasusada, Kasusa (no) Kami Kaneshige, and Nagasone Kotetsu are noted for the sharpness they attained, their work being classified as *saijo wazamono*, or "supremely sharp," and often having gold inlaid cutting attestations, called *saiden-mei* on their *nakago*. Indeed, it is stated by Fujishiro *sensei* in *Shinto-Jiten* that much of Kotetsu's fame and popularity in his own day was a direct result of his close relationship with sword testers.

Although most swords tested seem to have been *katana*, a surprising number of *wakizashi* appear to have been successfully tested. In spite of their having been apparently tested, I have never seen the results carved onto the *nakago* of either *yari* or *naginata*.

I have in my own collection were a sword that, unusually, has undergone two cutting tests, and these are described on the *nakago* in some detail. One may make certain interesting deductions from the inscriptions. The sword is *o-suriage*, or greatly shortened, and has lost the original signature of the swordsmith, but has been attributed to Kiyomitsu of Kaga Province. It is now quite a slender *wakizashi* and the results of the two cutting tests are inscribed on the remaining *nakago*. The earliest is dated 1672 and states that it cut through two *dō*. This may indicate that the owner needed to know that it was still an effective blade after the original shortening had taken place. It may also be deduced, from the position of the *hi* or groove as well as the higher *mekugi-ana* or peg hole, that this was inscribed into the blade after the shortening and original cutting test, but before the second test. The second test, performed in 1676, only four years after the first, states:

"Yotsudo Dodan Barai" (four bodies cut right through to the earth mound), and then "*Kiri-te Nakanishi Jurobei*" (cut by the hand of Nakanishi Jurobei). It may be thought that the owner once again needed to be convinced that, after so many alterations had been made to his sword, it was still able to cut well, and so it seems that it could. This full inscription was originally inlaid in gold, *kin-zogan*, and there are still small traces of it left. Unfortunately, most of it has been painstakingly picked out for the small amount it was worth as bullion, almost certainly after its surrender and export to Britain, and as such the devaluation of the sword is far greater than it might have been.

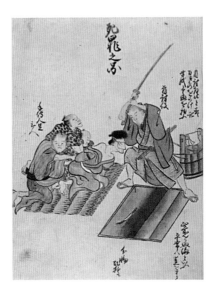

Above Left A formal execution by decapitation rather than a test.

Above Right The *dodan* or earthen mound on which the body is secured for cuts such as do or waist cuts.

In an old sword book entitled *Token Benran* it is mentioned that the tester, Nakanishi Jurobei no Jo Yukimitsu (to give him his full name), was able to cut through three bodies (and even on separate occasions, up to seven bodies!). The sword that cut three bodies into the *dodan* (earthen mound) was made by Hizen Ju Omi Daijo Fujiwara Tadahiro and had a straight or *suguha hamon* (which is often considered the sharpest *hamon*); this would have been a new sword at that time.

The sword that cut seven *dō* was by Seki Kanefusa, had a *midare hamon*, and was tested in the Enpo period. This latter test is often thought to be a highly

exaggerated result and certainly seems strange. However, we must assume that the test was witnessed but we do not know for sure the condition or thickness of the bodies, or other precise details of the test. It is worth mentioning also that there were many variables when testing. First, of course, was the blade's sharpness, but the technique and skill of the tester, as well as the hardness and toughness of the body, might all make great differences to the result of the test.

There appear to have been few tests from about 1690–1780. This was a period in which few swordsmiths of any note existed and sword production was very low, reflecting the peaceful times and decline in martial spirit of the *samurai*. However, by about 1780, the country was experiencing internal strife, and Japan's borders were being tested by Western navies trying to open trading relations. The great sword revivalist, Masahide, preached a return to the old ways of making swords, and this heralded the so-called *Shinshinto* period of sword-making.

It was obvious to many *samurai*, often rather junior members of their clans, that there would soon be war. They supported a return of the emperor to full ruling powers, and claimed that these had been usurped by the Tokugawa family of *shoguns*. Additionally, they felt that the *shogunate* was allowing foreign incursions into the country, in violation of the strict exclusion laws.

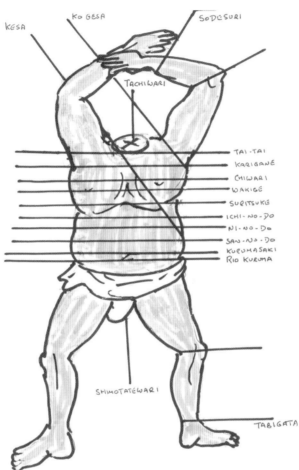

Above The various different cuts as defined by the Yamada family of testers in the Kansai period (1624–44)

The number of swordsmiths increased and so the practice of sword testing again became popular. In my collection there is a very good sword by Koyama Munetsugu, who was the foremost swordsmith in the Bizen Ichimonji style at this time. He was a retained swordsmith of the Kuwana clan and appeared to have a keen interest in the sharpness of his blades, since many were tested by the clan's *samurai*. It seems that he also had a close relationship with the Yamada Asaemon family, the official testers, and my sword was made as a gift to Yamada Asaemon Yoshimasa, the chief tester to the Tokugawa *shogun*. Many of Munestugu's swords were inscribed with tests carried out at the Senju execution ground and many different cuts were used and mentioned in the *nakago* inscriptions, such as *ryo-guruma* (hips), *taitai* (chest), and *chiwari* (armpits). This is a beautifully made sword that also was capable of the most difficult cuts, and is indeed a treasure.

Finally, in more modern times, tests were often made in the early Showa period, the time leading up to the Pacific War (1941–1945). Again, it was necessary for the 20th century *samurai*, imbued with patriotism and *bushido*, to know if his sword would cut. One of the most accomplished testers was a *kendo* master named Hakudo Nakayama. Tests were carried out on straw bales wrapped around bamboo, since this was supposed to have a similar consistency to flesh and bone. Hakudo demonstrated his skills in front of leading politicians and army officers, and even the emperor on one occasion.

Etiquette and Customs for Sword Appreciation and Viewing

If you practice any of the sword-related martial arts, such as *kendo* or *iai-do*, then from the very first day, before you even pick up the wooden practice sword, you will be made aware of *reigi*. This has been defined as covering such areas as "courtesy, decorum, etiquette, civility, propriety, and discipline." Such things are reflected in how one conducts oneself in the *dojo*, and how one relates to those of both higher and lower grades. *Reigi* is what prevents these martial ways from becoming uncivilized and brutal.

A fundamental precept of *reigi* in this context is respect for the sword, even in its imitated form of a *bokuto* or wooden substitute, which is customarily wiped with a clean cloth, before and after use. Swords are placed on the *dojo* floor with respect and care, avoiding noise or clatter, and they should never be placed on the *hakama* (traditional clothing) since this is considered a blatant breach of etiquette.

There are correct ways of bowing when entering or leaving the *dojo* and carrying a sword. These practices are sometimes a surprise to the novice, who might view the activities as purely sport, but they are of great importance from both a cultural and safety point of view.

Below The lack of aggressive intent, after these two gentlemen have demonstrated *kendo-no-kata*, may be seen by both swords being placed on the right-hand side where it is impossible to draw them quickly.

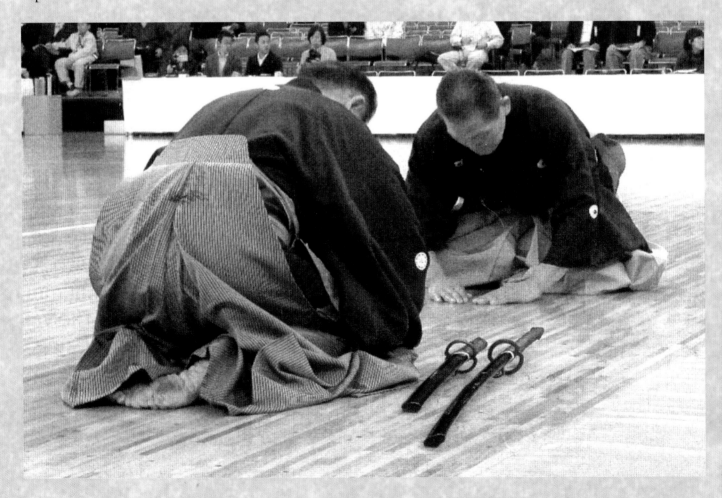

Reigi was a natural and accepted concept in old Japan, and one's behavior when handling swords was of great importance. Inappropriate actions could have led to serious consequences. Today, in Japan, there are occasions when swords are viewed by large numbers of people at the same time, such as at a *To-ken Taikai* or sword convention. Often these days, such events are attended by significant numbers of non-Japanese people, and their sword handling abilities need to be faultless. At the NBTHK convention in Tokyo, for instance, there may be up to two hundred swords to view and, as these are all important swords, no hint of a breach in etiquette is permissible. All swords are laid on tables with the *nakago* nearest the edge and the *monouichi* (upper third of the blade) resting on a *makura*, or small pillow. They are already prepared for viewing so there is no disassembling required in this situation. As one approaches the sword, very good manners require a small *rei* or bow in the direction of the blade, thereby acknowledging and respecting its age and beauty.

Above A formal mass viewing of some 200 swords at a Nihon Bijutsu Token Hokon Kyokai (NBTHK) convention in Tokyo. Here, several hundred people would view the swords, and correct swordhandling is essential.

The sword must then be picked up in one smooth action and supported on the cloth provided (the *fukusa*) while being studied. When lifting this naked blade, care should be taken that the *kissaki* (point) does not dip and touch the table itself. In other words, the sword needs to be almost scooped up so that the *kissaki* immediately rises rather than falls.

It goes without saying that the blade should not be pivoted on the *kissaki*. When clear of the table the methods and rules for examination are as described below. When replacing the sword back on the *makura*, similar care should be taken. As the viewing is finished the sword is replaced on the *makura*, a step back from the table should be taken, and the *rei* is repeated before one moves on to the next sword. It is worth mentioning here that at such a particular sword viewing

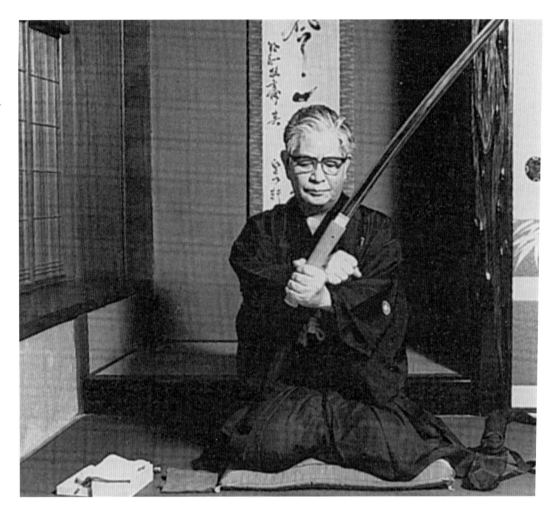

Right When a *tsuka* proves reluctant to be removed, the sword is held at the angle shown and the back of the left hand is struck sharply with the right. This is usually enough to loosen the *tsuka*.

opportunity, since there are many delegates attending, a timer will be in action. This makes a rather annoying sound and indicates that your one minute per sword is up and it is time to move on. Any delay in so doing has a domino effect down the line, so is best avoided.

Of course, common sense in addition to correct etiquette dictate that the blade should be kept facing forward and not swung around, risking a clash. The blade should never be permitted to come into contact with the skin, since natural acid on the hand will cause rust. Nor should a naked blade be rested on clothing, such as a sleeve.

There must be no talking while handling the blade as this may spray the blade with spittle and cause damage. Cameras or shoulder bags should not be worn since there is a chance that they could swing into a sword and cause damage. Although observed more in the breach than usual practice, wearing of a sober suit or jacket and tie are considered respectful and appropriate attire.

The arrangement of swords on tables on such occasions is a very easy and convenient way to view

swords, and many *kantei* or sword identification sessions are conducted in a similar manner. Alternatively, the swords may be laid out on the *tatami* mats on the floor. It may sometimes be rather difficult for the average westerner to adopt and maintain the *seiza* or kneeling position, more natural to our Japanese colleagues.

In modern days a light source is usually available when studying a blade. This enables the *hamon* and *jihada* (pattern of the body of the blade) to be seen clearly and in detail, but often involves a certain amount of twisting and turning in order to obtain the best angle between light and blade. Great care must be taken in this situation and a good grip must be kept on the *nakago*, while the other hand supports the blade with a *fukusa*.

Often, such a viewing will entail several people studying several blades between them, at the same table, either standing or in a kneeling position. It must be emphasized that it is of the utmost importance that all blades are kept facing to the front and not waved around. A clash of swords would be an unforgivable

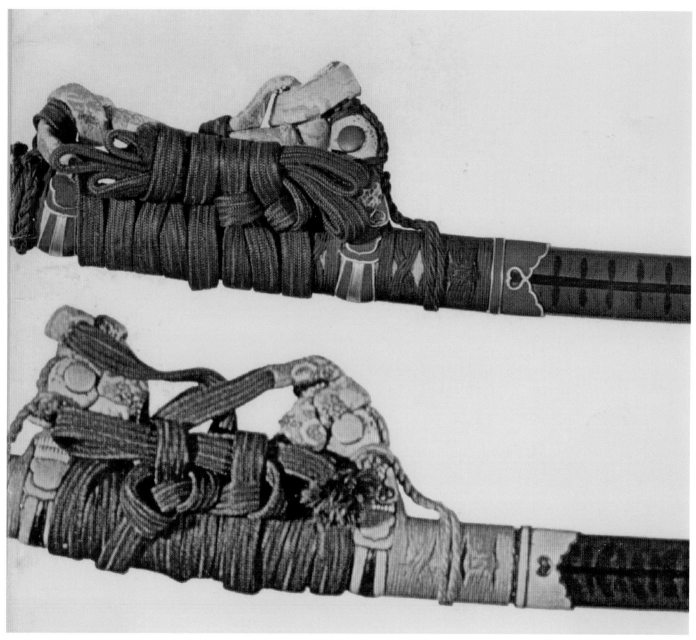

Above The more intricate knots tied on a *tachi* (slung sword) called *tachi-musubi*.

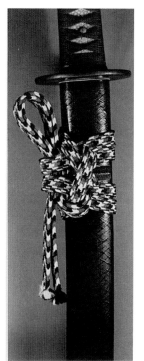

Left The sword knot known as *cho-musubi* or butterfly knot. Such knots would only be tied on swords that were on *katana-kake* (sword racks).

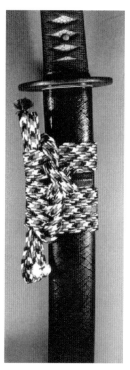

Right Another knot known as the *ronin-musubi*, or master-less *samurai* knot.

breach of etiquette and probably result in the perpetrator catching the next flight home. It is difficult to imagine how one would ever be invited to return under such circumstances. In all other respects, group viewing should follow the same rules as previously described.

In the days of yore, when swords were worn by *samurai*, the etiquette of the sword was far more wide-ranging and important even than today. The correct way to wear the *daisho* was soon learned by the young *samurai*. It was necessary that it be worn comfortably in the *obi*, or sash, with the cutting edge uppermost. The correct wearing was very important as this had a direct influence on the sword drawing and fighting techniques available. It might have to be worn comfortably for long periods of time while walking, standing, or sitting. In addition, the position of the *daito* (long sword) needed to accommodate the *shoto* (short sword), which was also thrust through the obi but at the center of the body and inside of the *daito*.

The precise angle at which they were worn was very important as neither of these swords could be permitted to interfere with the drawing of the other, if the wearer were confronted by an emergency. At the same time, the correct position helped avoid a clash of scabbards, known as *saya-atte*, or scabbard hitting. This meant that if two *saya* collided, instant retribution would follow since the sword had been struck, and this was perceived as tantamount to striking the owner. A technique was devised whereby as soon as the *saya* touched, the sword would be drawn and an attacking cut would be made (*nukitsuki*) all in the one action. *Saya-atte* might even be deliberately caused so that a ne're-do-well might have the opportunity of testing both his sword's cutting potential and his own technical ability, all in the one

Above If, on the other hand, the *tsuka* are facing to the right, where they may be more easily picked up and drawn, a state of readiness could be assumed, and the martial preparedness of the house could be easily seen.

swift incident. To avoid accidental *saya-atte*, it was considered best when walking out to walk to the left of a path or road and allow an approaching walker to pass on one's right-hand side, away from the *saya*. It is even thought that this legacy may be why the Japanese are one of the few nations in the world to drive on the left-hand side of the road.

It was quite easy to give the wrong impression, so great care was taken to neither offer nor invite provocation. This was done by the practice of a rigid code of etiquette in any given circumstances. It was usual, for instance, when visiting, especially a person of higher rank, to leave one's long sword at the entrance to the house. It would be taken, very deferentially, by a servant or a page who would handle it with a silk cloth and then place it on a sword rack ready for collection

on departure. The visitor would be allowed to keep his short sword, which he would be careful to keep in a position in which he could easily draw it if he were attacked. Even with the sole comfort of the short sword, care was taken to keep the left hand away from the *tsuba*, since a thumb pushing the *tsuba* forward, thus loosening the blade in the *saya*, might be perceived as the first preparatory move in drawing the sword.

The display of non-aggressive intentions was even more important if the long sword was taken to a meeting or social engagement. Here it would be removed from the *obi* or belt as the visitor made himself comfortable and knelt in *seiza* on the *tatami* mats or wooden floor. Incidentally, the *seiza* position of kneeling, with legs folded under the buttocks and toes flat, was considered a totally "dead" position since it was almost impossible to mount a quick attack from there without first coming up onto one's toes.

Ideally, the sword should be removed with the left hand, passed over to the right hand, and placed on the

mat on the right hand side of the owner. From here it was relatively difficult to pick up and draw quickly, while if placed on the left hand side, the opposite was true. It would be seen, therefore, as highly suspicious if the sword were placed on the left, especially with the cutting edge of the blade away from the owner. From this position it was very easy to grasp the *saya* with the left hand while reaching across and drawing the blade with the right hand. The significance of where the sword was placed meant that the owner was either relaxed and expecting or offering no trouble (if on the right), or wary and maybe ready to fight (if on the left). Whatever the case, the mood of the meeting was quite obvious to all.

Today, in a modern *kendo dojo*, the members always kneel in *seiza* both when formally starting and finishing the session, with their *shinai* to their left, in imitation of a state of *zanshin* (preparedness and awareness). Also, in *kendo* and *iai dojo*, the practitioners and teachers start and finish a session with a formal bow with everyone kneeling in a prescribed order. All should know their position in this line, which is in ascending order of rank or status, the lowest being at the end nearest the door. Apart from easily seeing one's *gohai/ sempai* (or relative superiority) situation, in the case of an attack on the *dojo* the lowest grades would offer themselves as delaying cannon-fodder and sacrificial lambs, while the higher ranks had time to prepare themselves for defense. This no doubt provided a great incentive to advance in the art and progress down the line towards relative safety. Even today it is customary in an *iai dojo* to begin and end a practice with a bow to one's own sword (known as *to-rei*).

There are also correct ways of placing a sword on a *katana-kake* or sword rack. If the sword is a traditional *katana, wakizashi* or a *daisho*, it should be placed on the rack with the cutting edges uppermost, the *katana* at the top and the *wakizashi* on the bottom, imitating the manner in which they are worn. A further refinement

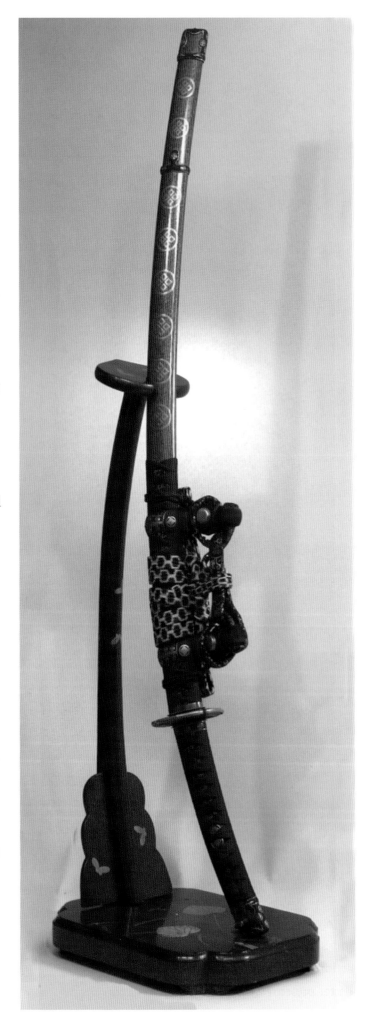

Right This spectacular *tachi* is correctly placed on the *tachi-kake*. It would normally be kept alongside a gentleman's armor.

Left The late Haruna *sensei*, having just replaced his sword into its scabbard in the *iai-do* action called *no-to*.

might be that the *kurikata* (retaining knob on the *saya*) should be visible, in other words that the *omote* side or front of the sword is showing and the *tsuka* (handle) is to the left-hand side. Once again, it is surprisingly difficult to pick up a sword so arranged and draw it immediately without changing hands and slowing the action down. To my mind, the swords happen to be also better presented in this way. To display the swords with

the *ura* showing was also acceptable but, as they could be drawn from this position in an instant, it was seen as a far more aggressive position and for this reason favored by many warriors.

When swords are "at rest" on the *katana-kake*, often the *sageo*, which is the retaining cord, is left on the sword. Usually, these are tied in a decorative knot to enhance the appearance of the display. There are many

Above When viewing a blade, it should never be allowed to touch naked skin and should be supported by a *fukusa,* as shown by Ikkansai Takahana.

different arrangements, variously called *daimyo-musubi* (Lord's knot), *ronin-musubi* (*ronin*'s knot), and *cho-musubi* (butterfly knot) and the like. Although very complicated-looking knots, in all instances they may be undone in one pull of a free end, so that they are not preventing rapid use of the sword. Indeed, it would have been possible to tell the state of any house or castle's martial preparedness, simply by seeing how the swords were displayed on their racks.

A *tachi,* or slung sword, ideally has a differently designed rack from that made for *katana.* A *tachi-kake* or *tachi* stand has a shaped base and a vertical stem with

Above In a museum arrangement, it is acceptable that a naked blade may be displayed on a silk-covered stand. A *katana* would be presented cutting edge uppermost, as in this blade, while a *tachi* would be cutting edge down, both in the manner in which they would have been worn.

a slot to accept the *saya*. *Tachi* should be placed on these racks with the end of the handle, the *kabuto-gane*, resting on a small indentation on the base. It will then stand vertically with the butt-end of the *saya* free in the air. Should it be necessary to place a *tachi* on a conventional *katana-kake*, then it should be placed with the cutting edge down, in the opposite manner to a *katana*. Once again, this is the position in which the sword would be worn. Ideally, a *tachi* on a rack would be placed next to the owner's armor since when he wore the armor, the *tachi* was the correct sword to wear. A beautifully made and lacquered sword rack will enhance the display of a sword "at rest" but it is incredible how unnatural a sword looks when placed incorrectly on the rack or stand.

Although it was a breach of etiquette to request a look at another's sword, there would have been occasions when a fully mounted sword was passed between two persons, possibly for inspection, study or appreciation. This would usually be accomplished while in *seiza*. After a short bow to the sword, the giver would remove it from the rack, clean it, and pass it across, usually in a horizontal plane, with both hands fully outstretched. The cutting edge would be towards him and the *tsuka* to his left. The right hand would be near to the end of the *saya* and the left would be palm uppermost near the *tsuba* with the thumb on the mimi or rim of the *tsuba*, ensuring the blade did not inadvertently slip from its *saya*. The recipient would grip inside of the giver's hand on the *saya* and take over the position by the *tsuba*. He would immediately turn the cutting edge towards himself, give a slight bow of respect, and proceed to examine the piece.

In ancient times, this might be accompanied by a bow from the giver and, if the rank of the receiver was exalted, or the sword was known to be especially important, the bow would place the sword at head

level. As an indication of good manners and respect for another's property, especially if exceptional lacquer work be evident on the *saya*, a silk *fukusa* would be used to handle the sword. This would normally be supplied by the host, but it is advisable to carry one's own and be fully prepared.

After observing the correct procedures as described above, finally the sword, complete with mounts, is safely in the viewer's hands and he may be permitted to study it. He should make himself aware of whether or not the *mekugi* (peg) is inserted in the *tsuka*, rather than find out by accident when the blade falls out of the *tsuka*! A close examination of the fittings and the lacquer work would precede the

Above The correct way to pass a blade to somebody else is to keep the cutting edge towards oneself and, in the absence of a *tsuka*, support the bottom of the *nakago* with one's left hand.

drawing of the blade. Today a sword with fine fittings should be examined while wearing white cotton gloves if possible, but, if not, with a *fukusa* as described above. The sweat from hands may cause discoloration or even rust and this is obviously to be avoided.

To draw the blade, the *saya* should be gripped in the left hand held slightly lower than the *tsuka*, but with the cutting edge uppermost, and drawn in one smooth action. Under no circumstances should a blade be drawn out only a few inches and be inspected since this is considered the height of bad manners. Inspection should take place only when the sword is fully withdrawn from the *saya*. The *saya* should be placed safely aside, beside you on the *tatami* with the *koiguchi* (scabbard mouth) to your rear, if that is your situation, or back on the rack or table, depending on the circumstances. While you are examining the blade, it is good form to cover the end of the *saya* with a cloth, or the flap of the sword bag if one is present, so as to

prevent any dirt or grit entering the *saya* and causing damage to the blade after it is replaced.

The normal method of removing the *tsuka*, from either a mounted sword or one in *shira-saya* (plain storage mounts), is first to remove the *mekugi* or peg with a *mekugi-nuki*; hold the *tsuka* near its base in the left hand with the blade at a slight angle (say 20 to 30 degrees from the vertical), with the inclination across your front side and the cutting edge uppermost; then with a tight left-hand grip, strike the top of your left hand smartly with your clenched right fist, on the little finger side rather than with the knuckles. The shock of the strike transmits through your left hand, through the *tsuka*, and usually loosens the hold of the *tsuka* on the *nakago*, allowing the blade to be easily removed from the *tsuka*. If this doesn't work after two or three attempts, it probably means that the blade is unlikely to be freed in this manner. I have occasionally found myself in this position where, on asking permission to remove the *mekugi*, it has not easily tapped out, or if it does, the *tsuka* proves stubborn. In this situation, not wishing to be responsible for causing any damage, either to my left hand or the sword, I have invariably asked the owner to remove it for me. If he, who is familiar with the sword, also has difficulty, it is best to leave it intact. It makes sense, if you are expecting a visitor to view your swords, to check the swords in advance to avoid this complication.

An alternative method of handing a sword from one person to another might involve passing the sword without its *saya* but retaining its *tsuka*. In this case, the giver would hold the end of the *tsuka* firmly at the end nearest the *kashira* with the blade held vertically in his

left hand, again most definitely keeping the cutting edge towards himself. The potential danger and perception of aggressive intent in doing it otherwise will be readily understood. In this circumstance the receiver will accept the sword by grasping above the giver's hand with his left hand and nodding to acknowledge that he has a firm grip, possibly acknowledging this verbally also. During this latter procedure both parties always have their right hand free! As soon as he has a firm grip, the receiver will turn the cutting edge towards himself.

Most properly, a silk handkerchief should be placed in one's mouth to prevent spittle fouling the blade, and speaking should be avoided when a naked blade is present, for the same reason. A blade should be withdrawn from the *saya* only in its entirety, and great care should be taken that it is not waved around and pointed at anyone else. The handle should be removed to inspect any inscriptions only with the express permission of the owner.

The blade may be examined in detail, but should not be handled other than with a *fukusa* or some other suitable soft fabric. If the *tsuka* is removed, it is permissible to handle the *nakago*, while supporting the rest of the blade with a *fukusa*. It is usual to leave the *habaki* (collar) in place while examining an otherwise bare blade, and it is considered correct manners to examine the *omote* or front side of the sword first. There have been occasions, outside of Japan, when I have been told to wear cotton gloves while only examining a blade. I personally prefer not to do this as I think it creates the possibility of the blade slipping through one's fingers.

To pass a fully stripped blade, the *nakago* must be

Above The sword is drawn with the *saya* held lower than the *tsuka* and along its *mune* or back edge, thus avoiding damaging the *saya* with the cutting edge.

gripped in the same manner as the *tsuka* on a mounted blade. The sword should be passed vertically to the receiver in exactly the same manner as described when the sword retains its *tsuka*. However, in this circumstance, it is advisable that the free right hand be placed under the *nakago-jiri* for extra support. When replacing the sword into the *saya*, the back of the *kissaki* is rested on the inner part of the *koi-guchi* (mouth of the scabbard), and the blade is then replaced in the exact opposite method to that described for drawing it. This applies in all circumstances.

The over-riding consideration is that the person handling the blade is, at all times, at the mercy of the blade should he mishandle it. This was, and remains the etiquette involved in handling a Japanese sword. It emphasizes great respect for the sword, personal safety, and a high degree of *zanshin*, or awareness. Although today we may not fear an attack, the other components still remain and should always be practiced, showing respect also for the *samurai* owners of the past, whose swords we are privileged to examine and enjoy today.

I am aware that on various visits to closely study good swords in Japan, both accompanied by others and on my own, sword-handling etiquette and ability have been closely scrutinized by our Japanese hosts and *sensei*. Often in this situation exalted sword personalities, such as museum curators or NBTHK officials, will be watching closely, and they have been known to comment on the "manners" of the guests. It is a direct reflection on oneself and one's teacher, whether good or bad. I am sure that, for foreigners in Japan, there is less tolerance than for the native Japanese, and we must be more scrupulous in our sword handling than are they.

Collecting and Studying
Japanese Swords

As in most societies, it was the nobility and higher ranks in Japan that were most easily able to indulge themselves in collecting, studying, and generally appreciating the artistic qualities of Japanese swords, while their underlings and social inferiors got on with the more mundane tasks of ensuring that there was enough rice for their families to eat. It became part of every nobleman's formal education to be conversant in the traditional Japanese arts of "the way of tea," calligraphy, poetry, and of Japanese sword appreciation. Whether *samurai* or high-powered modern executive, a Japanese gentleman may relax at home and unsheath a sword in order to contemplate the blade. This is not merely an idle gaze at a stunning work of art, but also a deep and meaningful

Above Right The "Black Ships" of U.S. Navy Commodore Perry's fleet opened Japan for trade and access by the Western powers. Treaties were established allowing foreigners to reside in the "Treaty Ports" such as Yokohama and later Kobe.

Right Diplomatic missions were sent out to many Western countries as Japan opened her doors for trade. These sober gentlemen formed a "*samurai* mission" to the United States in 1860 and they, and others like them, helped spark the interest in all things Japanese.

form of meditation, as practiced in *Zen*. There is, therefore, a long and respected tradition of Japanese sword appreciation among the Japanese upper classes, where swords are considered to be an important and peculiarly Japanese cultural asset.

By the middle of the 19th century, Western countries had forced trading treaties onto Japan and "opened" the country in spite of the *shogunate* policy of isolation that had been in place since the early Tokugawa, or Edo period. As part of this move, the foreigners had demanded the opening of certain free ports such as Yokohama and Kobe. In these ports, known as the Concession or Treaty Ports, Japanese law was suspended and that of the countries concerned replaced it. Such manifestly unfair laws were greatly resented by the Japanese government and added to the social unrest in the country. However, many Europeans and Americans came into direct contact with both the *samurai* and their formidable swords, sometimes with deadly consequences, but now they were considered outdated weapons.

Japan went through a century of revolutionary change, starting with the restoration of direct imperial rule and the overthrow of the *shogunate* system of government in 1868. The sword-carrying *samurai* soon became a thing of the past as Japan pursued an aggressive drive to modernize and become a first-class nation. Laws were passed prohibiting the wearing of swords by all but the new imperial army, navy, and police force. This transition was not achieved without some domestic bloodshed, but the conservative *samurai* were unable to resist the overwhelming pressures to

Above With the overthrow of the *shogunate* system of government, the Emperor Meiji, himself a keen sword collector and connoisseur, was (at least nominally) the head of the new government from 1868.

modernize. The precious swords, long romantically considered to have been the "Soul of the *Samurai*," had been found inadequate and largely ineffective against a modern peasant conscript army armed with repeating rifles. The *samurai* fighting spirit was found to be no answer to modern technology (an echo of things to come in the 1940s Pacific War) and those hitherto revered swords had failed to expel the ever-increasing presence of the foreigners. Eventually the patriotic cry of "Revere the emperor and expel the barbarians" was replaced by the more practical and realistic slogan of "Rich country—strong army."

An amazing reaction seems to have taken place to the *samurai*'s changing circumstances, as thousands of swords and armors were crated up and dumped on the docks at places such as Kobe and Yokohama, the foreign Concession Ports. From here, enterprising merchants sold and exported them to the foreigners, who eagerly snapped up bargains.

As the potential of this market was spotted, various bits of swords were also hastily thrown together, the handles rewrapped, and scabbards painted with ornate designs parodying the fine lacquer of genuine pieces. The name *hama-mono* (dock-things) was coined for these weapons that eventually found eager customers in New York, London, and Paris.

In Europe, especially, the arts of Japan became very fashionable, and important artistic movements such as the French Impressionist painting school were directly inspired by the woodblock prints of Hokusai and Hiroshige, even though these were only used as

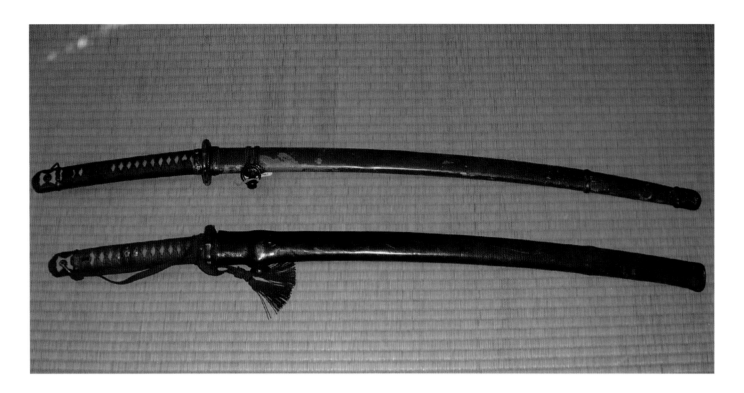

Above The *shingunto* was the standard army mounting carried by Japanese officers in the Pacific War (1941–1945). The lower one has a leather foul-weather cover and a knot of major to colonel rank. The similarity to a *tachi* mount may be seen in the upper sword.

packing in crates! It was at this time in the Meiji period that many of the large collections were put together in the West as gentlemen collectors bought these "exotic weapons" from this "quaint little backward country." Some of these collections became huge, as the buyers needed to pay only a fraction of the true value.

Many years ago I was acquainted with an old gentleman, then in his nineties, who recounted the story of a day spent in his youth at the East India Docks in the east of London. He was watching massive high cranes being used to unload crates from a ship from the

Above As was usually issued in the Burma theater, this is an official "retention slip" that gave permission for a soldier to take a Japanese sword as a souvenir. This one accompanied a sword with a cutting test result.

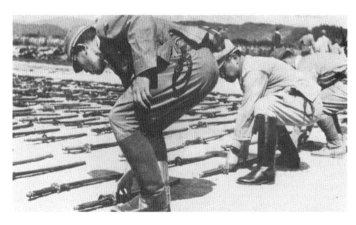

Above This mass surrender of swords took place in Kuala Lumpur, Malaya, in September 1945.

Orient. One crate slipped and fell and its contents were spilled over the dockside. This was not an uncommon occurrence, and it was considered by the dockers to be one of the perks of the job if they were able to help themselves to a few choice items. On this occasion, however, they were not interested, as the entire crate contained only "Chinese belt-buckles." Of course, these were actually *tsuba* and my acquaintance managed that day to begin what was to become quite a sizeable *tsuba* collection, most of which now sits in the vaults of an Oxford museum, never seeing the light of day.

It has been speculated that the type of items collected at this time closely reflected the national characteristics

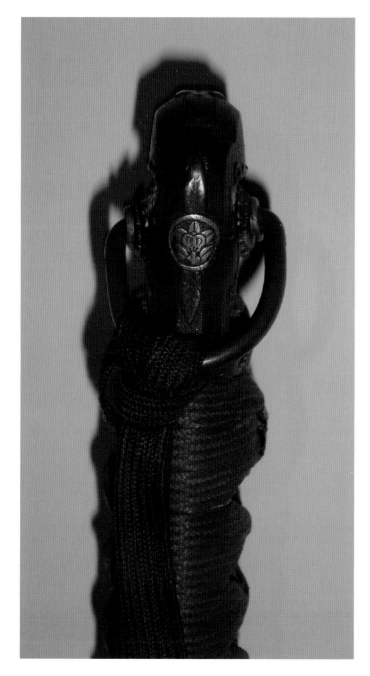

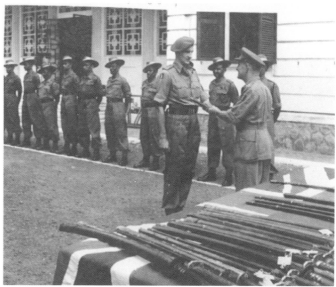

Above After Japanese officers' swords were surrendered to Allied troops at the end of World War II, ceremonies were held to distribute the swords to individual Allied officers (this is an Indian Army ceremony).

Left This *tsuka*, or handle, of a *shingunto* shows a silver family *mon*, or crest. Frequently, these were defaced to avoid family disgrace when the sword was surrendered, and often indicate a superior blade. This *mon* represents orange blossom.

often from swordsmiths who were still active or at least alive at the time. Many of these more knowledgeable collectors gave lectures and wrote papers that are still around today, and through the early part of the century there was a considerable amount of translation from Japanese sources on the subject of swords and armor.

Japan's headlong rush to adopt everything that was Western included some of the less desirable attributes. As well as embracing railways, telegraphic communications, and Western dress, it was seen as a priority to make the country militarily strong. To have a say in world affairs and dine at the same table as the "great powers," Japan needed a strong army and navy and, ideally, in imitation of these great powers, a few colonies dotted around that could also supply the raw materials on which the expansion fed. With some degree of success, beating China and then Russia in an historic naval battle along the way, Japan succeeded in these aims and her alliance with Great Britain against Germany in World War I gained her the status she required, as well as certain ex-German territories in the Far East. However, almost inevitably the expansionist

of the collectors. For instance, the Italians collected very ornate and decorative objects, and the Germans bought objects from specific schools that they could efficiently classify into groups, while the Americans bought everything, reflecting the multiracial make-up of that country. Many of the pieces found new homes in English country houses or museums, and a number of important exhibitions of swords, fittings, and armor, were held in the early 20th century.

Knowledge of the Japanese sword was not generally very high, but these early collectors often had a good eye for quality since they were normally surrounded by good quality objects in their everyday lives. Some, however, managed to learn a lot about the subject,

policies ended with the raid on the U.S. Navy's base at Pearl Harbor on December 7, 1941. The equally inevitable consequence of this action was that, some four-and-a-half years later, General Douglas MacArthur began the military occupation of the Japanese homeland. This was the start of the second great wave of Japanese swords moving from East to West.

At the fall of Japan in August 1945, following the atomic bomb attacks on Hiroshima and Nagasaki, Lord Louis Mountbatten (Supreme Commander South East Asia) decreed that official surrender ceremonies, complete with the somewhat old-fashioned yet symbolic handing over of a sword, should take place in all theaters of war. The significance of surrendering their swords was

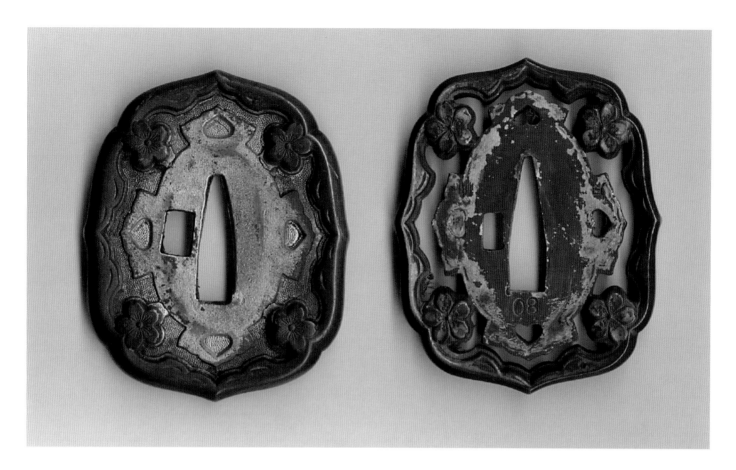

not lost on the Japanese officers, and the disgrace was deeply felt. As all officers of the Imperial Japanese Army and Navy had been required to carry a "*Samurai* Sword" as part of their uniform, many hundreds of thousands of swords were given up and often distributed among Allied officers as war souvenirs.

MacArthur ordered that the Japanese civilian population should also give up all their swords, which he decreed should all be destroyed! Horrific photographs exist of workers, standing knee deep in swords, shoveling them into a furnace. Fortunately for later collectors, this order was partially revoked after some strong lobbying, and swords of artistic or historical value were saved. It seems most probable that many Japanese simply hid away their swords under the floor or in the rafters, as in previous "sword hunts," but thousands were handed in or seized by the authorities. There is evidence that some very important swords went missing at this time and have not been located to this day. These included swords removed from shrines and private individuals. Some of these had been designated *Kokuho* or National Treasure swords, but whether they actually ever left Japan provides an area of

Top At sword shows or arms fairs, collectors may encounter literally piles of swords mounted as *shingunto*. It may save time to look first at those with pierced *tsuba* (shown at right), which may indicate that the sword has a superior blade, although both are brass and decorated with the cherry blossom design.

Above Dr. Walter Compton, flanked by Sato Kanzan and Homma Junji, inspecting the Saburo Kunimune National Treasure *tachi*, which he returned to the Japanese nation. Compton had the largest collection in the USA.

Left The author of many sword books, Yazu Kizu (1900–1983) was born in Osaka and emigrated to California in 1917. The sword he is holding is by the 19th century swordsmith Masao. The *horimono* reads, "Go not to your enemy. Let him come to you."

interesting speculation. Suffice to say that a great many swords, good, bad, and indifferent, found their way to the West during this period. Such swords, the most commonly encountered today, usually have a standard issue mounting called *shingunto* (Army) or *kaigunto* (Navy) and are easily recognizable. The blades in these mountings, however, vary greatly in quality from very good indeed to those of little value.

For obvious reasons, World War II and its aftermath caused an immediate decline in the popularity of Japanese culture in the West. Most of the swords that went to the West as surrender trophies found homes in the United States or Great Britain, but all of the Allied powers received some swords via homecoming troops. Indeed, it is said that many now reside in the sea off the disembarkation ports as the troops feared they were illegally trying to bring home unauthorized weapons! However, many swords found their way onto the walls of the veterans' homes or into regimental museums.

The United States was especially lucky in this respect, since her soldiers became the occupation forces in Japan. As such, when the laws prohibiting the

Above and Right These three hand-colored photographs were taken in the 1870s to 1880s, and help show the rapidly changing face of Japan. They clearly show the vast numbers of swords and armor available in "curio shops" to foreign souvenir hunters. The shops were most likely to have been located in the Treaty or Concession Port of Yokohama. The photo above shows several swords on racks, and a suit of armor. There are also two bows next to the armor.

The photo top right shows several swords with two suits of armor and a matchlock gun (*tanegashima*).

The photo at right shows what may be a specialist sword and armor shop in Yokohama, although the items on display do not appear to be of great quality. Note the large *o-dachi* to the front.

ownership and making of swords were enacted, many of the new "collectors" were able to acquire good old swords rather than just *gunto*. This meant that, after the war, there were vast numbers of Japanese swords in America. Both in the United States and in Europe, the few collectors who were still interested in the arts of the Japanese sword once again found it possible to form or add to good collections at very reasonable prices, largely due to the anti-Japanese feeling prevailing immediately after the war.

Throughout the 1950s and early 1960s there was a gradual growth of interest in the Japanese sword and

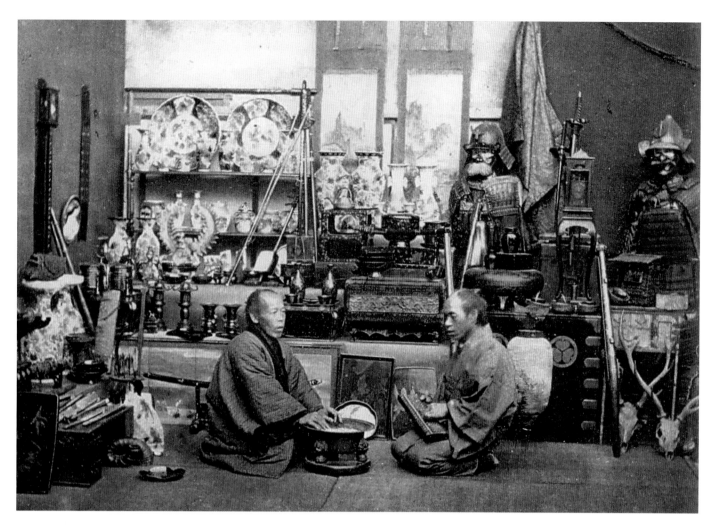

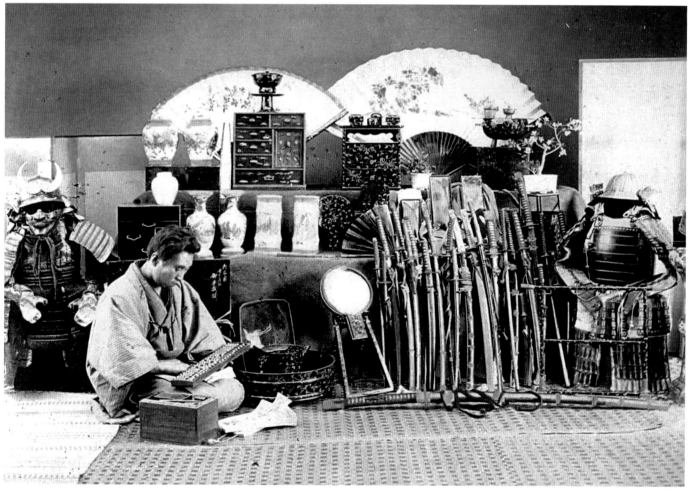

Right Sato Kanzan *sensei*, an inspirational teacher who helped found the NBTHK. He is seen here in a formal pose.

this heightened interest meant that many study clubs were formed or that existing ones became more popular. As an example, The To-ken Society of Great Britain, having been formed in the early 1960s, is the oldest such society in Europe, while the Japan Sword Society of the United States is the largest in the United States.

These and other organizations attempt to educate members on the subject, as well as holding seminars and sword shows known as *To-ken taikai*. The luckiest have had authoritative Japanese experts as their teachers, such as John Yumoto in the U.S. and Mishina Kenji in Britain. These clubs thrived and are still very active.

While study was emphasized during the early days of such organizations, acquisition of swords appeared to be of paramount importance, as well as still being quite an achievable goal. Maybe people were not exactly collecting Japanese swords; rather, one might say they were accumulating Japanese swords. In the West there was still little study or understanding of the sword or fittings as art, although in the new and democratic postwar Japan it was both policy and politically advisable to emphasize the artistic attributes of swords. This attitude coincided with the country projecting itself as full of tea drinking, flower arranging, giggling Geisha and ignoring Japan's martial past, an attitude strongly condemned by Japan's great and internationally acclaimed author, Mishima Yukio.

As the Japanese economy grew in the 1970s, a furious assault was launched from Japan into the USA, Europe, and Australasia to buy back these "peculiarly Japanese cultural assets." I have heard this period called by some older American collectors the time of the "Gold Rush." It is an apt description, since thousands of swords changed hands to feed the seemingly insatiable Japanese dealers' appetites. These Japanese were as far removed from the haughty *samurai*, who disdained to touch money, as *sushi* is from steak! Rather, they were often the greedy and sometimes unscrupulous merchants of Tokyo, Osaka, and Kobe. A feeding frenzy was precipitated that would last at least a decade and deprive the West of many of its best collections of Japanese art. It must also be admitted that these Japanese merchants soon found a fifth column of willing dealers in the West, who fully co-operated with them and fueled the "Gold Rush."

When Japan's "bubble economy" burst in 1989 the

Above The Dai Token Ichi sword fair in Tokyo, attended by most of the Japanese dealing fraternity, is visited by an increasing number of Westerners, who find a vast selection of swords to choose from.

dealers from Japan stayed away from the sword sales and business obviously became more difficult for the Western dealers who had based their business entirely on supplying the Japanese market. It soon became obvious that they needed to adapt to the change in circumstances or cease trading in Japanese swords, fittings, and armor. It was necessary for them to pay far greater attention to their domestic markets and the needs of the domestic collectors, which were not necessarily the same as those of their Japanese clientele.

The average Western collector needs to better understand Japanese swords before he can have the confidence to become a regular customer for the dealer. Most reputable dealers will guarantee that swords are not seriously flawed (such as having *ha-giri*) and some will even offer money-back guarantees if the sword turns out to fail *shinsa* because it is *gimei* (false signature). It is a good idea for the novice, and maybe even the rest of us, only to buy swords that have successfully passed *shinsa* and are accompanied by the paperwork to support it. This may be particularly relevant to swords that are purchased on internet websites or other places where it has been impossible to handle the sword and closely inspect it. These days, since so many swords have been submitted for Japanese appraisal at *shinsa*, the absence of a certificate of authenticity may, but not necessarily, mean the sword has failed the *shinsa*!

As part of their education and confidence building, the new collector should take advantage of the many opportunities to see and handle swords that are offered at the large shows devoted to the subject, both in the United States and Europe. Annual shows at San Francisco, Tampa, and Chicago are good examples of this, both from social and educational

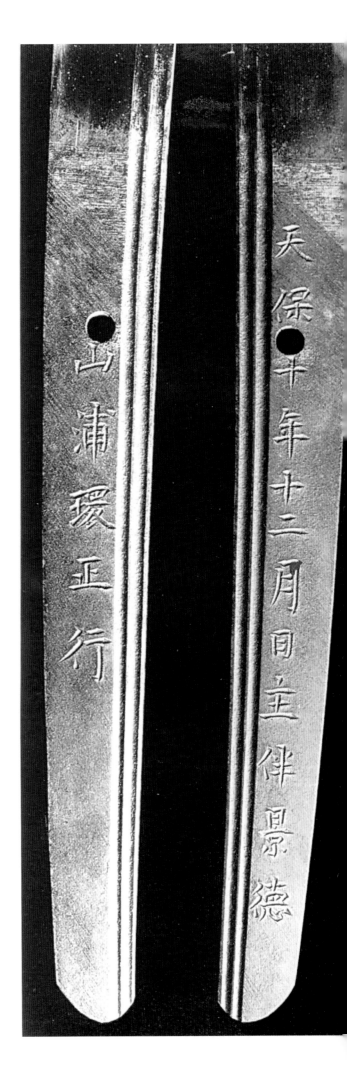

standpoints. Mostly, the novice will encounter friendly and informative table-holders who are happy to talk extensively about their wares.

It has always been difficult for the non-Japanese reader to access the invaluable information to be found in many books in Japan. The few English language books available are all rather basic, although invaluable in the earlier stages of collecting or studying the subject. Therefore, the translation of books such as *The Connoisseur's Book of Japanese Swords* by Nagayama Kokan (translated by Kenji Mishina), Fujishiro's *Koto and Shinto Jiten*, and *Nihon To Koza* (translated by Harry AFU Watson) and others has provided an amazing leap forward and raised standards to new heights of understanding. Add to this the access to top quality swords available to all, at events such as the NBTHK conventions, and it may be seen that the study and understanding of Japanese swords by Westerners is in a healthy state. New technology has been quickly utilized with internet websites and other forums devoted to the subject of Japanese swords.

The close study of Japanese swords is a highly time consuming and difficult process, but nothing can replace the time spent studying actual swords if a full appreciation is to be realized. The following brief notes, aimed mainly at the more novice collector, can be no more than a very rough guide to sword appraisal. Further, many of the points are highly subjective. It would be a great start to already have seen some good swords: if you have seen the best then you have a benchmark for judging those of lesser quality.

There is a reasonably logical procedure for examining a Japanese sword blade and this is used in the practice of *kantei nyusatsu*. In *kantei* sessions, a blade is presented to a participant, and any inscription there might be on the *nakago* is covered. The maker's name, or at least the period of manufacture and school, must then be guessed. If the procedures are followed, this apparently daunting task may be accomplished with less difficulty than might be expected. The procedure for *kantei* and the points to look for in order to determine tell good from bad are as follows.

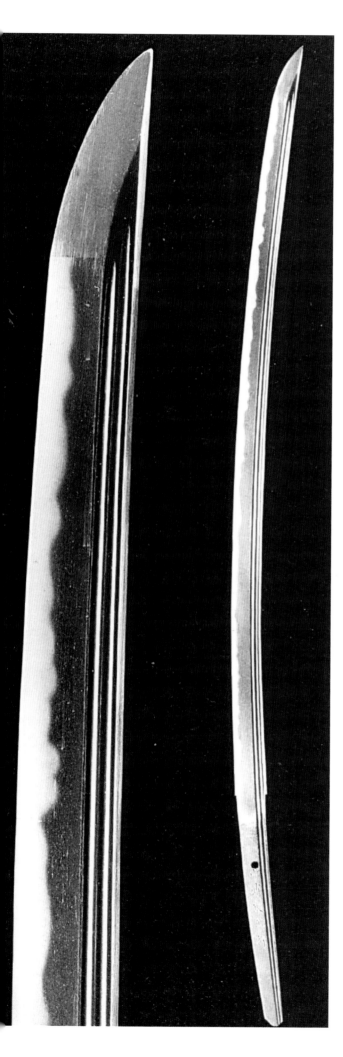

Sugata

First, the *sugata* or shape and overall form of the blade must be examined. When examining a blade's *sugata*, the blade is best held upright at arm's length. The shape should appear strong, with the curvature natural, and the *kissaki* should be in proportion to the width and length of the blade. There should be no "wasting" in the *monouchi* area, which might indicate reshaping, and the *fukura* (curved part of the point) must be natural for the same reason. All lines, such as *shinogi*, *yokote*, *ko-shinogi* and so on, should be correct and crisp, especially in a newly polished blade. It is important that the *shinogi* or ridgeline should not be burred, flattened or rounded since it is impossible to replace metal that has been removed. The *mune* or back edge's shape and height should also be noted. This may be rounded (*maru-mune*), three-sided (*mitsu-mune*) or, most commonly, roof-shaped (*iori-mune*). In this latter case the height of the *mune* is an important indicator of age.

Similarly, the type and degree of the *zori* or curvature is a good guide to both *jidai* (period of manufacture) and school. Any *hi* or other carvings should be studied to see if they are original or *ato-bori* (carved later), and of good quality. For instance, if a sword has been shortened or the *machi* moved, but the *hi* still stops above the *habaki* (and looks quite natural when the sword is mounted), then it must be a later addition, and this detracts somewhat from the sword.

The *sugata* may impart a great deal of information about the age of the blade and sometimes about the area in which it was made. However, if the blade has a good shape and sits comfortably in the hand, there is a fair chance that it has some quality. It is impossible for a good sword to have a bad shape unless it has been altered, damaged or repaired in some way. This frequently happens and so it is important to try and

Left This sword shows many fine features associated with *shin-shinto* blades (19th century). It has a strong, broad *sugata* (form) with an *o-kissaki* (large point) and an even curve, giving an overall impression of power and robustness. a powerful and robust impression. It is signed *"Yamura Masayuki (Kiyomaro)"* and was made for Ban Kagenori. Dated 1839, it was owned by Festing.

A selection of the most common features that are encountered in Japanese blades.

Komaru

Omaru

Sudareba *Toran ha* *Hitatsura* *Notare* *Juzuba* *Sambon sugi*

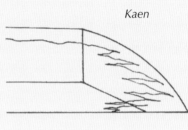

Jizo

 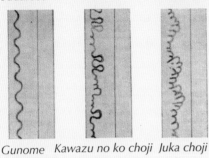

Gunome *Kawazu no ko choji* *Juka choji* *Choji* *Komidare* *Suguha*

Above Variations of the *hamon* or quenched and hardened cutting edge of the sword. Although some are specific to certain schools, *suguha* for instance is common to many.

Kaen

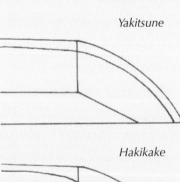

Yakitsune

Above Examples of the *fukura* or sharp part of the *kissaki*. The two on the left may be described as "full and rounded" while those on the right are less so.

Hakikake

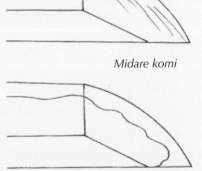

Midare komi

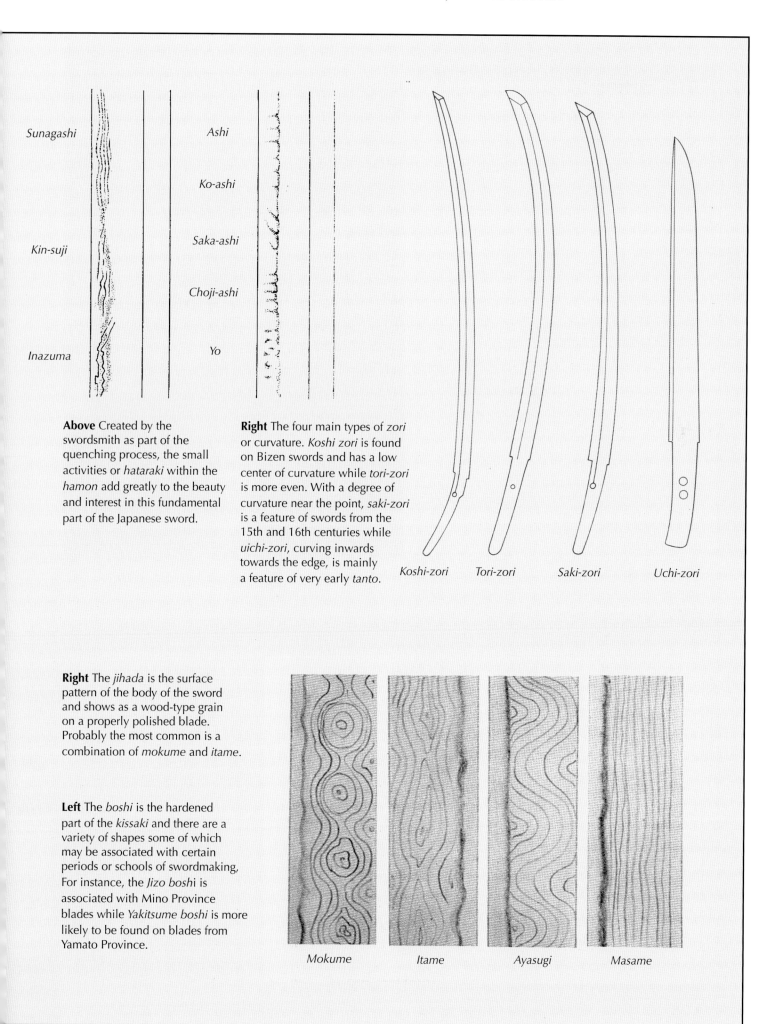

Sunagashi

Kin-suji

Inazuma

Ashi

Ko-ashi

Saka-ashi

Choji-ashi

Yo

Above Created by the swordsmith as part of the quenching process, the small activities or *hataraki* within the *hamon* add greatly to the beauty and interest in this fundamental part of the Japanese sword.

Right The four main types of *zori* or curvature. *Koshi zori* is found on Bizen swords and has a low center of curvature while *tori-zori* is more even. With a degree of curvature near the point, *saki-zori* is a feature of swords from the 15th and 16th centuries while *uichi-zori*, curving inwards towards the edge, is mainly a feature of very early *tanto*.

Koshi-zori Tori-zori Saki-zori Uchi-zori

Right The *jihada* is the surface pattern of the body of the sword and shows as a wood-type grain on a properly polished blade. Probably the most common is a combination of *mokume* and *itame*.

Left The *boshi* is the hardened part of the *kissaki* and there are a variety of shapes some of which may be associated with certain periods or schools of swordmaking, For instance, the *Jizo boshi* is associated with Mino Province blades while *Yakitsume boshi* is more likely to be found on blades from Yamato Province.

Mokume Itame Ayasugi Masame

163

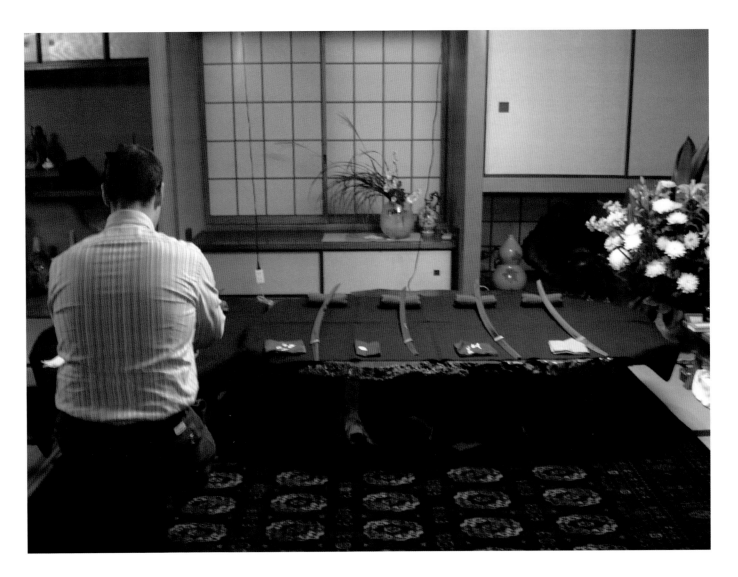

Above Swords laid out for viewing in a typical modern Japanese house. It is a great privilege to be invited into somebody's house like this, so it is important that no breach of sword-handling etiquette occurs.

imagine the *ubu* (unaltered) shape of the blade before any shortening (*suriage*) or alteration to the beginning of the blade at the top of the *nakago* (*machi-okuri*) has taken place.

Hamon

The next area to study is the *hamon*. This is often referred to as the "tempered" edge, but is where the sword has been quenched to provide a high carbon steel area that will hold a sharpened edge. It will be seen in contrast to the body of the sword. The *hamon* may be in an infinite variety of patterns, but appears as a milky white color on a properly polished blade. The upper edge of the *hamon* will be formed from tiny martensite crystals called *nie*. Sometimes these are too small to see individually with the naked eye and are then known as *nioi*, appearing as a misty or smoky white mass. Sometimes *nioi* are likened to the Milky Way while *nie* are like boiling bubbles.

It is *nie* and *nioi* that form the border (*nioiguchi*) and the pattern of the *hamon*. The *hamon* should be examined very closely, ideally by holding the blade at eye level pointed towards a spotlight. Good *nie* should be ordered and tidy, not coarse and disorganized. The *nioiguchi* should form an unbroken and constant line from the *machi* area (bottom of the blade) along its entire length and into the *kissaki*. A break in the *hamon*, called *nioi-giri*, is a serious flaw and should be avoided as this is an area of weakness that might crack, bend or break if the sword were to be used. It is also important that the *boshi* (the area of the *hamon* within the *kissaki*) is present and does not disappear off the edge. This is also a serious flaw in the blade and is only acceptable on great swords of historical and cultural significance!

No compromise should be accepted here.

Various activities within the *hamon* should be noted. These may be small, leggy lines coming down from the *nioiguchi*, referred to as *ashi* (legs), or various flowing lines such as *kinsuji* (lightening) or *sunagashi* (drifting sands). These and other activities or *hataraki* greatly enhance the enjoyment of the *hamon* and demonstrate the swordsmith's skill at *yaki-ire*, the quenching process.

The *hamon* is best viewed by looking along the blade at eye level and pointing it towards a light source. The *nie* and *nioi* will reflect the light and be easily seen if the polish is adequate. Failure to see the *hamon* clearly in this manner may mean that the blade has been quenched in oil at a temperature that is too low to produce *nie* and *nioi*. You may be dealing with a *Showa-to*, or World War II mass-produced blade of low quality.

Jihada

If *sugata* and *hamon* pass muster, the sword should be OK. However, we need to be assured that it is hand-forged and not a cleverly mass-produced piece such as a *Showa-to* mentioned above. This is ascertained by examining both the *jigane* and the *jihada*. The *jigane* is the actual steel from which the sword is made, and might show subtle changes in color and texture. The *jihada* is the surface pattern of the *jigane*, created by the forging process and emphasized by the polishing. This is mostly visible between the edge of the *hamon* and the *shinogi*, or ridgeline, in the area known as the *hira-ji*. The *jihada*, appearing like a wood grain, is described by its type and size (i.e. *ko-mokume*, or small burl) and there are many criteria for judging the quality of the *jihada*. The main patterns of *jihada* may be described as:

Mokume-hada: A rounded wood grain or burl, similar to that of a log cut straight across.

Itame-hada: A longer striated wood grain similar to a longitudinally cut log.

Ayasugi-hada: An undulating pattern usually associated with the Gassan school.

Masame-hada: A straight pattern, associated with the Yamato smiths, especially the Hosho school.

Muji-hada: No apparent grain is visible and the *hira-ji* is polished to a mirror-like finish. This feature is associated with *shinshinto* blades, but today skillful polishers are able to reveal the hidden tight pattern of these blades.

(Mixtures of these patterns are most commonly found, especially *mokume* and *itame*.)

The *jihada* should appear homogenous, natural, and uncontrived and may be enhanced by *nie* appearing on the surface, where they are termed as *ji-nie*. These *nie* may form patterns similar to the *sunagashi* in the *hamon*, and when appearing on the *ji* are called *chikei*. Also visible on better quality swords—mainly but not exclusively Koto period swords from Bizen Province—is a feature known as *utsuri*, a shadow or reflection of the *hamon*. This appears in a variety of shapes that may help identify the period of manufacture; however, this must not be confused with *tsukare*, or tiredness, in a blade, where the core steel (*shingane*) is beginning to come through the surface steel (*kawagane*), which sometimes resembles a kind of *utsuri*. If *tsukare* is present, then the amount should be noted, since personal preference may tolerate a moderate amount in an otherwise fine old blade.

To view the *jihada* the sword is held in a similar manner to when viewing the *hamon*, but usually it needs to be held lower and on its side. Then it may be easily adjusted until the *jihada* is visible. When viewing both *hamon* and *jihada* a supporting *fukusa* or cloth is usually employed to avoid accidents.

Kissaki

The *kissaki* or point section of the sword will be noted when studying the *sugata* but may be further studied since it is a very important part of the sword. Because of the difficulty in masking it, it is in the *kissaki* that the skills of the swordsmith and the polisher are most immediately apparent. Although most of the checkpoints will already have been noted, reemphasis of them will do no harm at all. The size of the *kissaki*, whether large, medium or small, may be an indication of age and will already have been noted in the study of the *sugata*.

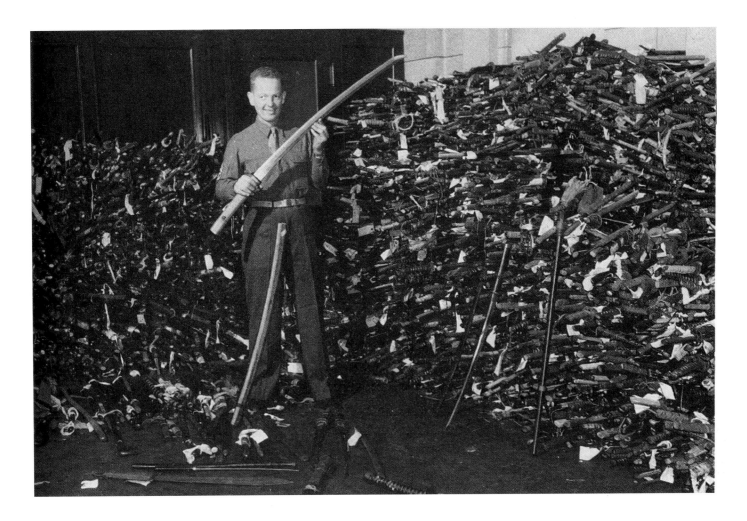

Above One of the warehouses in which the occupation forces stored confiscated Japanese swords. A few years ago, one at Sugano (possibly this one) was emptied and attempts were made to return 4,500 swords to the original owners or, as this was impossible in many cases, to distribute them to museums. It is said that this sergeant returned home after his tour of duty without a single sword as a souvenir.

Make sure that the *fukura*, or the rounded and sharp part of the point, is correct and appears natural rather than reshaped. It is unlikely that it will be straight (a common amateur restoration mistake) and the *boshi*, or tempered, part of the *kissaki* will naturally follow this line, especially in *shinto* blades, which tend to have *suguha* (straight or parallel to the *fukura*) in this part of the *boshi*. The *boshi* must not disappear off of the edge and any *kaeri*, or "turn back" onto the *mune*, should again be natural.

Make sure that there is a real temper line here and not a false or cosmetic one put on by a polisher. If it does not reflect the light like the rest of the *hamon*, then it has no *nie* or *nioi* and it is best to disregard the sword.

Faults and Flaws

While undertaking this detailed examination of a blade, any flaws or faults will become apparent. Some of these may be more acceptable than others, depending on the age of the blade and personal tolerance levels. For example, a 12th century blade is entitled to have a few problems that would not be tolerated in a modern sword. However, all faults and flaws obviously detract from both the beauty and value of a sword. Look for holes or bubbles in the sword, which may indicate air, or impurities, that have been included in the forging process and may be just under the surface of the blade. Also, check the *ha-saki* (cutting edge) very carefully for hairline vertical cracks running from the *ha-saki* into the *hamon*. Called *ha-giri*, these are often very difficult to detect and are extremely serious flaws: if the sword were used to cut, at the point of *ha-giri* it would bend or break. *Ha-giri* is not acceptable under any circumstance and in modern parlance has come to be called "fatal flaws." *Nio-giri*, or breaks in the nioguchi, are already mentioned above.

When the *shingane*, or core steel, begins to show through the *kawagane*, or skin steel, the sword is becoming *tsukare*, or tired. The cause of this is usually excessive polishing, often on swords where the *kawagane* is thin in the first place. Early tiredness may appear as small, darkish patches on the polished surface, but full tiredness is recognizable as patches of *jigane* that have no pattern at all on them. Such *tsukare* is often found on *kazu-uchi-mono* (mass-produced blades) of the *Sengoku-jidai*, where they have been caused by the economies of materials made at the time. Although a small amount of *tsukare* may not detract too much from a sword, it is obvious that a sword with *tsukare* cannot be polished further, since this will only exacerbate the problem and the sword is effectively at the end of its life.

Finally, if the surface of the blade appears to be undulating, which you will see when examining the *jihada*, although not exactly a flaw it may indicate that the sword has undergone poor or even amateur polishing at some time.

Nakago

Finally, inspection of the *nakago* or tang takes place. The *nakago* on a good sword will always be carefully finished. The patina should be a good color and the rust should not be cleaned off under any circumstances. Any inscriptions will be of interest. A good *mei* will be skillfully and confidently written, not untidy, jumbled or hesitant. It almost does not matter whether you can read the inscription (most modern Japanese cannot read the old *kanji* in sword inscriptions) so long as it looks confidently executed. However, beware of famous names on the *nakago*: the odds are that it is a forgery and it would be better if the blade were not signed at all. If you have the necessary reference books, a detailed comparison with accredited genuine signatures might be undertaken. However, since a good number of forgeries may be very old (even several hundred years!), this is by no means a guarantee of authenticity.

All flaws and faults in a blade obviously detract from it, and some of the worst are mentioned above. Occasionally, the entire *hamon* may have been reinstated if the original is lost. The most common reason for the loss of a *hamon* is that the blade has been in a fire, since heat, including that generated by buffing, will have this detrimental effect. In fact, many *yakinaoshi*, or reinstated *hamon*, were done in the feudal era by skilled swordsmiths. The *shogun* Tokugawa Ieyasu's favorite swordsmith retempered many important old swords after they were damaged in a serious fire at Osaka Castle.

However, a sword with a retempered edge is not desirable, as extra stresses and strains are put on the sword during the process, which generally weakens it. Further, the appearance is usually not as fine as the original. Swords with this feature are usually reasonably easy to spot. The second quenching or *yaki-ire* required to reinstate a lost *hamon* will often give the sword an unnaturally deep curvature, usually most apparent at the bottom end of the blade, nearest to the handle. Also, the *hamon* will often have lost its clarity and may appear somewhat fuzzy and indistinct, while the *jihada*, or forging pattern, might appear unnaturally coarse. The patina on the *nakago* will also not be natural and may appear rather "flaky." Finally, a feature known as *mizukage* (literally, water shadow) may be seen as a misty line rising from the beginning of the *hamon* and up into the *ji* at an angle of about 45 degrees. However, for some reason this feature sometimes also appears on the original work of other swordsmiths, such as Shodai Tadayoshi and Kunihiro, where it is not a feature of retempering but a characteristic of their work. *Mizukage*, therefore, should not be taken as a sign of retempering on its own—better as confirmation when accompanied by other features. Needless to say, blades with *yakinaoshi* should be avoided!

You will understand from the above what is meant by there being many subjective judgments to be made when appraising a Japanese sword blade. There is a certain amount of responsibility attached to owning a Japanese sword, and while we are all entitled to our opinions and gut feelings, it must be far more satisfactory to have a reasonably informed or educated opinion. Therefore, take every opportunity to study good swords and ensure the preservation of all swords.

Preservation, *Shinsa*, Polishing

Since there are swords that exist dating from the 9th and 10th centuries, and still in superb condition, attests to the fact that conservation and preservation are not new ideas. It seems quite natural that if an object is greatly admired then there is a desire that it should not be neglected or damaged but kept and passed on so that future generations might also enjoy it. It is also beholden on the current owner not to put the sword at risk by misuse or carelessness, and this includes using old swords in martial arts. In fact, it is no exaggeration to say that owning a Japanese sword brings many responsibilities and obligations that some might prefer not to have.

Swords come to collectors in many varied and often distressed conditions and it is beholden on the new owner to preserve and restore the sword to the best of his ability, although sometimes it may be considered that restoring the sword is not a viable option. I have recently added swords to my collection that are "write-offs" to all intents and purposes.

One that particularly springs to mind is a sword that was given to me by an old school friend. It had been in his father's loft for some sixty years. This blade, minus its *tsuka* (handle) was in a wooden *saya* with a rather bulky, leather foul-weather cover and had come from the Burma Campaign of 1945. I suspected that under the leather outer cover might be a lacquered *saya* of some interest, and I decided to remove the leather. To my surprise, under the first leather cover was a second one. However, about midway down the "package" were two strips of bamboo, each about six inches long, which were bound to the second leather cover with thread. It looked like a splint, and I immediately expected to find a broken *saya* underneath all this. On removing

Above Mishina Kenji, *mukansa togishi*, in his workshop in Tokyo. Mishina *sensei* speaks excellent English and has lived and worked in the UK for several years. He was head student at the Nagayama Kenshujo, the polishing school founded by Nagayama Kokan *sensei*.

the splint and the second leather cover, I encountered a thin linen or muslin bandage, which I unwrapped to expose a beautiful black-lacquered *saya* that was ribbed in the *inro* style. As expected, however, it was broken in two, and the bottom quarter was of plain wood that was also wrapped in linen and held securely in place by wire binding!

The blade of this sword had been badly abused and had lost much of its *monouchi*, while the *hamon* and

168

Above The essential personal maintenance kit, which includes:
Choji-abura (bottle of clove oil).
Uchiko (dusting powder wrapped in a thin linen ball).
Soft cloth to apply the oil.
Nugui-game (Japanese paper for wiping off *uchiko* and oil).
Fukusa (a silk cloth for handling a clean blade).
Mekugi-nuki (small hammer or tool for removing the retaining peg on the *tsuka*).

jihada were not visible. The *mekugi-ana* had been enlarged and a nut and bolt put through it, but an indistinct two-character inscription on the rusted *nakago* read: "*Norimitsu*." (Norimitsu was a talented Bizen swordsmith from the 15th century.) To top it all, there were at least two *ha-giri* (hairline edge cracks)—a serious and irreparable flaw!

Obviously, a sword such as described above is a relic that has little collectible or commercial value, and it is hard to justify spending money on restoration. However, it occurred to me that I was probably the first to see the lacquered *saya* in over sixty years, and the deceased Japanese owner may have been the previous one. There is no doubt that the sword had had a tough life. I thought it was highly probable that the original Japanese owner had taken an old family sword onto the battlefield and that the extensive *saya* repairs were probably field repairs, maybe even done by him. It seemed that this owner had highly rated the sword and

saya and had gone to a lot of trouble to preserve it under what must have been extreme conditions. I felt that, if only out of respect for the Japanese owner, the sword certainly deserved to be cared for and preserved. After repairing the break in the *saya* with a modern adhesive, I resolved to keep it in my care for these somewhat "sentimental" reasons.

Fortunately, most swords are not such extreme cases, and the main problem may be the condition of the blade. If the sword has any real problems, such as flaws or chips, it may be advisable for the less experienced collector to gain a more informed opinion of the

Left A "private" *shinsa* team deliberating at the London To-ken Taikai in 1989. The team was led by Mr. Iida Kazuo (far right) and included Mr. Tokuno (bearded).

restoration potential, before paying for the carriage back home. Professional polishers may often be able to restore blades in relatively bad condition, and it is amazing what transformation a good polisher can make to what may appear to be a badly distressed sword. Usually, this will mean finding a polisher in Japan, although there are a growing number of qualified polishers now active outside of that country, both Japanese and Westerners. Collectors should not be attracted by offers of cheap polishing offers, or quick turn-rounds since good polishing is neither quick nor cheap. You must expect your sword to be away for at least a year and probably a lot longer.

A polish in Japan will usually mean that the sword will have a new *shira-saya* (storage mount) made to accommodate the new polish, even when the sword is sent out with mounts. This is to protect the polish, which would not be possible if the blade were merely put back into the original *saya* with a dirty interior. It will probably also be necessary to have a new *habaki* (collar) to ensure that there is a tight fit into the *saya*. To keep any accompanying *koshirae* (mounts) together, and permit it to be displayed, a wooden

blade called a *tsunagi* is made. If the *koshirae* is also in Japan, obviously this would be a good time for any repairs to be carried out, but these will be at an additional cost to the polish. This may include lacquer repair, repatination of metal fittings, hilt-wrapping, and general repairs. Again, it is possible to have much of this done outside of the country, but the best craftsmen tend to still be in Japan.

Of course, when the sword is sent to Japan for a polish, it will have to go through the proper registration procedures showing it to be a legal import (keep evidence that you have sent it so that on its return you are able to prove that it was a temporary export and it is being returned to you after restoration; this should minimize any reimport charges). Either an agent or polisher usually takes care of this, presenting the blade into one of the monthly *Torokusho-shinsa*. This is not the same as a *shinsa* conducted by the Nihon Bijutsu Token Hozon Kyokai (NBTHK) or one of the other organizations before a judging or examination team, since no quality judgments are made. It is simply a legal permit to keep the sword in Japan.

Torokusho-shinsa will not give a permit to mass-produced *Showa-to*, which still remain illegal in Japan. If *Showa-to* are submitted they may be confiscated and destroyed, or at least returned to the owner abroad. It would be risky to try and argue that even a *Hosho-*

Left Honami Koshu, the 18th generation of his branch of the Honami family of polishers and appraisers, shows a magnificent *tachi* by Tomonari at a polishing demonstration in central Tokyo in October 2008.

Above A *Tokubetsu Hozon* (Especially Worthy of Preservation) certificate issued by the NBTHK in Heisei 16th year (2004) for a *katana* by Koyama Munetsugu.

kokouin (star-stamped) blade is a properly forged and traditionally made blade. It is disputed by some that the *kokuin* of "*Seki*" or "*Showa*" may sometimes be found on properly made blades, and such swords have been successfully entered into *shinsa*, after the offending *kokuin* have been removed. It may be useful at this stage to explain more fully the existing *shinsa* criteria and standards that the NBTHK apply to sword blades (as published in *Token Bijutsu* magazine, March 2006).

Above A *Hozon To-ken* (Worthy of Preservation) certificate issued by the NBTHK in Heisei 17th year (2005). The sword is signed "*Hizen Kuni Tadayoshi*," and the certificate attributes it to the *kudai*, or 9th generation.

Hozon Token (swords worthy of preservation)

1. Edo and earlier blades with correct *mei* or *mumei* blades on which the time period, province, and group may be identified, may be granted a *Hozon* paper.

2. Blades that meet the criteria given above may receive a *Hozon* paper, even if they are slightly tired or have *kizu*, so long as they do not prevent appreciation.

3. For blades from the Namboku-cho period (1333–1392) and earlier *zaimei* (genuine signatures) by famous smiths, retemper may be allowed if the blade is otherwise a valuable reference and if the *jiha* and *nakago* are sufficiently well preserved. However, this must be documented in the paper.

4. Repair on the *jiha* is allowed, unless it significantly detracts from the beauty of the blade.

5. Blades made in the Meiji (1868–1912) and Taisho (1912–1926) periods, and those by recently deceased smiths, only when the blade is well made, have *zaimei* (genuine signatures) and *ubu* (unaltered) *nakago*, may be given a *Hozon* paper.

6. Blades are reserved (for further consideration) if a decision cannot easily be made on the authenticity of the *mei*. This also applies to *mumei* blades on which an attribution is difficult to make.

7. Blades with *ha-giri* will not receive a *Hozon* paper.

Tokubetsu Hozon Token (swords especially worthy of preservation)

Blades with *Tokubesu Kicho*, *Koshu Tokubetsu Kicho* (on the old system) or *Hozon* papers, with good workmanship and a good state of preservation, may receive *Tokubetsu Hozon* paper, except under the following circumstances:

1. Both *zaimei* and *mumei* blades may not receive a *Tokubetsu Hozon* paper if they are significantly tired, have *kizu* or repair which impairs the beauty of the blade.

2. Retempered blades may not receive a *Tokubetsu Hozon* paper unless they were made by famous smiths and they are extremely high as a reference.

3. Edo period works by famous smiths with mid- or lower-grade workmanship may not receive a *Tokubetsu Hozon* paper.

4. Muromachi and Edo period *mumei* (unsigned) blades may not receive a *Tokubetsu Hozon* paper, as a rule.

5. *Suriage*—cut *mei* (shortened) Edo period blades may not receive a *Tokubetsu Hozon* paper.

6. Blades with *ha-giri* will not receive a *Tokubetsu Hozon* paper.

7. Blades that received a *Hozon* paper in item 5 (Meiji or Taisho periods) that may be considered to be the smith's best quality, may receive a *Tokubetsu Hozon* paper.

Juyo Token (important sword)

1. Blades made in the period from Heian to Edo, already having *Tokubetsu Kicho*, *Koshu Tokubetsu Kicho*, *Hozon* or *Tokebetsu Hozon* papers, of extremely high quality workmanship and state of preservation, and judged as close to *Juyo Bijitsuhin* may receive a *Juyo Token* paper.

2. Blades that meet the criteria given above and made in or before the Namboku-cho period may receive a *Juyo Token* paper even if they are *mumei*. Blades made in the Muromachi and Edo periods, as a rule, have to be *ubu* (unaltered) and *zaimei* to receive a *Juyo Token* paper.

Tokubetsu Juyo Token (especially important sword)

Among *Juyo Token*, the ones of excellent quality and superior condition, judged as being the same as the top level *Juyo Bijutsuhin*, or conceivably equivalent in value to *Juyo Bunkazai*, may receive a *Tokubetsu Juyo Token* paper.

For those collectors living outside Japan, it is rather difficult to get any feedback from a failed *shinsa*; the NBTHK does not automatically provide a "failure slip." While it may be possible to make inquiries, it is not easy. This is in contrast to the Nihon Token Hozon Kyokai (NTHK), who hold many *shinsa* outside of Japan, which no doubt influences their policy. A failed

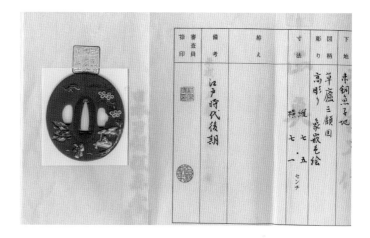

Above An NTHK Kanteisho *origami*, issued at their London *shinsa* in 2003, attributes this *tsuba* to a late Edo period *Kyokinko* (Kyoto work).

Above An old-system *Tokubetsu Kicho* paper (known popularly as a green paper) issued by the NBTHK on Showa 49th year (1974) for a *wakizashi koshirae*.

Above A *Juyo Token* (Important Sword) issued by the NBTHK in Heisei gannen (1989) for a sword by Hizen Tadahiro.

Right The *mukansa*-level *togishi* (polisher) Abe Kazunori demonstrating his skills in London in 2007.

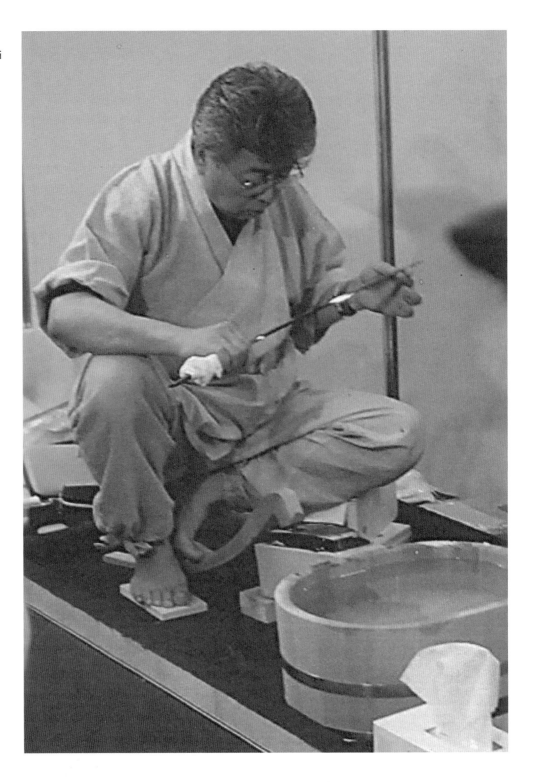

shinsa with the NTHK results in a "pink slip" explaining the reason for failure, and if this is *gimei* (false signature) the name of the probable actual maker will be stated. They also give good advice about it not being the end of the world to have failed *shinsa* and not to sell swords in a panic after failing!

While it is possible to carry a sword into Japan as part of personal baggage, arranging this is a difficult and time consuming process, especially for a non-Japanese national. Only three swords are permitted entry in this manner. I find it far simpler and more convenient to pay a little extra and have the polisher oversee all the bureaucratic procedures, including the registration and submitting to NBTHK *shinsa*, and there is no limit to the number of swords that may be sent in this way. The agent will also arrange all the necessary export permits, insurance, and so on, after all the work is completed. The *torokusho* card must be surrendered on export, so the whole procedure must be repeated if the sword ever returns to Japan! If you see a sword with the plastic

torokusho permit, outside Japan, then you know that the sword has been illegally exported.

I usually breathe a sigh of relief when I know that the sword is safely in my chosen polisher's hands and the job may begin. It is the polisher's job to bring out the beauty of the steel itself, particularly in the *jihada* and *hamon*, and to further reveal all the sword's characteristics that the sword-maker himself intended, as well as to make any repairs that are possible. This means that the polisher must understand the intentions of swordsmiths through the ages so that in the foundation stage of the polish he can initially restore *sugata*, or form, as was intended in any given era.

The steel itself must be persuaded to show all the characteristics of certain schools or regions and, as well as the skill to do this, the polisher must have a wide range of knowledge and be expert at *kantei*, or sword judging. This is quite different to the pre-Meiji era, when the polisher's job was primarily to put a sharp edge on the blade or repair any chips. When the *samurai* class was disbanded and swords were no longer in daily use as weapons, the artistic side of swords was again emphasized in order to preserve the culture and tradition of sword-making. It was the Honami group of polishers that began to polish so that the beauty of the

jihada was clearly visible. Thus the appeal of the swords was broadened to include "ordinary people" rather than just the warrior class. It is no exaggeration to say that this was a revolutionary initiative by this conservative group of polishers.

If the sword has *horimono*, this will make the polish more difficult; the more complicated the *horimono* the more difficult the polishing job. Depending on the condition of the *horimono*, different options become available to the owner. As is often the case, the *horimono* may have been polished over in a previous polish and now be flattened, or detail may have been lost. If this is so, it is sometimes possible for it to be recut, in which case the polisher would probably employ a professional *horimono* cutter to do the job. One must be convinced of the quality and importance of the *horimono* to have this carried out, since it may well cost as much as the polish itself! Usually, if you require the *horimono* to be preserved as it is, then it will be enough to tell this to the polisher. He will then avoid polishing right over it by employing a somewhat different technique in this area and only charge you another ten percent for the privilege. The necessity for having a good dialog with your polisher may be easily appreciated; this is not always possible unless you know him personally.

Left Professional *horimono-shi* (carvers) may be able to recut *horimono* that have been worn away by polishing. The polisher will usually oversee this work.

Above The *shirogane-shi* (*habaki*-maker) Hiroshi Miyajima is one of Japan's best-known individuals in this field. Often a new *habaki* will be needed when a sword is polished.

I would find it difficult to send a sword to Japan and not know which polisher was going to work on it, and that somebody else (an agent) was going to make that decision.

It is usual for the polisher to be a kind of project manager for your blade's restoration, as he will have many contacts in the sword restoration business. Certainly, he will work closely with *shira-saya* and *habaki* makers, as well as all other types of restorers.

Once the sword is returned to you after polishing, the preservation and care is really only about maintaining the polish. Certainly, this needs to be done, since it is possible that initially the sword may "sweat" somewhat. This is because water is an integral part of the polishing process and some may actually be retained in the folds of the steel. This will gradually come to the surface. The blade's surface needs to be cleaned before it turns to rust, and this is done by the application of *uchiko*, wiping it off and reoiling the blade. This must be checked on a weekly basis for the first couple of months after polishing. Sometimes the polish needs to be bedded down and the newness reduced to give it a more subtle finish. Careful application of *uchiko* will achieve this over a period of time.

In Japan, blades are usually kept in an oiled condition. The oil is called *choji-abura* or clove oil, which has a distinctive smell. But it may not be necessary to keep them with an oil coating in other

countries, depending on the humidity. However, if swords are kept oiled, and most people prefer this, the blade should be regularly checked; if it is drying then it needs to be cleaned off (again with *uchiko* applications), and reoiled. It is recommended that blades that are kept in this oiled condition are not stored in a vertical position, such as leant against a wall. In such a situation, oil will accumulate at the bottom of the *saya* and possibly attract dirt. Better to have the blade either lying flat, such as in a drawer or sitting on a sword rack.

To protect the outer surfaces of the *shira-saya*, it is customary to wrap it in a specially made bag, sometimes of silk and often purple in color. It is necessary that the bag be tied firmly onto the *shira-saya*, thus preventing any movement between the *tsuka* and *saya* that might cause damage to the blade.

It may be that your swords are lent for exhibition or shown to others at various times; also you will want to look at your own blades, of course. Especially in the former case, one should make sure that a blade is thoroughly cleaned before being put back into storage,

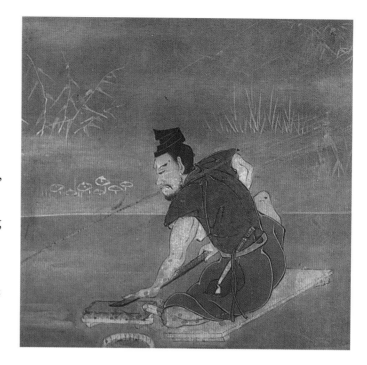

Above The polisher or sharpener of swords provided an essential service in wartime, when he was able to repair damaged swords. In the Edo period his services were required on newly made swords that tended to emphasize more the artistic properties of the Japanese sword. This was even more so in the Meiji period.

Below A member of the Imperial Guards demonstrating *iai-do*. The *dojo* is in the Imperial Palace in central Tokyo.

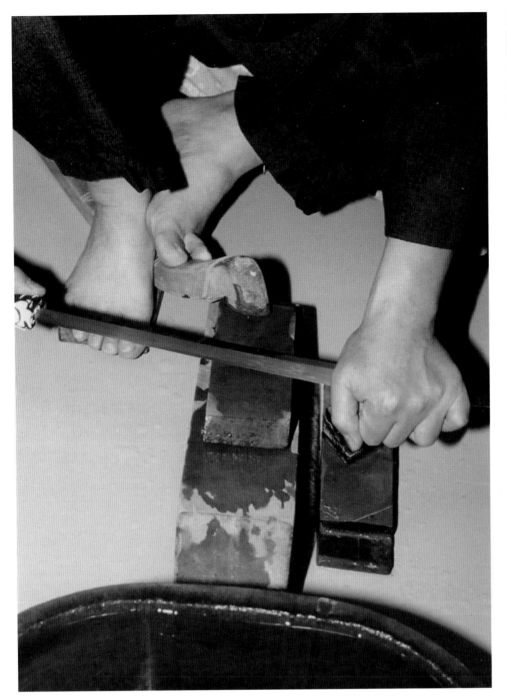

Left The *togi-kamae* or polisher's position, is very taxing and difficult to maintain. However, it is essential that the body's weight is fully utilized and controlled during polishing.

since often-undetectable marks may be left on the otherwise perfect surface of the blade; if left this will cause rust.

The use of *uchiko*, referred to above, may require some clarification. *Uchiko* ideally is a white powder that is the slip or slurry filtered and drained from a polisher's water. Thus it is mildly abrasive and should be used with care. The powder is usually wrapped in silk to form a soft ball, and it is not advisable to have cheap *uchiko*, which is sometimes only powdered stag horn. To apply it, the blade must be stripped of all fittings, including the *habaki*. The ball of *uchiko* is tapped along the blade, leaving the powder on the surface. It should be evenly distributed along both sides and also the *mune*, or back edge. Then, with soft paper—ideally Japanese paper made for the purpose and known as *nugui-game* (wiping paper)—the *uchiko* is lightly dusted. This light dusting will hopefully remove any coarse particles that might scratch the polish. Then, holding the blade by the *nakago* and gripping the surface lightly but firmly with the paper, the first six inches or so of *uchiko* is wiped off, in the direction of the *nakago*. To do it in the other direction risks drawing dirt from the *nakago* onto the polished surface. The same applies when *horimono* are

present. (*Uchiko* should not be applied to *horimono*.) It is then safe to wipe the rest of the blade in the direction of the *kissaki*, or point. Only single and continuous strokes should be used, rather than a back and forth action that may cause faint but unsightly scratching. Care needs to be taken not to grip the paper too tightly. Obviously there is a danger of cutting oneself, so one's hand should be positioned at the side of the *mune* rather than along the cutting edge. The blade is then ready for an even coating of oil if required.

It goes without saying that a polished blade should never be touched with the naked hand since sweat will cause immediate rusting to the surface. Many techniques in *iai-do* do involve the hand touching the blade, so most *iai* practitioners are meticulous in cleaning their swords after practice.

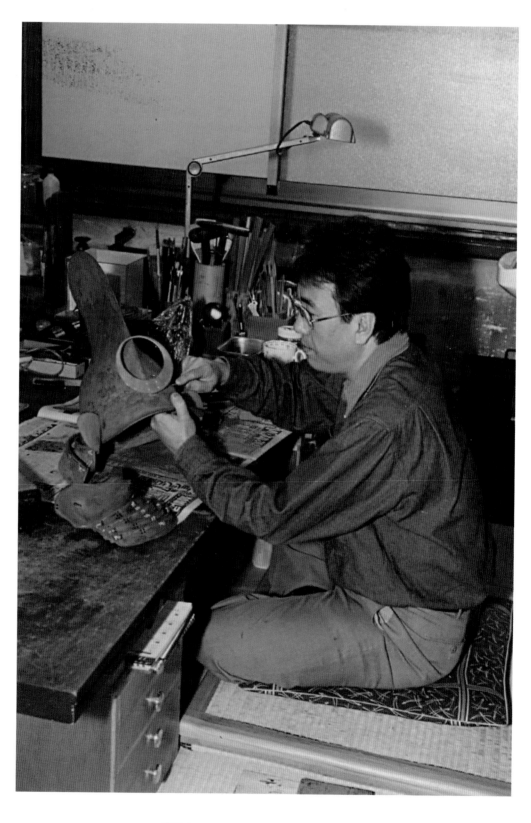

Right The same principles of preservation apply as much to armor as to swords. Mr. Ozawa is the restorer employed by Tokyo National Museum, shown here working on a helmet known as an *oboshi kabuto*.

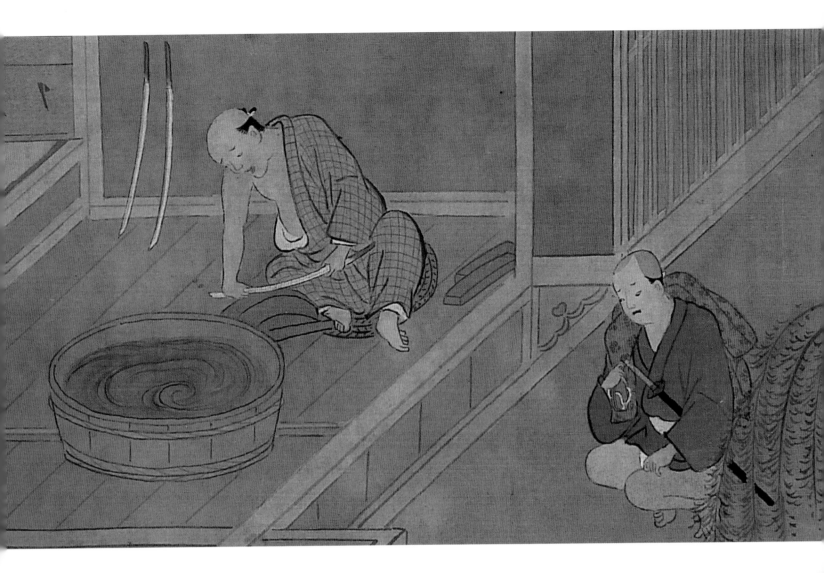

The following are comments on polishing written by Mishina Kenji, who is well known in the West and is now a *Mukansa*-level polisher. It was originally written as a contribution to an internet discussion group.

"It is a most important thing for a sword polisher to understand what type and what quality of sword he intends to polish and such understanding is only obtained through experiences which include observation of the work of his teacher and the senior students. It is natural that fine swords go to skillful polishers for polish. For instance, most of fine swords owned by *shogun* and *daimyo* families were polished by the *Hon-ami* polishers, some of them done by Kiya and Takeya polishers in olden days. Therefore, any student who expects to be a first-class polisher needs to practice sword polishing in a workshop where fine swords are always worked on. It is very dangerous that a polisher, who has no experience

Left A sword polisher depicted in a scroll entitled "Scenes of Craftsmen" by Hishikawa Moronobu, about 1680. In the Edo period the main function of the polisher was to sharpen the sword. *(Courtesy of the British Museum)*

Right The *tsukamaki-shi* (hilt-wrapper) Yamada Yoshiyuki. Hilts are required on new *koshirae*. Practitioners of *iai-do* need to have a strong and reliable wrap as the sword is in constant use. Sometimes old or original *tsuka* that have become damaged need to be replaced or repaired by a *tsukamaki-shi*.

Below *Habaki* (literally edge-wrap) are made in a variety of metals including gold and silver. Mostly in gold, these *habaki* by Miyajima show some of the variety of designs by this master artisan.

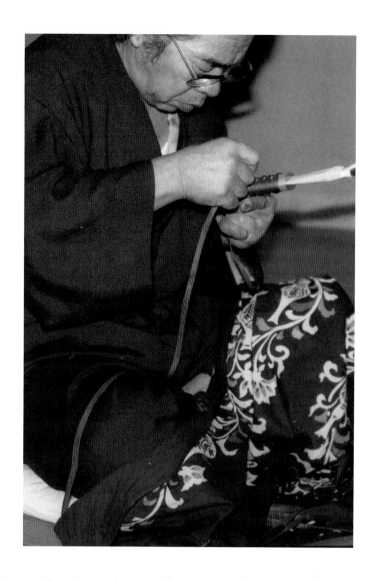

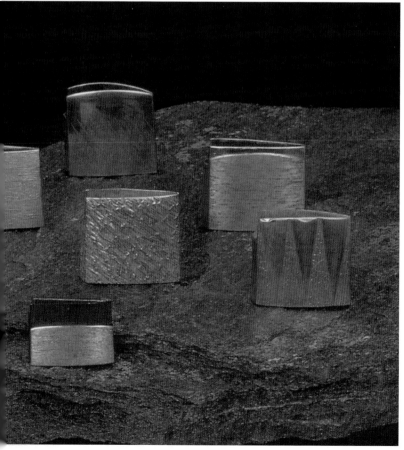

of polishing fine swords, tries to polish such high quality swords as he could damage them. I think the expression of 'damaging sword in polishing' should be understood appropriately by collectors and of course by polishers. Many people do not realize the result of the damage after polish. It can be said that people who understand it properly have already attained a certain level of sword study.

"Generally speaking, *Hon-ami* polishers are conservative in order to avoid any kind of accident and succeed in their tradition to the next generation. We know many swords have been conserved for 1,000 years. We are hesitant and very careful to use new materials, even if they look very useful, and we should refuse using them when we sense any possibility of damaging a sword. I know a few famous polishers who used chemicals and gained fame with their flashy polishing in the past, but it became clear that the chemical was damaging the swords they polished.

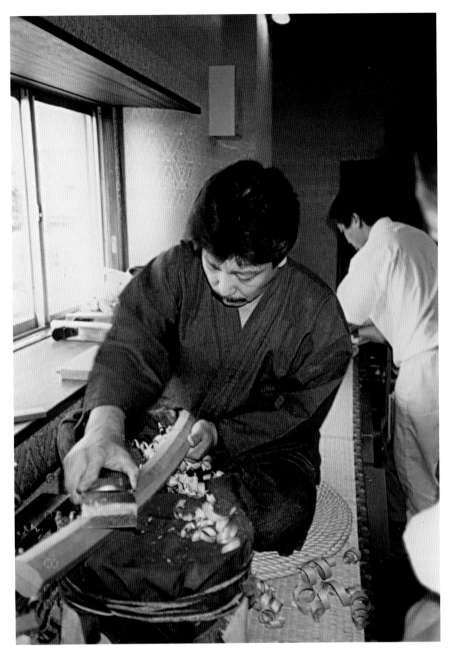

Above Takayama Kazuyuki, Japan's leading *sayashi*, or scabbard-maker, will often organize and design new *koshirae* when required, although he also makes *shira-saya* for newly polished blades.

the meantime, apprenticeship under a first-class polisher does not guarantee his future as a first-class polisher. That is why we have only a small number of first-class polishers here (with this theory, *Hon-ami* polishers are not always first-class polishers!).

"People in Japan say that I am a polisher who understands the science and theory (conservative polishers hate this) as I graduated from a university and understand English. Though I have experienced that science and theory, this does not make a first-class polisher. Hard work, patience, and experience with some talent are indispensable elements to becoming a first-class polisher. I know many students who failed to become first-class polishers because they lacked one of these elements. Sword polishing is a very complicated business and has not been fully explained in theory. Therefore we have to rely heavily on our sixth sense and aesthetical eye that are fostered through experiences.

"I have no intention of neglecting low-class polishers (I also have no intention of offending them with this expression, 'low-class,' but it sounds better than 'cheap polisher' or 'cleaner') and it is true that most Japanese swords are polished and conserved by them. It is by no means possible that the few first-class polishers would be able to take care of all of 2,300,000 swords that have been registered in Japan until now.

"Turning my eyes to the situation in foreign countries, I know there are a certain number of local professional polishers in several countries. I admit some of them are improving their skill and we don't mind leaving the conservation work of the Japanese sword to them, as there are too many swords in foreign countries to be polished only by Japanese

"Collectors sometimes take bold and reckless action in order to remove rust and in trying to see the *hamon* and *jihada*. I do wish they would not make irretrievable mistakes.

"It may sound arrogant to say, but it is widely acknowledged in Japan that the choice of teacher is essential when starting a sword polishing apprenticeship. A low-class polisher never produces a first-class polish, and there is no chance for a self-trained polisher to become a first-class polisher. In

polishers. Also, the complicated procedures and expense of transferring swords to Japan make the situation worse.

"Please remember ... the Japanese sword is very delicate and easily damaged with inappropriate handling and polishing. Considerable devaluation could be caused by the damage. The same damage is differently estimated depending on the value of the sword. Compare the difference between a 100,000-dollar sword and 1,000-dollar sword; for instance, say the damage causes ten percent devaluation of each sword. Ten percent means 10,000 dollars for the former and only 100 dollars for the latter. It is as simple as that calculation, and [it] becomes clear how important the choice of polisher and handling the sword are.

"Meanwhile, there are many people who are making mistakes in the choice of sword polisher in Japan because of the long waiting list of first-class polishers and high polishing charges too. I know that a long and hard apprenticeship (at least five years are needed in full time engagement) does not attract young Japanese people these days and we are concerned about the shortage of young skillful polishers, who are expected to be future first-class polishers.

"Though mastering traditional sword polishing is never gained in a short time, talent is also required to do so. First-class polishers will always have a long waiting list for their polish and collectors need to be patient to wait for their turn. I would say that patience must be rewarded as impatience could cause serious problems.

"The question of *koshirae* restoration is somewhat complex and we may cross into arguments about how far restoration goes before it becomes replacement, and the desirability of this. For instance, I have a sword where the lacquer on the *saya* is flaking away; so do I have the *saya* completely relacquered or do I stabilize the situation and keep it as it is? Being of a conservative nature, I prefer the latter and I may be at variance with modern thinking in this respect. My preference is to have done the minimum required for safety and taste while preserving as much of the original as possible. This might include *tsuka-maki* (hilt rewrapping), minor *saya* repairs, and the like.

"Of course, it is quite possible to have a complete modern *koshirae* made for a blade and although I have never done it, I am assured that considerable thought and planning are required. I know of two skilled and talented people outside of Japan who have co-operated in the production of a set of mounts for a *daisho* with superb results. This included the production of all *kodogu* (the small metal parts such as *fuchi-kashira*, *menuki*, and *kogai*, as well as the pair of *tsuba*. However, such skill is rare in the West but more easily accessed in Japan.

"The planning for a *koshirae* starts with a budget and the decision as to whether the *koshirae* will be made up of old parts (*tsuba*, etc) or be totally new throughout and, in the latter case, whether all metal parts will be made by the same craftsman. Often, the new *koshirae* may also be designed and the production overseen by the 'senior' artist involved, in consultation with the client. This seems quite appropriate where new swords or shinsakuto (newly made swords) are concerned. Such teams involve a number of different craftsmen, including scabbard-makers, lacquerers, metal workers, hilt-makers and wrappers, and *habaki* makers. These are all first-class artisans and often the work is truly spectacular. It is considered important to support the makers of the various elements of *koshirae* in order not to lose the traditional skills.

"A reprehensible practice by some less than reputable dealers is the stripping of a *koshirae* for commercial purposes. By this I mean the removal of a *tsuba* or the cutting of a hilt wrap in order to secure the *menuki*. While all these constituent parts may individually add up to greater monetary value than the whole, nevertheless an original *koshirae* may be ruined and lost forever. Such actions may be described as the unacceptable face of Japanese sword dealership."

Appendix

Transliterations: Periods, Provinces, Swordsmiths' Names

兼曆 JŌ-REKI 1077	永保 EI-HŌ 1081	應德 Ō-TOKU 1084	寬治 KWAN-JI 1087	嘉保 KA-HŌ 1094	永長 EI-CHŌ 1096	兼德 JŌ-TOKU 1096	康和 KŌ-WA 1099	長治 CHŌ-WA 1104

Corrected or improved transliteration

嘉兼 KA-JŌ 1106	天仁 TEN-NIN 1108	天永 TEN-EI 1110	永久 EI-KYU 1113	元永 GEN-EI 1118	保安 HŌ-AN 1120	天治 TEN-JI 1124	大治 TAI-JI 1126	天兼 TEN-SHŌ 1131
長兼 CHŌ-SHŌ 1132	保延 HŌ-EN 1135	永治 EI-JI 1141	康治 KŌ-JI 1142	天養 TEN-YŌ 1144	久安 KYŪ-AN 1145	仁平 NIM-PEI 1151	久壽 KYŪ-JU 1154	保元 HŌ-GEN 1156
平治 HEI-JI 1159	永曆 EI-REKI 1160	應保 Ō-HŌ 1161	長寬 CHŌ-KWAN 1163	永萬 EI-MAN 1165	仁安 NIN-AN 1166	嘉應 KA-Ō 1169	兼安 SHŌ-AN 1171	安元 AN- 1175

1077 Sho-ryaku
1087 Kan-ji
1096 Sho-toku
1106 Ka-sho
1160 Ei-ryaku
1163 Cho-kan
1184 Gen-ryaku
1207 Sho-gen
1211 Ken-ryaku
1219 Sho-kyu
1222 Tei-o

治兼 JI-SHŌ 1177	養和 YŌ-WA 1181	壽永 JU-EI 1182	元曆 GEN-REKI 1184	文治 BUN-JI 1185	建久 KEN KYŪ 1190	正治 SHŌ JI 1199	建仁 KEN-NIN 1201	元久 GEN KYŪ 1204
建永 KEN-EI 1206	兼元 JŌ-GEN 1207	建曆 KEN-REKI 1211	建保 KEM-PEI 1213	兼久 JŌ-KYŪ 1219	貞應 JŌ-O 1222	元仁 GEN-NIN 1224	嘉祿 KA-ROKU 1225	安貞 AN-TEI 1227

Above, Opposite Above and Below
The *nengo* or year periods with transliterations and corresponding date.

寛喜 KWAN-GI 1229	貞永 JŌ-EI 1232	天福 TEM-PUKU 1233	文曆 BUN-REKI 1234	嘉禎 KA-TEI 1235	曆仁 REKI-NIN 1238	延應 EN-Ō 1239	仁治 NIN-JI 1240	寛元 KWAN-GEN 1243
宝治 HŌ-JI 1247	建長 EN-CHŌ 1249	康元 KŌ-GEN 1256	正嘉 SHŌ-KA 1257	正元 SHŌ-GEN 1259	文應 BUN-Ō 1260	弘長 KO-CHŌ 1261	文永 BUN-EI 1264	建治 KEN-JI 1275
弘安 KO-AN 1278	正應 SHŌ-Ō 1288	永仁 EI-NIN 1293	正安 SHŌ-AN 1299	乾元 KEN-GEN 1302	嘉元 KA-GEN 1303	德治 TOKU-JI 1306	延慶 EN-KEI 1308	應長 Ō-CHŌ 1311
正和 SHŌ-WA 1312	文保 BUM-PŌ 1317	元應 GEN-Ō 1319	元亨 GEN-KŌ 1321	正中 SHO-CHŪ 1324	嘉曆 KA-REKI 1326	元德 GEN-TOKU 1329	元弘 GEN-KŌ 1331	建武 KEM-MU 1334
延元 EN-GEN 1336	興國 KŌ-KOKU 1339	正平 SHŌ-HEI 1346	建德 KEN-TOKU 1370	文中 BUN-CHŪ 1372	天授 TEN-JU 1375	弘和 KŌ-WA 1381	元中 GEN-CHŪ 1384	明德 MEI-TOKU 1390
應永 Ō-EI 1394	正長 SHŌ-CHŌ 1428	永亨 EI-KŌ 1429	嘉吉 KA-KITSU 1441	文安 BUN-AN 1444	宝德 HŌ-TOKU 1449	享德 KŌ-TOKU 1452	康正 KŌ-SHŌ 1455	長禄 CHO-ROKU 1457

1229 Kan-ki
1234 Bunryaku
1238 Ryaku-nin
1243 Kan-gen
1321 Gen-kyo
1429 Ei-kyo
1441 Ka-kichi
1452 Kyo-toku

寛正 KWAN-SHŌ 1460	文正 BUN-SHŌ 1466	應仁 Ō-NIN 1467	文明 BUM-MEI 1469	長亨 CHŌ-KŌ 1487	延德 EN-TOKU 1489	明應 MEI-Ō 1492	文亀 BUN-KI 1501	永正 EI-SHŌ 1504
大永 DAI-EI 1521	享禄 KŌ-ROKU 1528	天文 TEM-BUN 1532	弘治 KŌ-JI 1555	永禄 EI-ROKU 1558	元亀 GEN-KI 1570	天正 TEN-SHŌ 1573	文禄 BUN-ROKU 1592	慶長 KEI-CHŌ 1596
元和 GEN-WA 1615	寛永 KWAN-EI 1624	正保 SHŌ-HŌ 1644	慶安 KEI-AN 1648	兼應 JŌ-Ō 1652	明曆 MEI-REKI 1655	萬治 MAN-JI 1658	寛文 KWAM-BUN 1661	延宝 EM-PŌ 1673
天和 TEN-WA 1681	貞享 JŌ-KŌ 1684	元禄 GEN-ROKU 1688	宝永 HŌ-EI 1704	正德 SHŌ-TOKU 1711	享保 KŌ-HŌ 1716	元文 GEM-BUN 1736	寛保 KWAM-PŌ 1741	延享 EN-KŌ 1744
寛延 KWAN-EN 1748	宝曆 HŌ-REKI 1751	明和 MEI-WA 1764	安永 AN-EI 1772	天明 TEM-MEI 1781	寛政 KWAN-SEI 1789	享和 KŌ-WA 1801	文化 BUN-KWA 1804	文政 BUN-SEI 1818
天保 TEM-PŌ 1830	弘化 KŌ-KWA 1844	嘉永 KA-EI 1848	安政 AN-SEI 1854	萬延 MAN-EN 1860	文久 BUN-KYŪ 1861	元治 GEN-JI 1864	慶應 KEI-Ō 1865	明治 MEI-JI 1868

1460 Kan-sho
1487 Cho-kyo
1528 Kyo-roku
1532 Ten-mon
1624 Kan-ei
1661 Kan-bun
1741 Kan-po
1744 En-kyo
1801 Kyo-wa
1844 Ko-ka

加賀 or 加州 Kaga / Kashū	能登 or 能州 Noto / Nōshū	佐渡 or 佐州 Sado / Sashū	丹波 or 丹州 Tamba / Tanshū
丹後 or 丹州 Tango / Tanshū	但馬 or 但州 Tajima / Tanshū	因幡 or 因州 Inaba / Inshū	伯耆 or 伯州 Hōki / Hakushū
出雲 or 雲州 Izumo / Unshū	石見 or 石州 Iwami / Sekishū	隱岐 Oki ∣ 土佐 Tosa	播磨 or 播州 Harima / Banshū
美作 or 作州 Mimasaka / Sakushū	備前 or 備州 Bizen / Bishū	備中 or 備州 Bitchū / Bishū	備後 or 備州 Bingo / Bishū
安藝 or 藝州 Aki / Geishū	周防 or 防州 Suō / Bōshū	長門 or 長州 Nagato / Chōshū	筑前 or 筑州 Chikuzen / Chikushū
筑後 or 筑州 Chikugo / Chikushū	豊前 or 豊州 Buzen / Hōshū	豊後 or 豊州 Bungo / Hoshu	肥前 or 肥州 Hizen / Hishū
日向 or 日州 Hyūga / Nisshū	大隅 or 隅州 Ōsumi / Gūshū	薩摩 or 薩州 Satsuma / Sasshū	肥後 Higo ∣ 讃岐 Sanuki
紀伊 or 紀州 Kii / Kishū	淡路 or 淡州 Awaji / Tanshū	阿波 or 阿州 Awa / Ashū	伊豫 or 豫州 Iyo / Yoshū

Above and Below A list of provinces in which swords were made, showing the Japanese characters for the standard and alternative forms with an English transliteration.

Opposite Above and Below Transliteration of characters commonly used for swordsmiths' names.

山城 or 城州 Yamashiro / Jōshū	大和 or 和州 Yamato / Washū	河内 or 河州 Kawachi / Kashū	和泉 or 泉州 Izumi / Senshū
攝津 or 摂州 Settsu / Sesshū	伊賀 or 伊州 Iga / Ishū	伊勢 or 勢州 Ise / Seishū	志摩 or 志州 Shima / Shishū
尾張 or 尾州 Owari / Bishū	三河 or 三州 Mikawa / Sanshū	遠江 or 遠州 Tōtōmi / Enshū	駿河 or 駿州 Suruga / Sunshū
甲斐 or 甲州 Kai / Kōshū	伊豆 or 豆州 Izu / Zushū	相摸 or 相州 Sagami / Sōshū	武藏 or 武州 Musashi / Bushū
安房 or 房州 Awa / Bōshū	上総 or 総州 Kazusa / Sōshū	下総 or 総州 Shimosa / Sōshū	常陸 or 常州 Hitachi / Jōshū
近江 or 江州 Ōmi / Gōshū	美濃 or 濃州 Mino / Nōshū	飛彈 or 飛州 Hida / Hishū	信濃 or 信州 Shinano / Shinshū
上野 or 上州 Kōsuke / Jōshū	下野 or 野州 Shimosuke / Yashū	陸奥 or 奥州 Mutsu / Ōshū	出羽 or 羽州 Dewa / Ushū
若狹 or 若州 Wakasa / Jakushū	越前 or 越州 Echizen / Esshū	越中 or 越州 Etchu / Esshū	越後 or 越州 Echigo / Esshū

	1	2	3	4	5	6	7	8	9	10	11	12	13	14
A	家	一	春	治	玄	張	晴	泰	日	入	仁	宝	堀	友
B	倫	朝	具	知	共	鞆	朋	倫	住	才	利	俊	歳	年
C	壽	時	季	豊	富	遠	虎	同	近	親	周	了	力	立
D	興	音	乙	往	兼	包	勝	景	晩	量	和	方	上	吉
E	義	善	能	良	賀	賢	度	克	祥	如	覺	賴	依	仍
F	自	歸	馮	夜	安	忠	旦	督	但	當	爲	高	貴	孝
G	番	隆	宮	武	竹	種	達	龍	次	續	綱	恒	經	常
H	貫	永	長	直	尚	成	業	仲	中	波	奈	南	宗	吉
J	村	氏	雲	梅	右	瓜	則	法	教	範	儀	德	順	憲
K	應	意	度	信	延	宜	國	軍	月	康	恭	保	補	正
L	政	冒	當	匡	増	希	丸	又	万	松	房	英	冬	藤
M	風	不	伏	二	佛	是	惟	伊	小	有	在	秋	顯	觀
N	鑑	明	章	銘	敦	篤	天	淡	貞	定	眞	實	左	西
O	山	散	廿	清	淨	浪	米	神	金	菊	喜	行	幸	雪
P	光	滿	三	道	通	重	鎮	茂	下	新	心	十	シ	四
Q	廣	弘	寛	門	野	嚴	禮	久	秀	衡	平	兵	ヒ	彦
R	盛	守	森	林	宴	元	基	本	師	持	用	百	千	泉
S	仙	助	介	祐	資	佐	相	菅	末	季	純	住	放	角

Code	Reading	Code	Reading	Code	Reading	Code	Reading
A1	IYE	J1	MURA	N11–N12	SANE	Q9	HIDE
A2	ICHI	J2	UJI	N13	SA	Q10–Q11	HIRA
A3–A7	HARU	J3	UN	N14	SAI	Q12	HYO
A8	HADA	J4	UME	O1–O2	SAN	Q13	HI
A9	NICHI	J5	URI	O4–O8	KIYO	Q14	HIKO
A10	NYU	J6	URI	O9	KIKU	R1–R5	MORI
A11	NI	J7–J14	NORI	O10	KI	R6–R8	MOTO
A12	HO	K1–K3	NORI	O11	YUKI	R9	MORO
A13	HORI	K4–K6	NOBU	O12–O14	MITSU	R10–R11	MOCHI
A14	TOMO	K7	KUNI	P1–P3	MISHI	R12	MOMO
B1–B9	TOMO	K8	GUN	P4–P5	MICHI	R13–R14	SEN
C1	TOSHI	K9	GWATSU	P6–P8	SHIGE	S1	SEN
C2–C3	TOKO	K10–K13	YASU	P9	SHIMO	S2–S7	SUKE
C4	TOYO	K14	MASA	P10–P11	SHIN	S8	SUKA
C5	TOMI	L1–L4	MASA	P12	JU	S9–S10	SUYE
C6	TO	L5	MASU	P13–P14	SHI	S11–S12	SUMI
C7	TORA	L6	MARE	Q1–Q7	HIRO	S13	SUDE
C8	TO	L7	MARU	Q8	HISA	S14	SUMI
C9–C11	CHIKA	L8	MATA				
C12	RYO	L9	MAN				
C13	RIKI	L10	MATSU				
C14	RYU	L11–L12	FUSA				
D1	OKI	L13	FUYU				
D2–D3	OTO	L14	FUJI				
D4	O	M1	FU				
D5–D6	KANE	M2	FU				
D7	KATSU	M3	FUSHI				
D8–D9	KAGE	M4	FUTA				
D10–D11	KAZU	M5	BUTSU				
D12	KATA	M6–M8	KORE				
D13	KAMI	M9	KO				
D14	YOSHI	M10–M11	ARI				
E1–E11	YOSHI	M12–M14	AKI				
E12–E14	YORI	N1–N4	MASA				
F1–F3	YORI	N5–N6	ATSU				
F4	YORU	N7	AMA				
F5	YASU	N8	AWA				
F6–F9	TADA	N9–N10	SADA				
F10	TO						
F11	TAME						
F12–F14	TAKA						
G1–G3	TAKA						
G4–G5	TAKE						
G6	TANE						
G7–G8	TATSU						
G9–G10	TSUGU						
G11	TSUNA						
G12–G14	TSUNE						
H1	TSURA						
H2–H3	NAGA						
H4–H5	NAO						
H6–H7	NARI						
H8–H9	NAKA						
H10	NAMI						
H11	NA						
H12	NAN						
H13–H14	MUME						

Glossary

Ashi lit. legs; activities within the *hamon* being small lines running down from the edge of the *hamon* towards the cutting edge

Ashiguru foot soldiers

Ayasugi-hada a wavy pattern of *jihada* mostly appearing in swords made by the Gassan family of swordsmiths

Bakufu a word loosely meaning military camp but generally taken to mean the *shogunate*

Bokuto wooden swords

Boshi hardened and quenched part of the point

Bushi a warrior

Bushido the Way of the Warrior

Chikei small activities on the *ji*, or surface of the blade formed of *nie*

Choji clove-shaped *hamon*

Choji midare hamon irregular shaped *hamon* based on a clove pattern

Chokuto ancient straight swords

Cho-musubi a way of tying the *sageo*, the butterfly knot

Daimyo feudal lords

Daimyo-musubi a knot for a *sageo*, the lord's knot

Daisho pair of swords

Daito general name meaning "long sword"

Fuchi-kashira usually paired, they form the pommel and collar of the handle

Fudai term applied to *daimyo* of the inner circle close and loyal to the *shogun*

Fukoto a movement to return to the old ways of making swords in the thirteenth and fourteenth centuries

Fukura the sharp edge of the point

Fukuro-yari spear that encases the pole in a socket instead of it being secured by a tang

Fukusa silk cloth used when viewing swords

Gaikokujin foreigner

Gassaku two swordsmiths collaborating in the making of a blade

Gekoku-jo the lower classes overthrowing their social superiors

Gendai-to modern swords

Gimei fake signature

Gohai/sempai one's immediate "inferior"(*gohai*) or "superior" (*sempai*) in society

Goji-mei five-character signature

Gokkaden the five traditions of sword-making

Gunto army sword

Habaki blade's collar

Hadome iron cross section on a pole, used to parry an attack or trip an opponent

Hagakure lit. "Hidden Leaves"; it is a treatise on *Bushido*

Ha-giri a serious flaw which is a hairline crack running from the cutting edge into the blade

Hakama traditional pleated dress as worn by *samurai* and modern practitioners of martial arts

Hamon the pattern of the hardened edge

Han-dachi lit. half-*tachi*, a mount that incorporates the *saya* mounts of a *tachi*

Ha-saki the sharp cutting edge of a blade

Hataraki lit. "workings"; these are the small activities seen within the *hamon* and also sometimes on the surface or *ji* of a blade

Hi grooves

Hikaki cutting the *hi*, or grooves

Hira-ji the body or surface of the blade on which the *jihada* or pattern is seen

Hirumaki metal base on the pole of a *naginata* or *yari*

Hizen-to a term applied to swords made in Hizen Province, usually by the main Tadayoshi family

Hocho kitchen knife—a specific shape of a dagger

Hoko spear with a blade protruding from one side only

Horimono carvings on blades

Hozoin so-jutsu school of spear fighting

Inro small lacquered boxes that have often have a ribbed effect that lends its name to ribbed lacquer scabbards

Iori-mune a roof-shaped back of the blade

Itame-hada a type of *jihada*, being wood-grained pattern seen on the surface of the blade

Ji surface of the blade

Jigane the actual steel from which the sword is made

Jihada surface pattern

Ji-nie small martensite crystals on the surface or body of the blade

Jumonji-yari spear with cross-shaped blades

Juttetsu the ten pupils of Masamune

Juyo Bijitsuhin a sword classified before World War II as an important art object by the Japanese government

Juyo Token important sword

Kabuto-gane lit. metal helmet; it is the metal mount at the top end of the handle of a *tachi*

Kabuto-wari sword cutting test on a helmet

Kaeri turn-back of *boshi*

Kaigunto the mounting of the swords worn by officers of the Imperial Japanese Navy during World War II

Kami spirits

Kamikaze lit. "Divine Wind" that destroyed the Mongol fleet in the thirteenth century

Kanbun-shinto sugata the new-sword shape of the Kanbun period

Kanji Chinese characters

Kantei nyusatsu sword appraisal competition when one casts a vote on the likely maker's name

Kata A form of fencing practice with predetermined attacks and defenses

Katakama-yari a cross-shaped *yari* with uneven sized blades protruding from the sides

Katana long sword worn through the sash with the cutting edge uppermost

Katana-kake rack for a *katana*

Kawagane surface or skin steel

Kazu-uichi-mono things made in number

Kendo/iai dojo the hall where *kendo* and *iai* are practiced

Kiku chrysanthemum

Kiku Gyusaku swords made by the Emperor Gotoba and signed with a *kiku*

Kinno-to "Emperor Supporting Swords"

Kinsogan gold inlay

Kinsuji a small activity within the *hamon* made of *nie* and appearing like small black shiny lines

Kiriha-zukuri early straight shaped swords

Kissaki the point of a sword

Kizu a flaw or fault in a blade

Kodzuka the handle of a *ko-gatana* or auxiliary knife

Kogai a skewer-like implement often found in the scabbards of short swords and paired with the *kodzuka*

Ko-gatana small auxiliary knives

Koiguchi lit. "carp's mouth"; it is the mouth of the scabbard

Kokuho an object given the status of "National Treasure" by the Japanese government

Ko-maru boshi small circular quenching pattern in the point of the blade

Ko-nie small *nie* or martensite crystals mainly found within the *hamon*

Konuka-hada lit. rice-brand pattern found on the *ji* of *Hizen-to*

Ko-shinogi the small ridge line within the point

Koshirae the entire mounting of a sword, excluding the blade

Koshi-zori zori on the hip; a curvature whose deepest part is low on the sword, located close to the hip

Koshu Tokubetsu Kicho trans. Special and Extraordinary Workmanship (this old *shinsa* designation is no longer awarded)

Koto old sword period, pre-1600

Kurikata retaining knob on the scabbard through which the *sageo* passes

Machi-okuri when the notches at the junction of the tang and the sharpened part of the blade are moved upwards, thereby effectively shortening the blade

Magari-yari alternative name for the *jumonji-yari* above

Makura pillow

Makura-yari pillow *yari*

Maru-mune a rounded back edge to the blade

Masame-hada a straight patterned *jihada*

Mekugi retaining peg in the handle of a sword

Mekugi-ana the hole through which the peg goes through to retain the handle securely.

Mekugi-nuki instrument for removing the *menuki*

Menuki hilt ornaments found under the wrapping, said to facilitate the grip

Mitsu-mune a three-sided back edge to the blade

Mizuheshi the working of the *tamahagane* into thin sections and then dividing them into small pieces and picking those most suitable for *kawagane* or *shingane*

Mizukage lit. "water shadow," a faint line sometimes seen at the start of the *hamon* and may be a feature of a requenched blade

Mokume-hada a burl or wood-grained pattern of *jihada*

Monouchi the top third of the blade nearest the point, which is considered the most effective cutting part of the blade

Mukansa a rank of artisan which when achieved, means that although he submits work into the annual competition, he is considered above being judged

Nagamaki a type of polearm similar to *naginata*

Naginata a polearm similar to a halberd

Naginata oshigata drawing of a *naginata*

Naginata-naoshi naginata that has been altered into a sword

Naka center or middle

Nakago tang

Nakago-jiri the butt or end of the tang

Nie visible martensite crystals in the *hamon*

Ningen Kokuho popularly called a "Living National Treasure"

Nioi the same as *nie* but too small to be seen individually by the naked eye; they form a cloud-like appearance in the *hamon*

Nioi-giri a break in the line of the edge of the *hamon*; this is a serious flaw in a blade

Nioiguchi the edge of the *hamon* bordering the *hira-ji*

Nambam-tetsu foreign steel

No-dachi lit. "moor swords"

Nugui-game hand-made fibrous Japanese paper used for wiping the blade

Nukitsuki drawing the sword

Omote front side of blade, opposite of *ura*

Origami lit. "folded paper" but here refers to certificates of authenticity and quality

O-yoroi lit. "great armor," as worn in the Gempei Wars by high ranking *samurai*

Reigi etiquette

Ronin lit."wave-men," *samurai* without feudal ties or obligations

Ronin-musubi masterless *samurai*'s style of sword knot for *sageo*

Sageo knot

Saijo wazamono supremely sharp

Sakité hammer man assistant

Satetsu sand bearing iron ore

Saya scabbard

Saya-atte scabbards clashing together

Sayashi scabbard-maker

Seii-taii-shogun Barbarian Suppressing General

Seiza a formal kneeling position

Sengoku-jidai period of the country at war

Sensei teacher

Seoi-tachi shoulder *tachi*

Seppuku ritual suicide by disembowelment

Shinai practice swords, normally made from bamboo

Shinai-kendo modern fencing with a bamboo sword

Shingane core steel

Shingunto the style of swords worn by the Imperial Japanese Army during World War II

Shin-ken lit. "true swords," sharp swords used in martial arts

Shinogi the ridge line running the length of most Japanese sword blades apart from *tanto*, or daggers

Shinogi-tsukuri tachi slung sword blade with a ridge line throughout its length

Shinsa judging and appraisal

Shinsaku-to newly made swords

Shinshinto utsuri a sort of reflection or shadow of the *hamon*, as seen in the *ji* of, in this case, very late swords

Shinto new sword period

Shirake utsuri a very white coloring to the *ji* with no clearly defined shape or pattern

Shira-saya plain wood storage scabbards

Shogun the military ruler

Shogunate the office of the *shogun*

Shoto a general name for a short sword

Showa-to mass-produced blades from the Pacific War period (1941–1945)

Sode-garami sleeve entanglers

Sohei militant clerics/monks

Sugata form or shape

Suguha hamon straight quench line

Su-ken straight sword

Sunagashi an activity within the *hamon* formed by *nie* and resembling "drifting sands"

Sunobe sword blank

Suriage shortened

Su-yari straight spear

Tachi long sword worn slung from the hip with the cutting edge down

Tachi-kake rack for a *tachi*

Tamahagane raw material for forging a sword

Tameshigiri cutting tests with swords

Tanto dagger

Tatami traditional straw mats found in Japanese houses

Tatara smelter in which the *tamahagane* is produced

Tokubesu Kicho trans. Especially worthy of preservation

Tokubetsu Juyo shinsa Especially Important Swords

Tori-zori an even curvature on a blade

Tozama outer *daimyo*

Tsuba hand guard

Tsuka the handle of a sword

Tsukamaki handle wrapping

Tsukare tiredness when core steel starts to show through the surface steel

Tsumi-wakashi piling the small selected pieces of *tamahagane* and melting them so that they may be fused together

Ubu unaltered condition (for instance, not shortened)

Uichigatana long sword, also called *katana*

Uchiko the powder used to clean and remove oil from a blade

Ura reverse side of a sword (ie, not the front)

Utsuri a kind of reflection of the *hamon* in the surface of the blade

Wakizashi short swords

Yaki-ire The quenching process that creates the *hamon*

Yakinaoshi requenching a blade to replace a damaged *hamon*. This is a serious flaw

Yamabushi mountain-warriors

Yamato Daimishi Japanese fighting spirit

Yari spears

Yari-mochi yari-carrier

Yokote the vertical line dividing the point from the rest of the blade

Zaimei genuine signature

Zanshin awareness

Zori curvature

Index

First published in 2009
This edition published in 2017 by Tuttle Publishing,
an imprint of Periplus Editions (HK) Ltd

www.tuttlepublishing.com

ISBN 978-4-8053-1457-9

Distributed by
North America, Latin America & Europe
Tuttle Publishing
364 Innovation Drive
North Clarendon, VT 05759-9436 U.S.A.
Tel: 1 (802) 773-8930
Fax: 1 (802) 773-6993
info@tuttlepublishing.com
www.tuttlepublishing.com

Japan
Tuttle Publishing
Yaekari Building, 3rd Floor
5-4-12 Osaki
Shinagawa-ku
Tokyo 141-0032
Tel: (81) 3 5437-0171
Fax: (81) 3 5437-0755
sales@tuttle.co.jp
www.tuttle.co.jp

Asia Pacific
Berkeley Books Pte. Ltd.
61 Tai Seng Avenue, #02-12
Singapore 534167
Tel: (65) 6280-1330
Fax: (65) 6280-6290
inquiries@periplus.com.sg
www.periplus.com

20 19 18 17 10 9 8 7 6 5 4 3 2 1
Printed in China 1706CM

TUTTLE PUBLISHING ® is a registered trademark of
Tuttle Publishing, a division of Periplus Editions (HK) Ltd.

ABOUT TUTTLE:
"Books to Span the East and West"

Our core mission at Tuttle Publishing is to create books
which bring people together one page at a time. Tuttle
was founded in 1832 in the small New England town
of Rutland, Vermont (USA). Our fundamental values
remain as strong today as they were then—to publish
best-in-class books informing the English-speaking
world about the countries and peoples of Asia. The world
has become a smaller place today and Asia's economic,
cultural and political influence has expanded, yet the
need for meaningful dialogue and information about this
diverse region has never been greater. Since 1948, Tuttle
has been a leader in publishing books on the cultures,
arts, cuisines, languages and literatures of Asia. Our
authors and photographers have won numerous awards
and Tuttle has published thousands of books on subjects
ranging from martial arts to paper crafts. We welcome
you to explore the wealth of information available on
Asia at **www.tuttlepublishing.com**.

ADDITIONAL ILLUSTRATIONS
Front cover Samurai and the Conquered, a ukiyo-e print by
Utagawa Kuniyoshi. *Courtesy of Wikimedia Commons*

Front and Back Endpapers Samurai battle on old vintage
Japanese traditional paintings, ©Maxim Tupikov/Shutterstock.com

Book spine Honda Tadakatsu, veteran *samurai* general of
several significant battles, including Anegawa (1570),
Mikatagahara (1573), and Nagashino (1575). *Courtesy of
the British Museum/Jo St. Mart*

Page 1, 125 Gassan Sadaichi about to quench a blade in the
yaki-ire process.

Pages 2/3 Kimura Mataso fighting another *samurai*, while
Kato Kiyomasa watches on horseback.

Pages 4/5 The formidable ladies of Kyushu Island
defending a bridge against the conscript imperial cavalry
during the Satsuma rebellion of 1877. Mostly, they are
using *naginata*, at the time a favored weapon of women of the
samurai class, as well as swords.